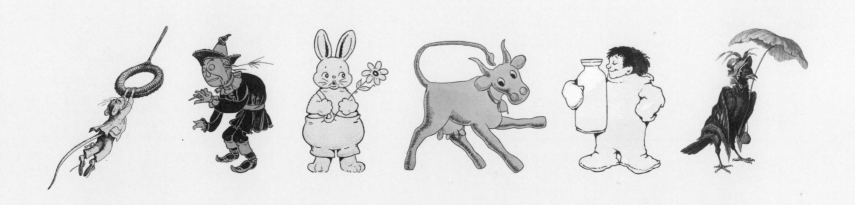

Drawn to Enchant

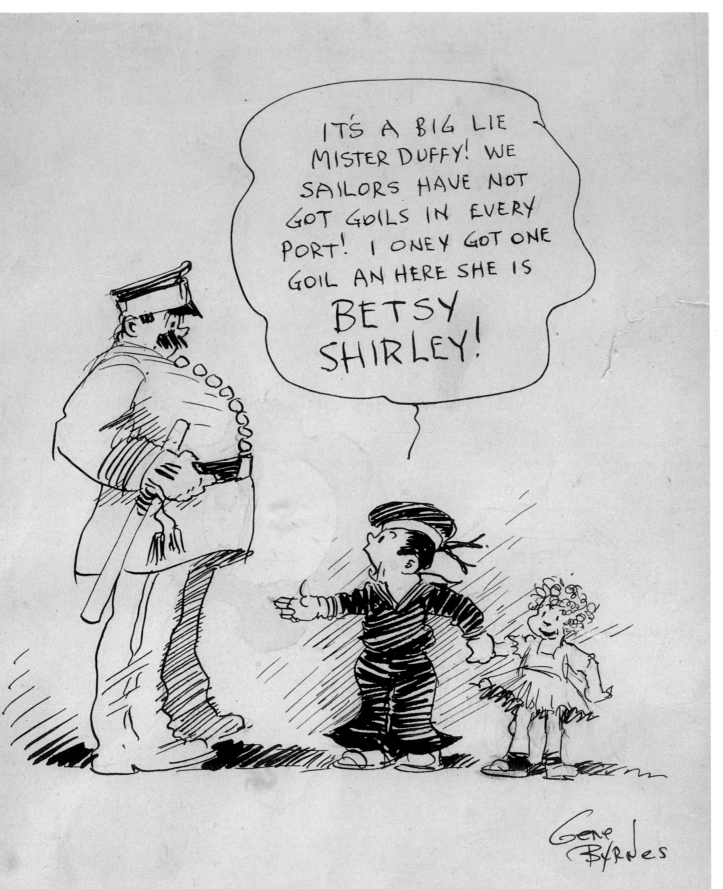

Drawn to Enchant

Original Children's Book Art
in the Betsy Beinecke Shirley Collection

TIMOTHY G. YOUNG

with the assistance of Patrick Kiley

BEINECKE RARE BOOK AND MANUSCRIPT LIBRARY

Distributed by Yale University Press, New Haven and London

LIBRARY OF CONGRESS CATALOGING-IN-PUBLICATION DATA

Young, Timothy G. (Timothy Garrett), 1965–
 Drawn to enchant : original children's book art in the Betsy Beinecke Shirley collection /
Timothy G. Young ; with the assistance of Patrick Kiley.
 p. cm.
 Includes index.
 ISBN 978-0-300-12673-0 (alk. paper)
 1. Illustrated children's books — United States — Catalogs.
2. Illustration of books — United States — Catalogs. 3. Shirley, Betsy Beinecke — Library — Catalogs.
4. Illustrated children's books — Private collections — Connecticut — New Haven — Catalogs.
5. Beinecke Rare Book and Manuscript Library — Catalogs.
I. Kiley, Patrick, 1980– II. Beinecke Rare Book and Manuscript Library. III. Title.
 NC975.Y68 2007
 741.6'420747468 — dc22

 2007011956

Design & Typography by Howard I. Gralla
Photography by Stan Godlewski
Color separations by Professional Graphics, Rockford, Illinois
Printed and bound by CS Graphics PTE LTD, Singapore

Distributed by Yale University Press, New Haven and London
P. O. Box 209040, 302 Temple Street, New Haven, Connecticut 06520-9040
www.yalebooks.com

Frontispiece:
GENE BYRNES, 1889–1974. [Sketch], Pen and ink on paper.
One of Gene Byrnes' "Reg'lar Fellers" defends the honor of the winsome Betsy Shirley.

Cover illustration:
JUSTIN H. HOWARD, active 1856–1876. [Crowd of children around banner, others playing with McLoughlin alphabet blocks] for *The Doings of the Alphabet* (New York: McLoughlin Bros., ca. 1869).

Contents

DEDICATED TO Betsy Beinecke Shirley,

FOR HER PASSION AND DEVOTION TO COLLECTING AND

TO Greer Allen, FOR HIS VISION AND GUIDANCE

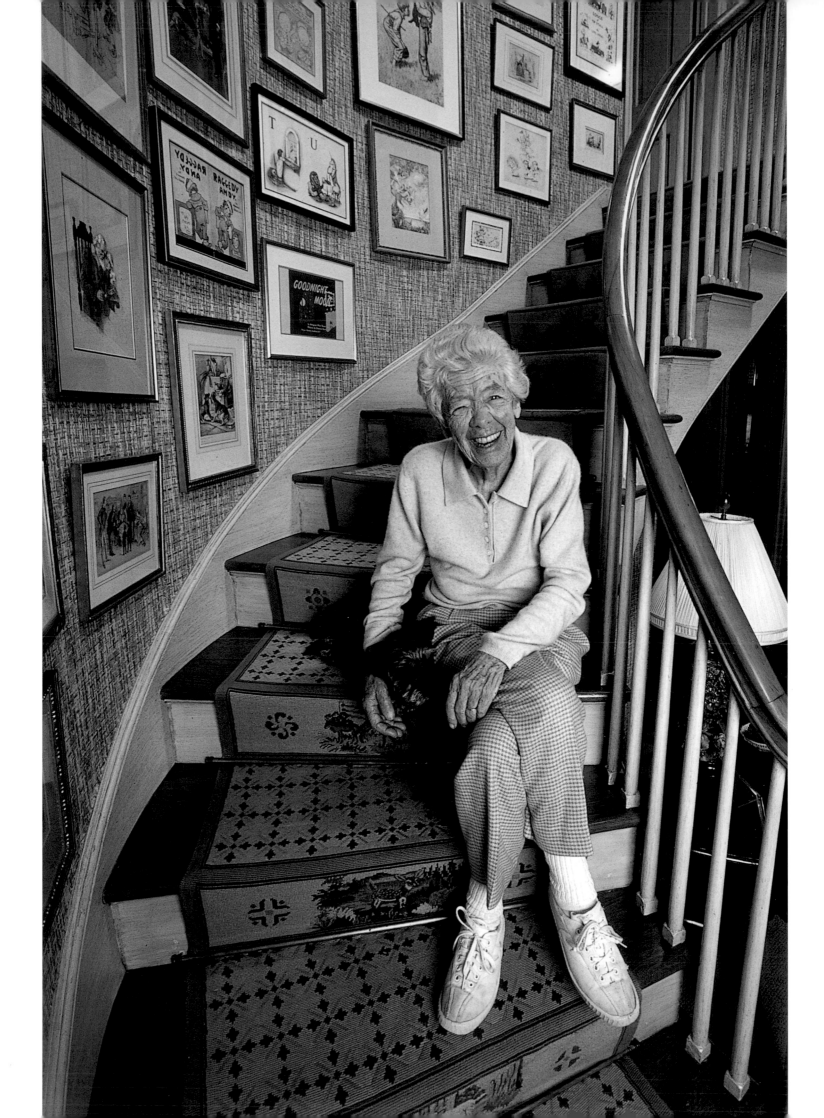

Foreword

My mother for years maintained that she started collecting children's books because of our father's interest in Kentucky rifles. Rare book collecting ran in her genes. Her uncles, Edwin and Fritz, were both collectors – as was her brother Walter. She was a great reader herself. That she took to the field in general came as no surprise, but her particular interest in or, as it turned out, passion for children's books really took off in her early grandmother days.

I still remember a seemingly casual telephone call from her about 35 years ago. "I've decided to collect children's books. What books do your children like best?" I replied that there were a bunch of favorites, but the current Number one "best seller" was Maurice Sendak's *Where the Wild Things Are* – and "… by the way, Mom, the curly haired Wild Thing reminds them of you." Within a few days she announced that she had found the book – but wasn't altogether sure how she felt about the reminding. She should have felt great – honored even. The Wild Things were fun – no rules – all play. Just imagine being asked to share a "wild rumpus" – and she a grandmother! Very cool, indeed!

Well, as we all know, her new interest soon turned into passion as she became more knowledgeable and as the collection grew. One thing does lead to another and her curiosity and acquisitiveness – her competitiveness too – worked well together. She assembled one of the country's premier collections of American children's literature – books and illustrations and more. Books filled every available nook and cranny; illustrations covered the walls of every room. The collection ranged through first editions, original manuscripts, paintings, drawings, sketches, prints, letters, games, puzzles, albums, and textiles – a study of childhood for the ages, a guide to the history and development of our country. Her home became a Mecca for scholars. It was as well a place where even a casual visitor might come face-to-face with a familiar and treasured remembrance. She knew every title in the collection – and in most cases, something extra and interesting about each item. She relished the opportunity to share her passion with one and all – and it didn't take much to get her going. But best of all, while her approach to collecting was serious and scholarly, she never lost

Betsy with Cap'n Hook on the stairway of her home, lined with original artwork, 2004.

the fun or failed to appreciate the whimsy that attracted children to the stories and pictures in the first place.

She began to donate her collection to the Beinecke Library at Yale in 1987 – working through different themes each year. The remaining portion – including thousands of items – was brought to New Haven in early 2005 after her death. She had always hoped to create a printed catalogue of the collection. This is the first volume – original artworks.

BETSY SHIRLEY MICHEL

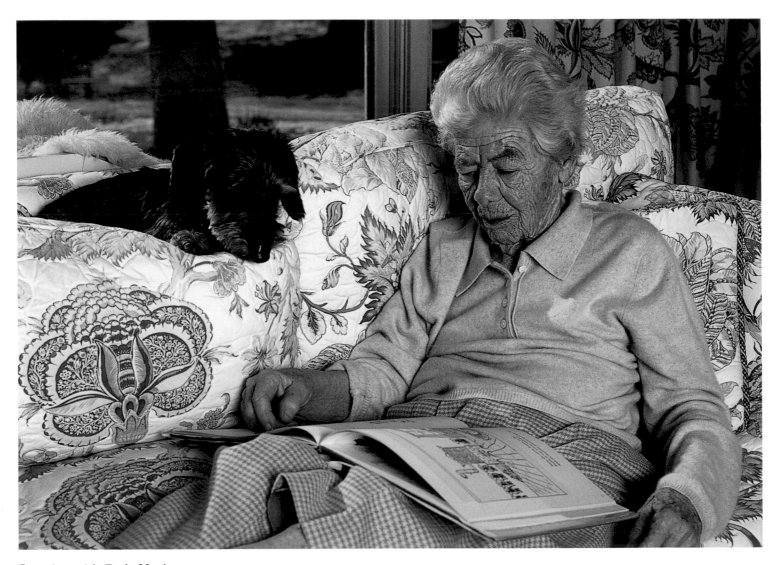

Storytime with Cap'n Hook, 2004.

A note on Betsy Beinecke Shirley

Betsy Shirley was an American original. Initially she wanted her grand-children to recognize the heritage of the United States as seen through everyday children's books, and with the support of her husband Carl, their library expanded to include artwork, manuscripts, and even non-American items such as the very first christmas card (London, 1843), a pictorial non-sense letter by Edward Lear (its words in the shape of a sea-serpent) and a silhouette paper-cut handmade by Hans Christian Andersen while he told fairy tales to young children.

With her modest profile, few people knew of Betsy's serious commit-ment to being both a scholar and a passionate collector. She constantly read and studied everything and had a proficient understanding of what she owned (or might consider acquiring). A frequent lender to major exhibitions (often anonymously), she also organized four shows entirely from her own shelves and walls: "Instruction with Delight" at Macculloch Hall Histori-cal Museum (1985); "From Witches to Wonder-Land" at The New York Public Library (1985–86); "A Child's Garden of Dreams" at the Brandywine River Museum (1989–90); and "Read Me A Story – Show Me A Book" at the Beinecke Library (1991). Betsy was elected to membership in The Grolier Club in 1980 and to The American Antiquarian Society in 1982.

The earliest manuscript in her collection is a document from November 22, 1640, in the hand of John Eliot, best remembered for his Indian Bible but also one of those responsible for preparing the Bay Psalm Book. This document, George Alcock's last will and testament, details how Alcock's children should be educated and may be the earliest record of educational theory in colonial America. Another interesting document in the Shirley collection is an indenture that deals with distribution of property, signed February 21, 1734, by Elizabeth Vergoose – at one time believed to be the original "Madam Goose" (or Mother Goose) of nursery rhyme lore. The earliest books in Betsy's collection include Cotton Mather's *Addresses to Old Men, and Young Men, and Little Children* (Boston, 1690), Thomas White's *A Little Book for Little Children* (Boston, 1702), and Benjamin Keach's *War with the Devil or the Young Man's Conflict with the Powers of Darkness* (New York, 1707).

The Shirley collection also focuses on original artwork, for, to quote Alice of Wonderland: "what good is a book without pictures?" In the present volume we celebrate the judgment and taste that filled Betsy's walls and surrounded her daily life, exhibiting the vision of a connoisseur with a touch of gentle humor matched only by the twinkle in her eyes whenever she spoke of her collection.

JUSTIN G. SCHILLER

Introduction

Do you remember your favorite book from childhood? Maybe the theme remains strong in memory, or a few lines spring to mind, but most likely, you have a vivid recollection of a brilliantly colored cover painting or a tender etching of a clever animal. Visual memory can last a lifetime, especially when we link an image to a beloved story. Betsy Beinecke Shirley knew very well the lasting impressions a treasured book can have on a reader. She built her collection around the books she loved as a girl – and expanded her sights to gather icons of the genre – those curious monkeys, intrepid pirates, and mischievous fairies who have come to populate the imaginations of generations of American children.

The Shirley collection, housed now in the Beinecke Rare Book and Manuscript Library of Yale University, consists of thousands of volumes of books (many quite rare) and hundreds of manuscript items (letters from young readers to their favorite authors, mock-ups of books, even a swatch of wool from "Mary's Lamb"). Illustrations for children's books make up an especially appealing part of the collection. While art is sometimes gathered by collectors merely as ornaments, Mrs. Shirley not only bought the finished images reproduced in books, but recognized the value for researchers in sketches and rough designs, rare proofs and prints, even sequences of pictures for unfinished books. The collection she built now resides, by and large, in the beautiful modern building that was the gift to Yale from her father, Walter Beinecke, and his brothers, Edwin and Frederick. A selected number of paintings and drawings were passed along to beloved family members following her passing in 2004.

This volume is a celebration of the collection and of the woman whose keen eye located so many intriguing gems. The book is arranged into sections by theme, which proceed roughly by age-level according to reading audience – beginning with alphabet and picture books, and continuing to adventure stories and beyond. A final section highlights wonderful odds and ends that give the Shirley collection such amazing breadth. Each image is reproduced with an accompanying caption that adds context and a few interesting details about how it was fitted into its final form, be it a book, a poster, or an ephemeral printed delight. At the end of this book,

readers will find an appendix that gives biographical sketches of the majority of the artists featured.

But before you skip through the enchanted groves of childhood reverie, we must ask a few key questions about what this all means: How does a picture make its way into a book? What makes a good children's book artist? What training do you need? What precise talents do you have to have? Do you even have to like children?

A look through the biographies will reveal some interesting facts, even if they don't answer any of the questions directly. Many of the artists represented on these pages were highly trained. Did their move from high-toned gallery art to juvenile illustration represent a downward slope in their careers? We certainly hope not. The careers of illustrators have often been under-appreciated, while at the same time, their works reach large audiences. Then again, children's books don't necessarily need detailed and layered scenes. A simple line and a dash of color might be just perfect for an elementary rhyme.

Then there are artists who were self-taught, who came into their own by way of their quirky drawings and funny tales. Look at the panoramas of Ludwig Bemelmans and see if you have the heart to critique his unique artistic vision. Others were primarily known as political cartoonists or designers before finding outlets in making books for juvenile readers. A special few began literally by drawing for children, as in the case of the adored Beatrix Potter.

Some artists can indeed be found on the walls of world-renowned museums – N. C. Wyeth, Everett Shinn, Maxfield Parrish – but young audiences know them best for the playful scenes they provided for favorite tales. Still, some folks are children's artists through and through: H. A. Rey, Kurt Wiese, Garth Williams, Wanda Gág. The artistic paths these artists took to find their works on children's pages are as varied as the images they produced.

It takes something special to make a successful children's book. In this day and age, the myth that anyone can write a kid's book persists. The assumed simplicity of the medium is a pitfall. Much work must go into a brief tale that will hold a child's interest (again and again). The same is true for the artwork. Capturing a book's theme, while not overpowering

the graphic balance with the storyline is a difficult job. Those who can do it well, like Maurice Sendak and Chris Van Allsburg, display an understanding of just how much visual information will hold a reader enthralled.

A read through the selection of images in this book will provide another form of instruction about children's literature. The earliest image is from around 1780; the latest, from 2001. While this is not a complete timeline in any fashion, one can begin to trace a lineage of imagery. The earliest types of American children's books were, by necessity, reprints of English volumes. By the time original titles started to become available in North America in the early decades of the nineteenth century, themes were standardized: moral tales, cautionary stories, educational texts, stories about pious deaths of good children. The type of item represented by the earliest artifact illustrated in this volume, a harlequinade, was out-of-the-ordinary. Though imbued with a religious message, it functioned more as a plaything. The nineteenth century saw a tremendous output in – and change in – the type of books produced for children. While morality remained a common theme, "toybooks," items of pure pleasure, became more available. Many publishers specialized in gift books, with some, like McLoughlin Bros., becoming known for a wide range of titles, from folk tales to collections of silly rhymes.

The late nineteenth century gave wider range to the imagination as specialty magazines for children became popular along with series of stories for older readers which introduced adventure tales and even science fiction. Publications for children had truly become an important market force. By the time a juggernaut such as *The Wizard of Oz* came on the scene in 1900, it was clear that creating juvenile titles was no modest affair. The twentieth century, which saw all forms of literature and art undergo self-examination, was when the children's book, as a form, matured. New themes were explored – growing up, overcoming obstacles, the conquering of fears – in picture books as well as first readers. The most recent image in this volume is from *Little Cliff's First Day of School*, in which an African American child deals with a universal experience.

These changes and their importance were very much on Betsy Shirley's mind as she built her collection. Her goal was to show how books and reading were crucial to the development of American children. In a way,

she was creating a reflection of the reading lives of children, not just the contents of their bookshelves. This is why having a research collection with so many beautiful examples of artists' works is significant. The component parts, with their unfinished sketches, erasures, and annotations go hand-in-hand with the finished works and the printed versions to create a representation of how books were made and how stories were passed along.

The Shirley collection is about visual literacy as much as it is about verbal literacy. It is exciting to see cartoons, such as Pogo and the Toonerville Trolley, celebrated here. Equally so, the juxtaposition of the Brer Rabbits of A.B. Frost and Barry Moser exhibit the power of an engaging story with a strong central character. Then again, what about The Happychaps, The Goops and The Brownies? : Strange little creatures, to be sure, but the kind kids love.

The Beinecke Library will continue to add to Betsy Shirley's collections. There are a great number of wonderful artists working today who would fit nicely with the assembled society. What we have to build on is a wonderful body of work, one that reflects the world of children's literature as seen by a very clever and discerning consumer and admirer. This celebration of original artwork for children's books is indeed Drawn to Enchant.

TIMOTHY G. YOUNG
Curator of the Betsy Beinecke Shirley Collection
of American Children's Literature

Drawn to Enchant

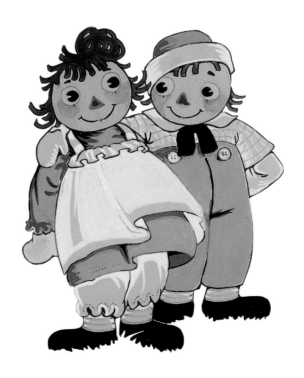

Learn Your ABCs

What is more simple — or *abecedarian* — than a book that teaches the alphabet? Fundamental parts of a child's education, representations of the twenty-six letters used in English evolved from the horn books of the fifteenth century to the fanciful and often esoteric displays found in modern books. The examples from the Shirley collection shown on the following pages are from the nineteenth and twentieth centuries. Some rely on the basic formula — matching a letter with an easily recognizable object — while others focus on illustrating traditions and stories, as with the Shaker and Mother Goose alphabets. The most recent contemporary example, from *The Alphabet of Civility*, intends to provide instruction in good manners as well.

JUSTIN H. HOWARD, active 1856–1876

[Crowd of children around banner, others playing with McLoughlin alphabet blocks]
for *The Doings of the Alphabet* (New York: McLoughlin Bros., ca. 1869)
Watercolor on paper

A variation of this study appears as the first illustration in McLoughlin's rhyming story of the alphabet, which was later reproduced for *Aunt Louisa's Golden Gift* (ca. 1870–89): "The twenty-six letters, on pleasure intent, / At Alphabet House, a day's holiday spent; / Observe now, and see, in what order they went."

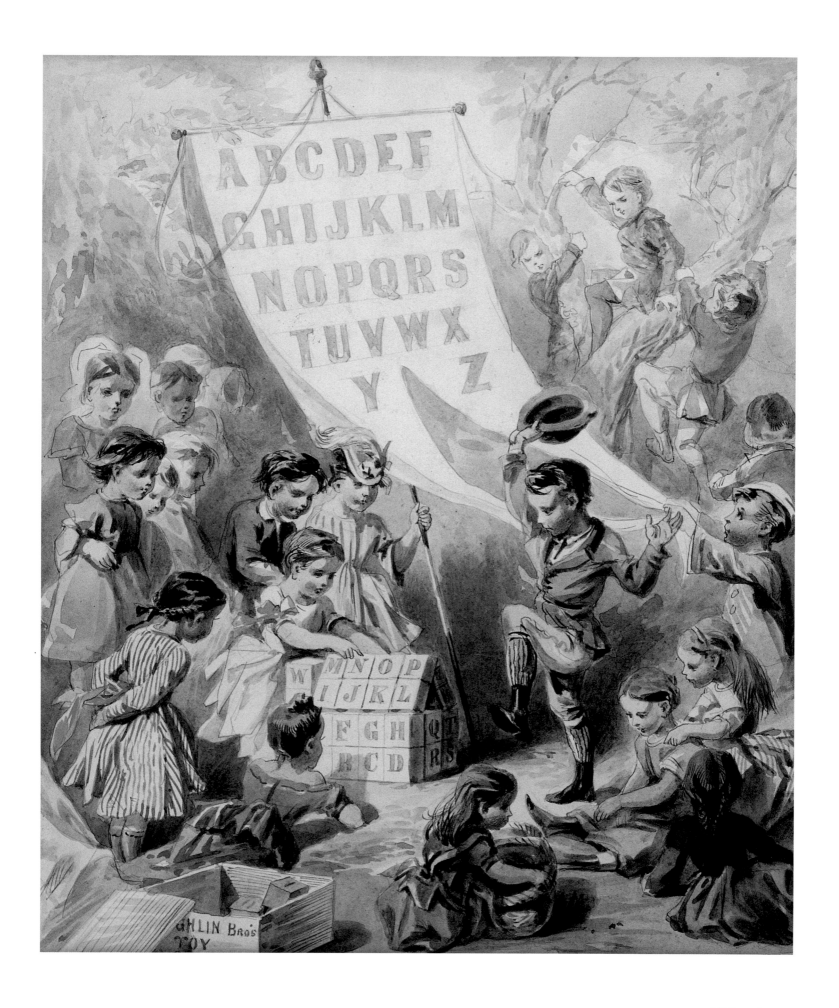

MAUD FULLER PETERSHAM,
1890–1971, and
MISKA PETERSHAM, 1888–1960

[Boy and girl with animals and hornbook]
for *An American ABC*
(New York: The Macmillan Co., 1941)
Proof print with hand-coloring

This is a proof sheet for the dust jacket
for the Caldecott Honor Book of 1942.
The husband and wife team illustrated more
than seventy books for children, many of
which they also authored.

[Boy with a gun running from a skunk,
rabbit, and raccoon]
Proof print with hand-coloring

This illustration was not used in the final
version of the book.

C. B. FALLS, 1874–1960

"'M' is for 'Mouse'"
for *The ABC Book*; *Designed and Cut
on Wood* (Garden City, N.Y.: Doubleday,
Page & Co., 1923)
Color proof print from woodblock

Falls designed and illustrated this book
to help his daughter learn the alphabet.
A subsequent version, *The Modern ABC
Book* (1930), used subjects from contempo-
rary life.

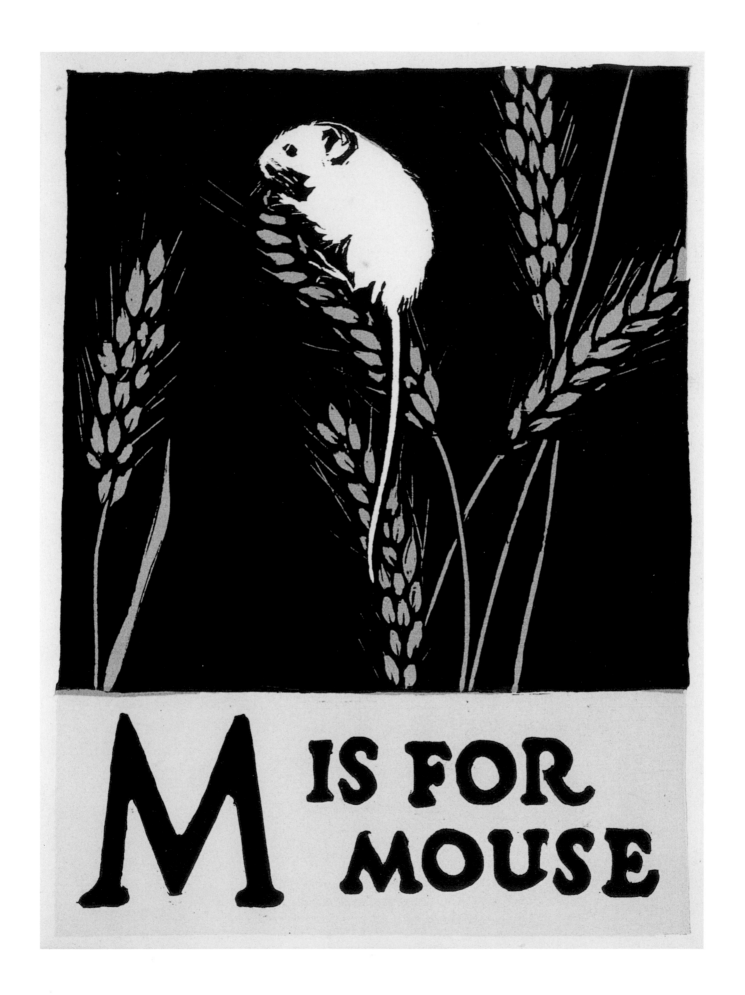

M IS FOR MOUSE

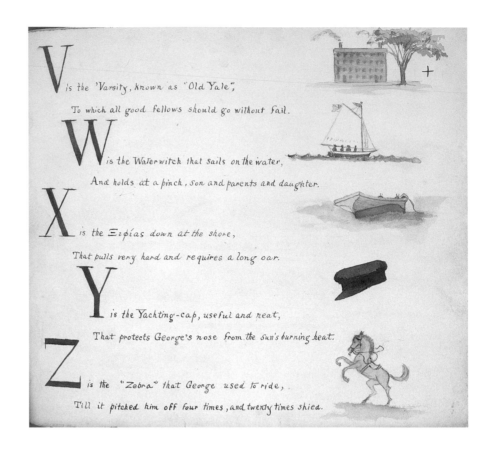

V is the 'Varsity, known as "Old Yale",

To which all good fellows should go without fail.

W is the Waterwitch that sails on the water,

And holds at a pinch, son and parents and daughter.

X is the Εκθίας down at the shore,

That pulls very hard and requires a long oar.

Y is the Yachting-cap, useful and neat,

That protects George's nose from the sun's burning heat.

Z is the "Zebra" that George used to ride,

Till it pitched him off four times, and twenty times shied.

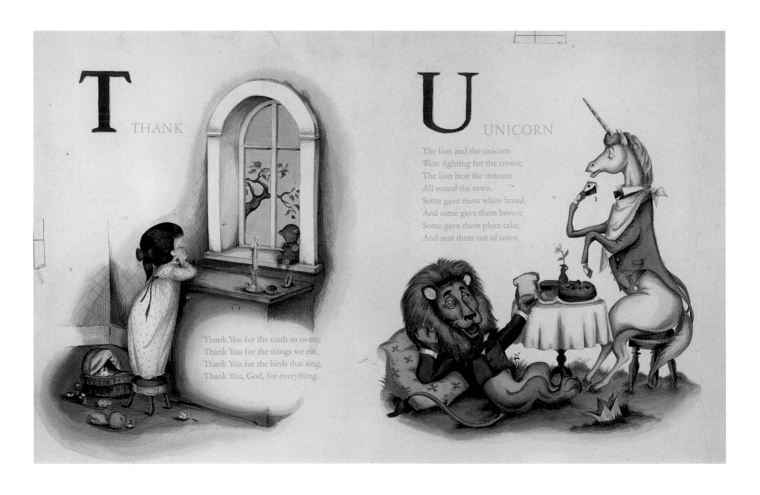

T THANK

Thank You for the earth so sweet,
Thank You for the things we eat,
Thank You for the birds that sing,
Thank You, God, for everything.

U UNICORN

The lion and the unicorn
Were fighting for the crown;
The lion beat the unicorn
All round the town.
Some gave them white bread,
And some gave them brown;
Some gave them plum cake,
And sent them out of town.

Caroline Ketcham Eaton, 1843–1910

[Letters V–Z with rhymes and illustrations], ca. 1890
for "Illustrated Alphabet for Little Folks"
Pen and ink with watercolor on paper

Eaton's bound and colored manuscript was never published. Though she was drawing on a late-nineteenth century mania for rhymed and illustrated abecedaries, her son George, and her family's cottage at Sheffield Beach in South Lyme, Connecticut (the "shore"), both receive mention. Perhaps Eaton's sage matriculatory advice to readers stands out above all: "V is the 'Varsity, known as 'Old Yale," / To which all good fellows should go without fail."

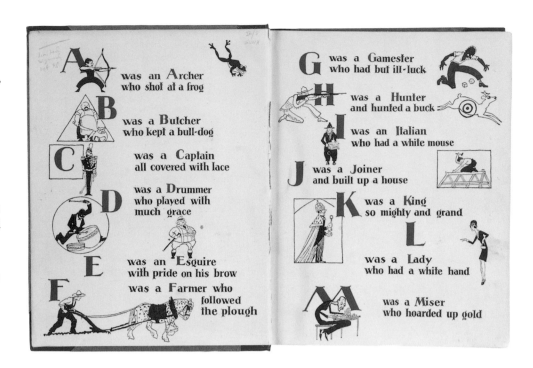

Joan Walsh Anglund, b. 1926

The letters 'T' ("Thank") and 'U' ("Unicorn") for *In a Pumpkin Shell: A Mother Goose ABC* (New York: Harcourt, Brace, and Co., 1960) Watercolor on board

Anglund's vintage ABC book, still available in print, illustrates each letter of the alphabet with the help of a nursery rhyme. The two studies represented here were altered slightly for the published versions.

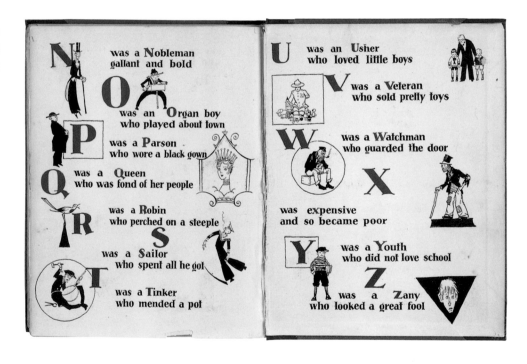

Willy Pogány, 1882–1955

[Illustrated alphabet A–M]
[Illustrated alphabet N–Z]
Printed image from *Willy Pogány's Mother Goose* (New York: T. Nelson & Sons, [1928])

These two halves of Pogány's nursery rhyme-inspired alphabet serve as the endsheets for his book. This *Mother Goose* includes more than eighty rhymes describing the fates of Humpty Dumpty, Jack and Jill, and Little Bo Peep, as well as 140 illustrations; the book's sixty color plates reflect the art deco sensibility of the time. Like other of Pogány's children's classics, *Mother Goose* was also made available in a deluxe gilt-stamped cloth edition.

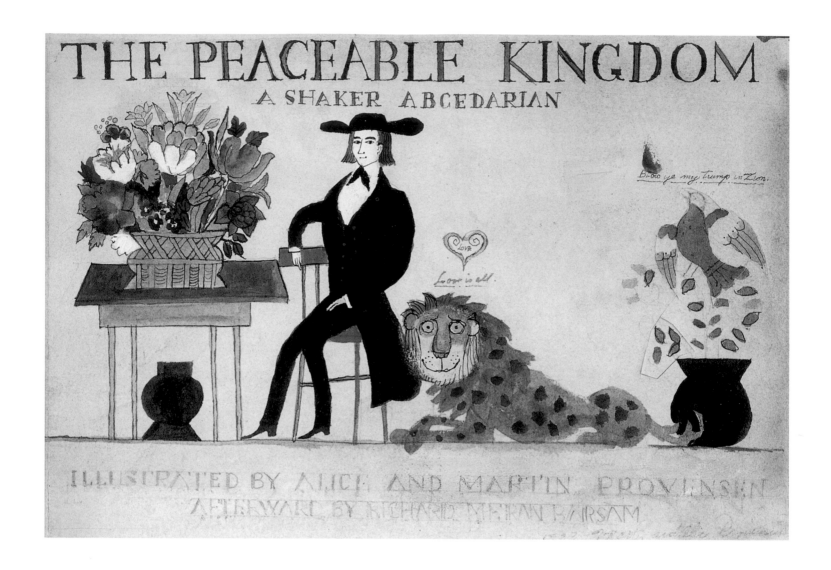

THE PEACEABLE KINGDOM
A SHAKER ABCEDARIAN

ILLUSTRATED BY ALICE AND MARTIN PROVENSEN
AFTERWARD BY RICHARD MEPAN BARSAM

ALICE PROVENSEN, b. 1918 and MARTIN PROVENSEN,
1916–1987

Study for a cover design
for *A Peaceable Kingdom: the Shaker Abecedarius*
(New York: Viking Press, 1978)
Watercolor and pencil on paper

The title on this early cover sketch differs slightly from the final ver-
sion. An abecedary, or abecedarius, is a table or book containing the
alphabet. This one uses the animal kingdom, from alligator to zebra,
as subjects. The final version omits the words above the animals'
heads.

CYNTHIA VEHSLAGE

"P" for "Parents"
for *The Alphabet of Civility*, by Virginia Clarkson
(Washington, D.C.: Starrhill Press, 1993)
Pen and ink on paper

"Parents can be fun. Enjoy at least one every day." Clarkson's offbeat
alphabet book highlights values of respect, humor and generosity.

In the Nursery

Before a child can read by herself, books will enter her life as a part of the nursery — as important, in so many respects, as other comforting furnishings. The experience of being read to sleep, despite what developmental effects it may have, will surely have one undeniable result: populating the playtime thoughts of the young child with fantasy friends and feats of dreamlike imagination. Cows jumping over moons! Butterflies dancing with grasshoppers! A family of bears befuddled by the intrusion of a little girl!

Artwork for nursery rhymes and whimsical tales hold a special place in the Shirley collection. They cover many of the most universally recognizable characters — by some of the most beloved illustrators. The variant cover of *Goodnight Moon* was one of Betsy Shirley's prized images, acquired from Clement Hurd's son. The three different images for Mother Goose tales (a particular passion) demonstrate how the teams of writer/illustrator play with themes: Baum and Parrish; Baum and Denslow (ad-libbing with *Father* Goose); and Denslow doing all of the honors.

The images of Raggedy Ann and Andy evoke a particularly tender memory for those who grew up not only with Johnny Gruelle's books detailing the adventures of this playful pair, but with actual dolls themselves, which were some of the most popular tie-ins in the history of Amcrican children's publishing.

Among the most prolific publishers of nursery rhymes and brightly-colored toybooks for young children was the New York firm McLoughlin Brothers. In addition to popularizing so many foreign stories (a number of them reprinted without permission), they commissioned hundreds of original works, including several shown in this section. *The Butterfly's Ball* was a frolic by the artist Richard André. *The Jolly Gymnasium*, however, seems to never have been issued, sadly denying the peek into Frederick Opper's madcap world, pre-*Happy Hooligan*.

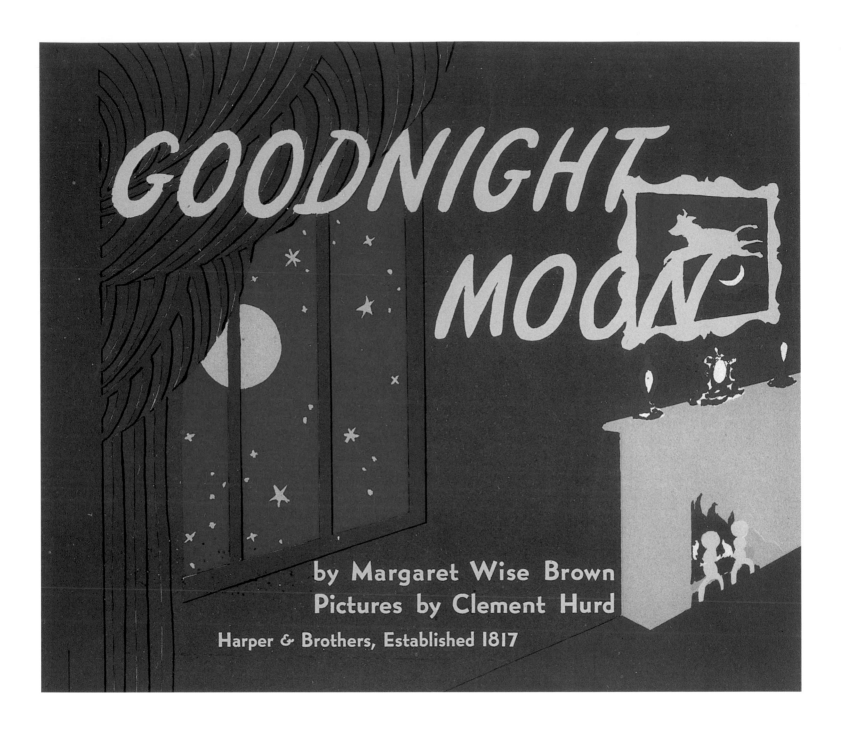

by Margaret Wise Brown
Pictures by Clement Hurd
Harper & Brothers, Established 1817

CLEMENT HURD, 1908–1988

Proof print (variant) of cover design for *Goodnight Moon*, by Margaret Wise Brown (New York: Harper and Row, 1947)

Though Hurd illustrated over seventy-five children's books, the Yale graduate's collaboration with author Margaret Wise Brown is his most popular; it has sold over two million copies, and has never been out of print since first publication. This press proof is one of three known copies.

JUSTIN H. HOWARD, active 1856–1876

"Hey Diddle Diddle," undated
Pencil on paper

The title for this standard Mother Goose rhyme is rendered in a mirror script in preparation for a wood engraving. It may have been a study for McLoughlin Brothers' *Mother Goose's Melodies*, which Howard probably designed during the 1880s. The artist's name has been signed "C. J. Howard," likely the engraver's mistake. The work of Charles J. Howard, another McLoughlin artist specializing in caricature during the years 1873–1905, is very similar to that of Justin Howard.

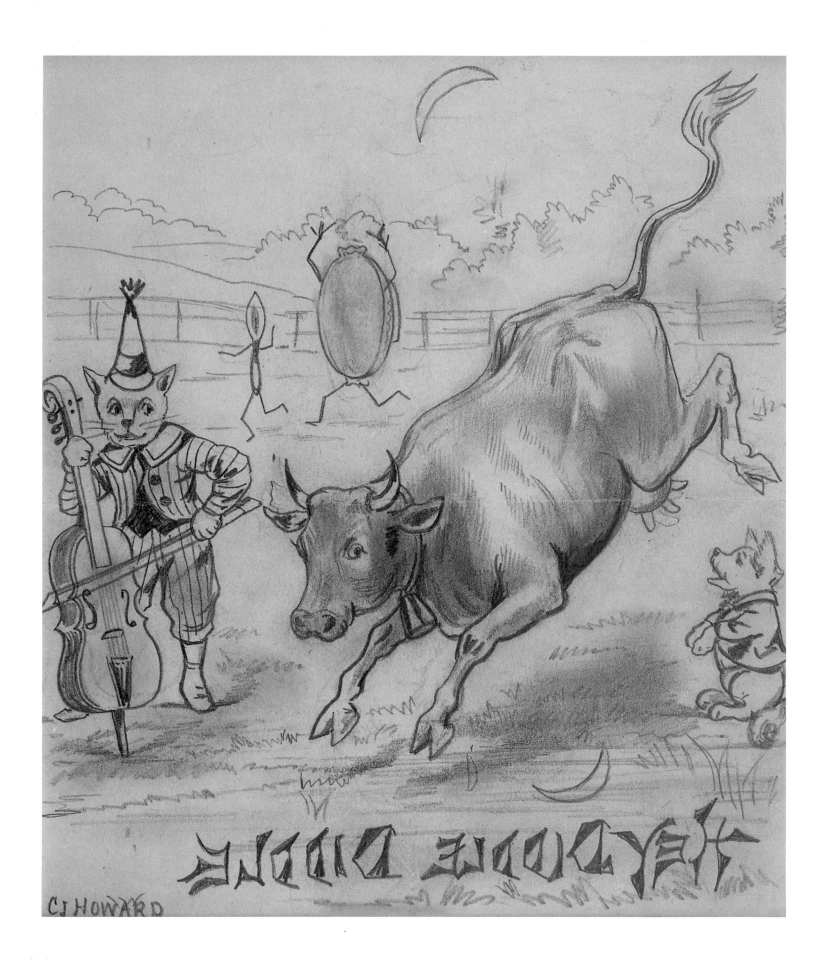

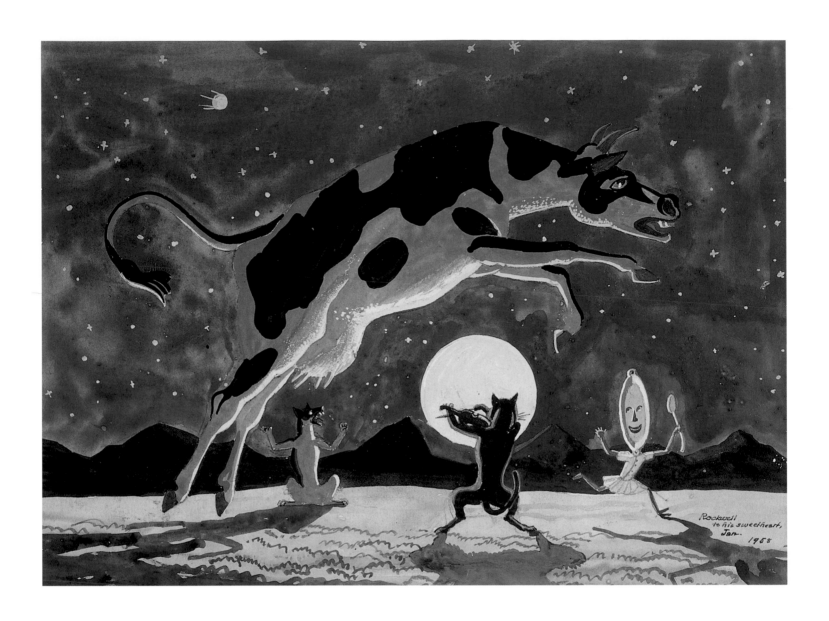

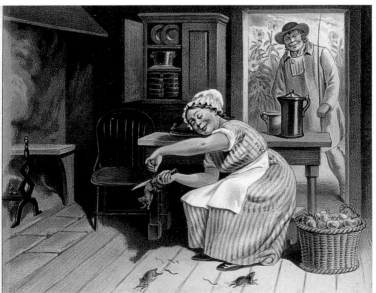

ROCKWELL KENT, 1882–1971

"The Cow Jumped Over the Moon," 1958
Gouache on board

Kent dedicated this painting to Jan Wesley, the daughter of his friend David Wesley, a newspaper journalist and fellow political activist.

WILLIAM L. SHEPPARD, 1833–1912

"Three Blind Mice, See How They Run"
for *The Old Fashioned Mother Goose Melodies Complete: With Magic Colored Pictures*
(New York: G. W. Carleton & Co., 1879)
Proof print and color separation

This illustration proof, showing a woman snipping off the tails of three mice while a man (presumably her husband) looks on from the doorframe behind her, accompanies one of the book's thirty-nine nursery rhymes. The rhyme itself is written in pencil on the verso of the separation, possibly by Sheppard. The "magic" indicated by the title of the book is achieved by the use of "transformation flaps" composed of the color separations.

EDWARD P. COGGER, b. 1833

"The Queen of Clubs"
for *The Queen of Hearts and the Damson Tarts* (New York: McLoughlin Bros., 1869 and 1871)
Proof print hand coloring

This proof was used as a printing guide for making colored woodcuts for two separate versions of the popular toybook, following drawings made by Percy Cruikshank in the late 1850s. It was one title in the publisher's "Joyful Tales" series.

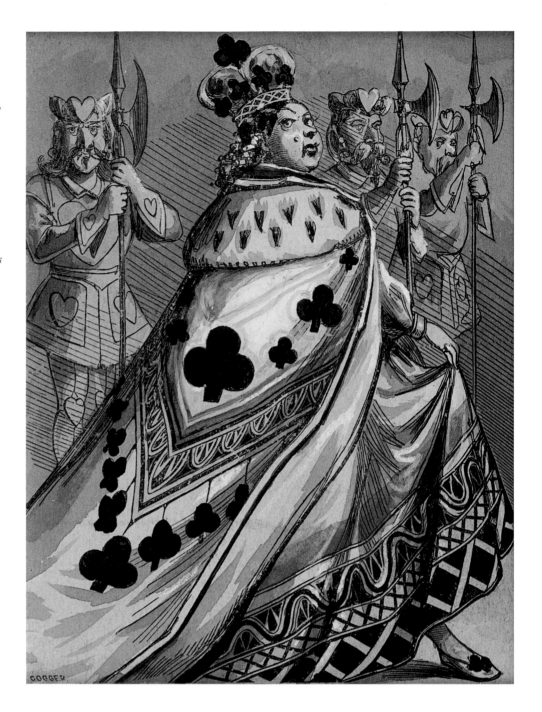

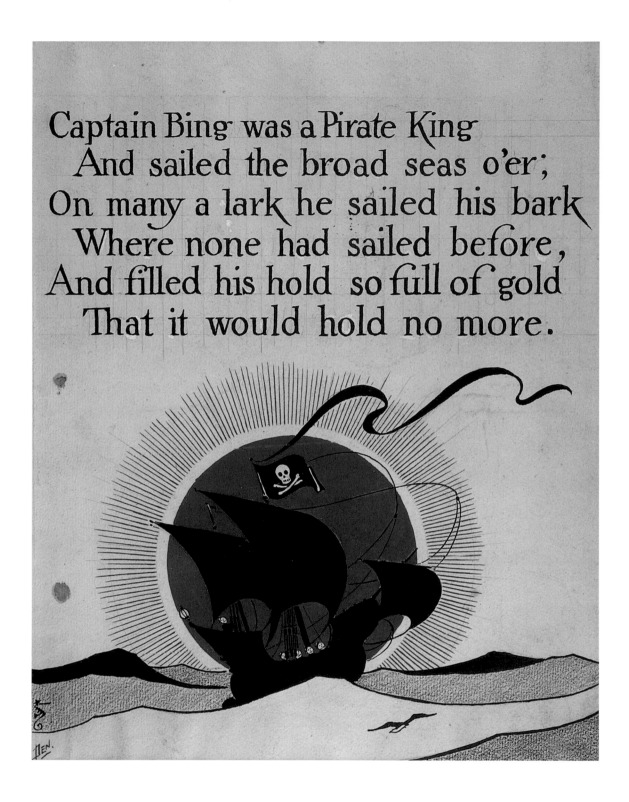

Captain Bing was a Pirate King
And sailed the broad seas o'er;
On many a lark he sailed his bark
Where none had sailed before,
And filled his hold so full of gold
That it would hold no more.

MAXFIELD PARRISH, 1870–1966

"The Black Sheep" for *Mother Goose in Prose*,
by L. Frank Baum (Chicago: Way and Williams, 1897)
Proof print on vellum

"Black Sheep, Black Sheep, have you any wool?" Baum's prose versions of the Mother Goose rhymes made up his first book, and also saw the book illustration debut of the talented artist Parrish.

W. W. DENSLOW, 1856–1915

"Captain Bing was a Pirate King" for *Father Goose: His Book*,
by L. Frank Baum (Chicago: George M. Hill Co., 1899)
Ink, charcoal, and watercolor on board

This is one of ninety-nine verses (hand-lettered by Ralph Fletcher Seymour) that accompanied Denslow's illustrations for his first book with L. Frank Baum. In the lower left is the artist's seahorse insignia.

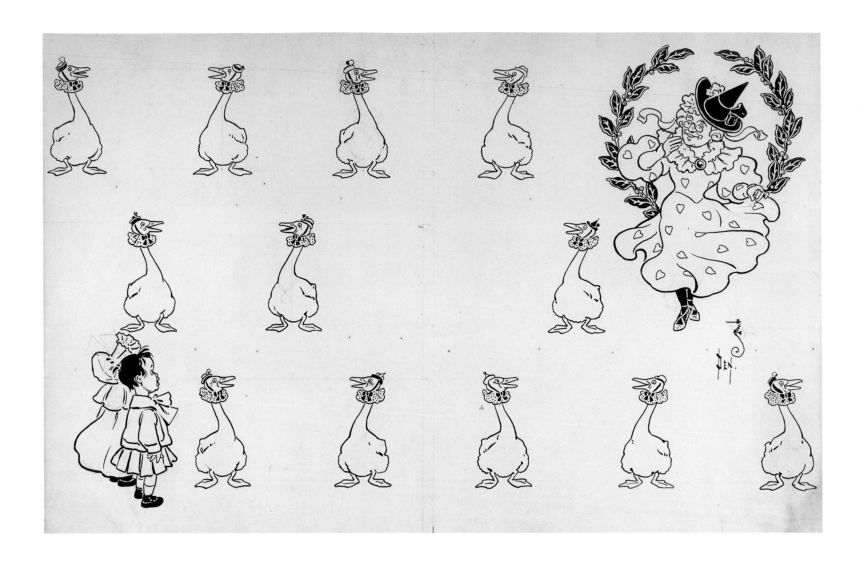

W. W. Denslow, 1856–1915

[End-papers] for *Denslow's Mother Goose*
(New York: McClure, Phillips & Co., 1901)
Pen and ink with pencil on paper

Denslow included forty-three rhymes in his version of "Mother Goose," some of which Denslow censored for content, with the verses hand-lettered by the noted typographer Fred W. Goudy. *Denslow's Mother Goose* was the first of several children's classics for which Denslow used his own name in the title following his break with L. Frank Baum over the rights to the musical version of *The Wonderful Wizard of Oz.*

Unidentified artist

[Cover study] for *The Story of the Three Bears*
(New York: McLoughlin Bros., 1892)
Proof print with watercolor

This study for the cover illustration stands out mainly for the bears' finery, which was toned down for the final version. Part of the publisher's "Little Kitten" series, the decorative illustrations in this volume feature the bear family clad in vibrant Victorian-era clothing, and living in a home furnished with sturdy Victorian furniture. Not surprisingly, the story is also furnished with a suitably hearty Victorian moral: "And Goldilocks made up her mind never again to enter any one's house without being invited, and never to make herself quite so much at home as she did in the bears' house."

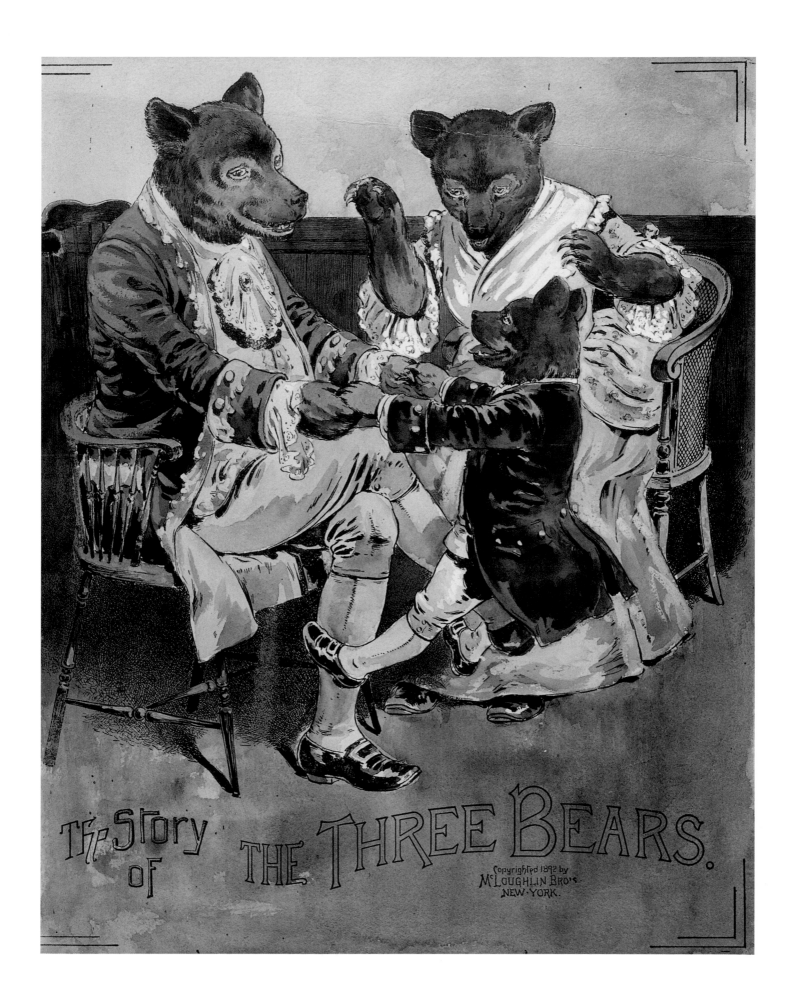

The Story of THE THREE BEARS.

Copyrighted 1892 by
McLoughlin Bro's
NEW·YORK.

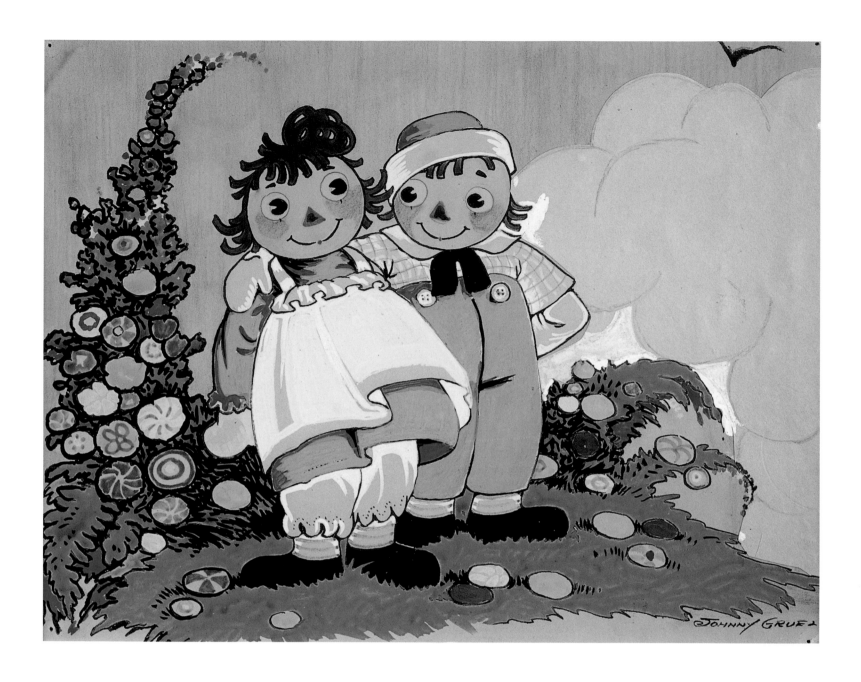

MAUD HUMPHREY, 1868–1940

"Dollie in Danger"
for *Little Brighteyes Story Book*
(New York: McLoughlin Bros., 1901)
Watercolor on paper

The copyright on this frontispiece illustration itself shows the date 1898. *Brighteyes* is a collection of very short, edifying stories and rhymes pictured in Humphrey's style of idealized youth.

JOHNNY GRUELLE, 1880–1938

[Raggedy Ann and Andy], ca. 1920
Watercolor, gouache, colored pencil, and collage on paper.

The first of the Raggedy Ann stories appeared in 1918, as Gruelle's homage to his daughter, Marcella, who had died the year before. The popularity of his first stories led to the addition of a brother, Raggedy Andy, in 1920. The pair would be featured in more than forty books created by the illustrator. This watercolor study, however, was never reproduced for publication.

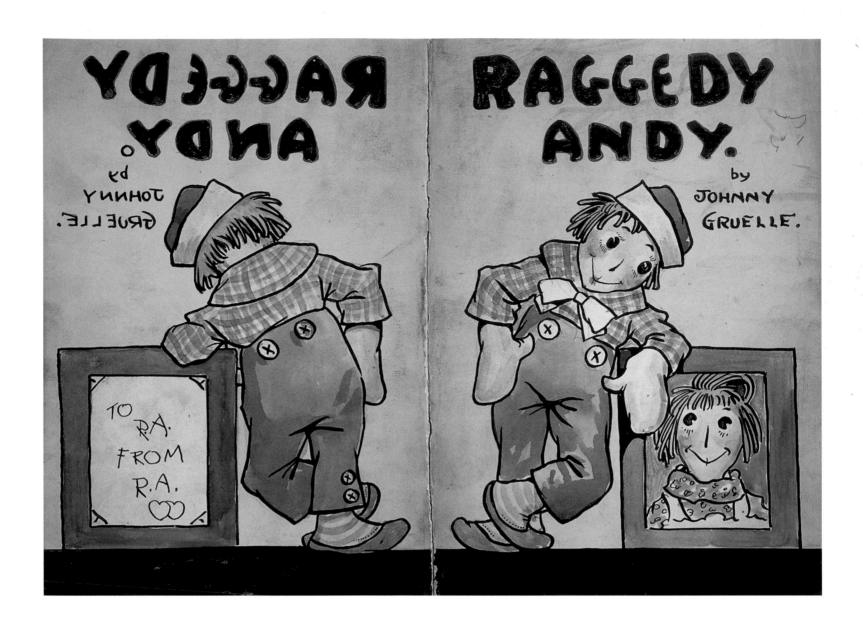

JOHNNY GRUELLE, 1880–1938

Study for front and back covers, ca. 1920
for *Raggedy Andy Stories*
(Chicago: P. F. Volland Co., 1920)
Watercolor on board

This is a slight variant of the final cover design. The book introduced "the little rag brother of Raggedy Ann" two years after the original, and met similar enormous success.

W. BRUTON

[Girl serving tea]
for *Afternoon Tea; Pleasant Rhymes with 37 Illustrations*
(New York: McLoughlin Bros., ca. 1883)
Pen and ink with watercolor on board

Bruton's image of a girl serving tea appears as the cover illustration for a pirated American edition of the 1880 London original. A rather anonymous figure among the slew of McLoughlin Brothers artists, Bruton mimics the Aesthetic-movement style of illustrator Kate Greenaway (1846–1901).

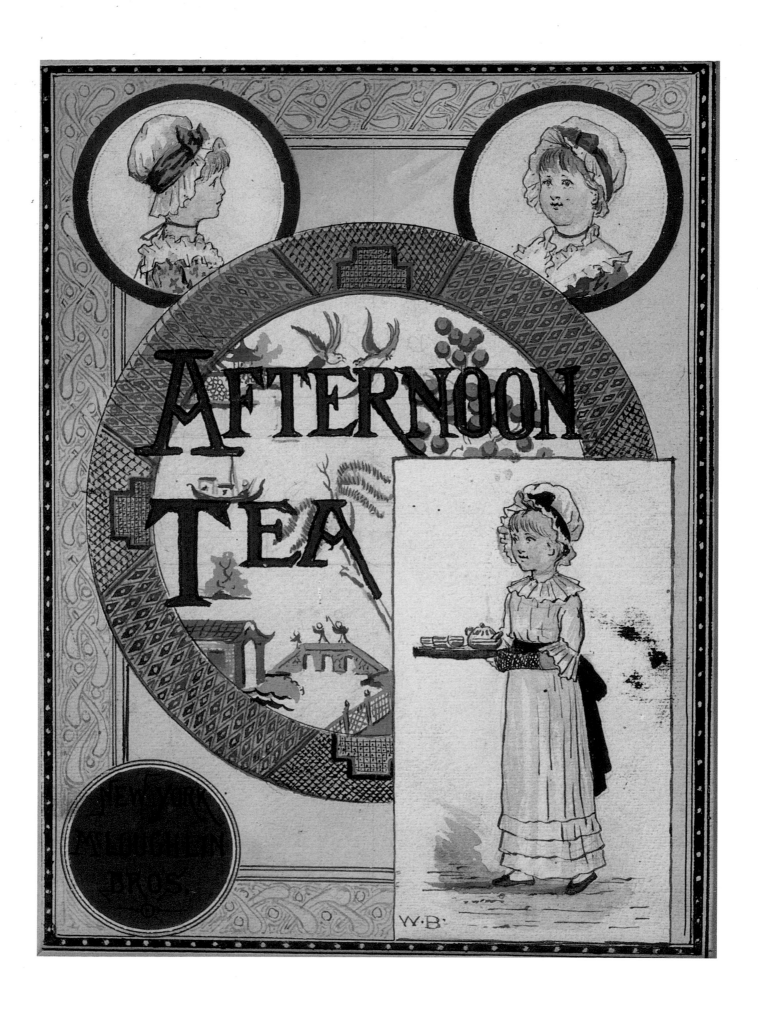

AFTERNOON TEA

NEW YORK
McLOUGHLIN
BROS.

W·B·

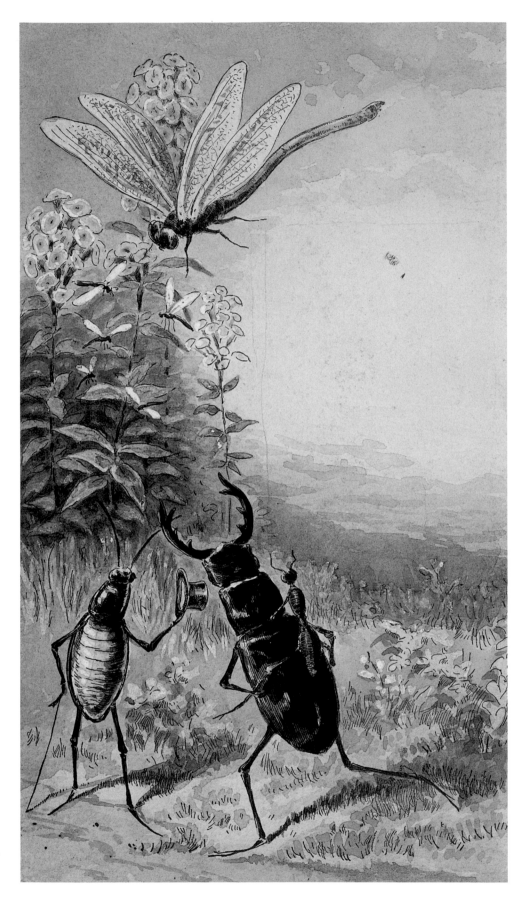

R. André, 1834–1907

"And there came the beetle …"
for *The Butterfly's Ball*, by William Roscoe
(New York: McLoughlin Bros., 1891)
Pen and ink with watercolor on paper

"The Butterfly's Ball and the Grasshopper's Feast," a thirty-two line poem written by William Roscoe (1753–1831) in 1807, was one of the first English stories published solely for children's amusement, free from moralizing instruction of any kind. It was an immediate success in England and America. This illustration is the first to appear in McLoughlin's version, part of the "Joyful Tales" series. The full accompanying verse introduces a few of the diminutive party-goers: "And there came the beetle, so blind and so black, / Who carried the emmet his friend on his back; / And there was the gnat, and the dragon fly too, / With all their relations—green, orange, and blue."

R. ANDRÉ, 1834–1907

[The grasshopper and the butterfly]
for *The Butterfly's Ball*, by William Roscoe
(New York: McLoughlin Bros., 1891)
Pen and ink with watercolor on paper
shown with printed copy (left)

"Then the grasshopper came with a jerk
and a spring, / Very long was his leg,
though but short was his wing; / He took
but three leaps, and was soon out of sight, /
Then chirped his own praises the rest of
the night." André's drawing (right) was
used to illustrate both the cover (left) and
one of the twelve quatrains of Roscoe's
popular "airy revel."

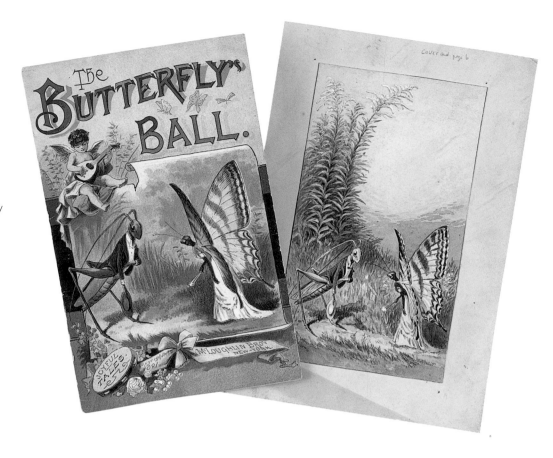

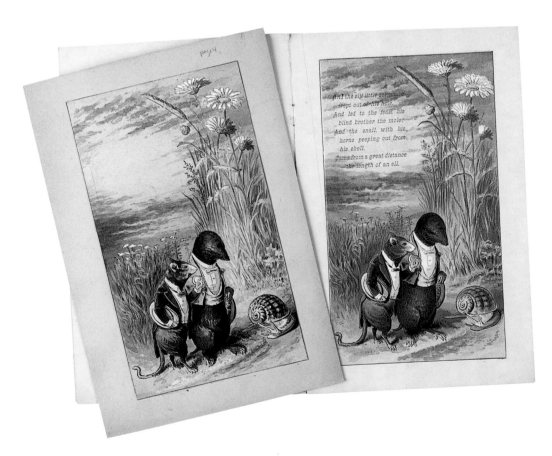

R. ANDRÉ, 1834–1907

[The dormouse, the mole, and the snail]
for *The Butterfly's Ball*, by William Roscoe
(New York: McLoughlin Bros., 1891)
Pen and ink with watercolor on paper
shown with printed copy (right)

The colors in André's watercolor drawing
(left) were deepened by the chromolitho-
graph printing process developed by
McLoughlin Bros. — but Roscoe's verses
stand out nonetheless: "And the sly little
dormouse crept out of his hole, / And led
to the feast his blind brother the mole; /
And the snail, with his horns peeping out
from his shell, / Came from a great dis-
tance — the length of an ell."

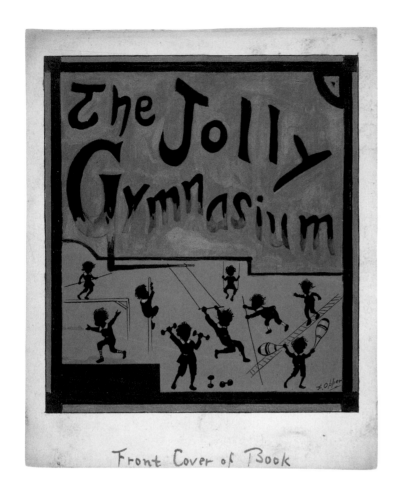

Front Cover of Book

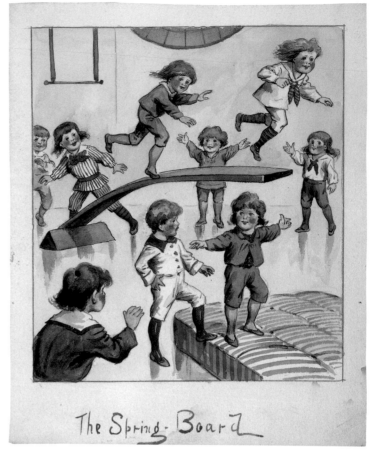

The Spring-Board

Frederick Burr Opper, 1857–1937

[Study for the cover]
"The Spring Board"
"The Horizontal Bar, the Dumb-Bells and the Balancing-Pole"
Watercolor on board

This series of illustrations was for *The Jolly Gymnasium*, a McLoughlin title that was, by all accounts, never published.

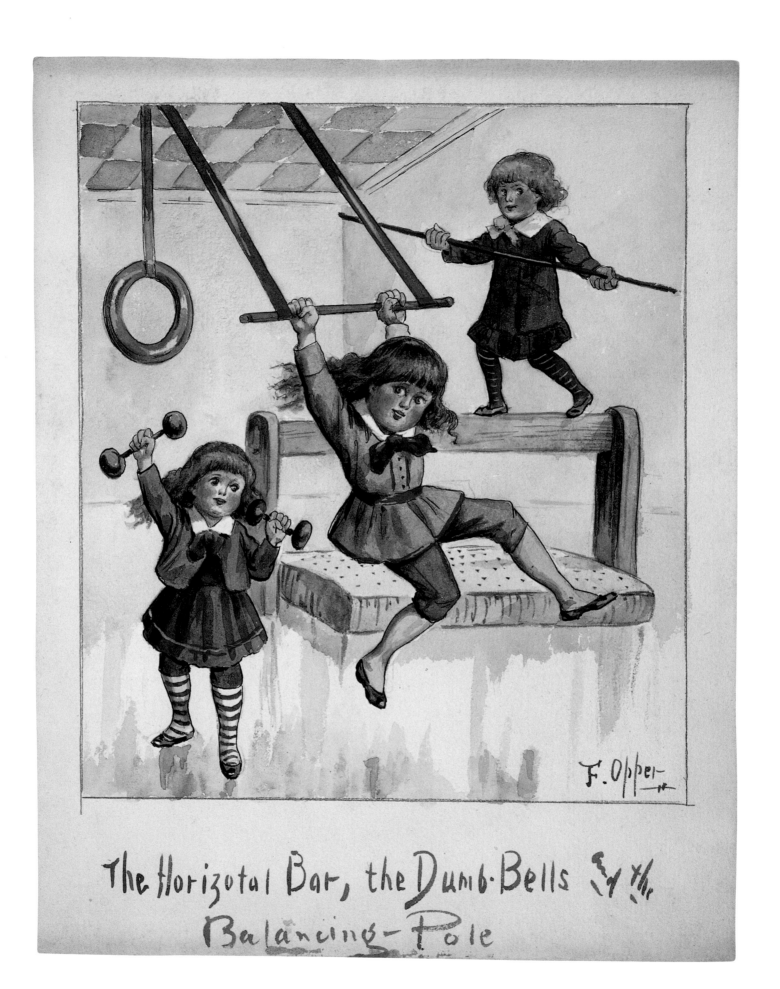

The Horizotal Bar, the Dumb-Bells & the Balancing-Pole

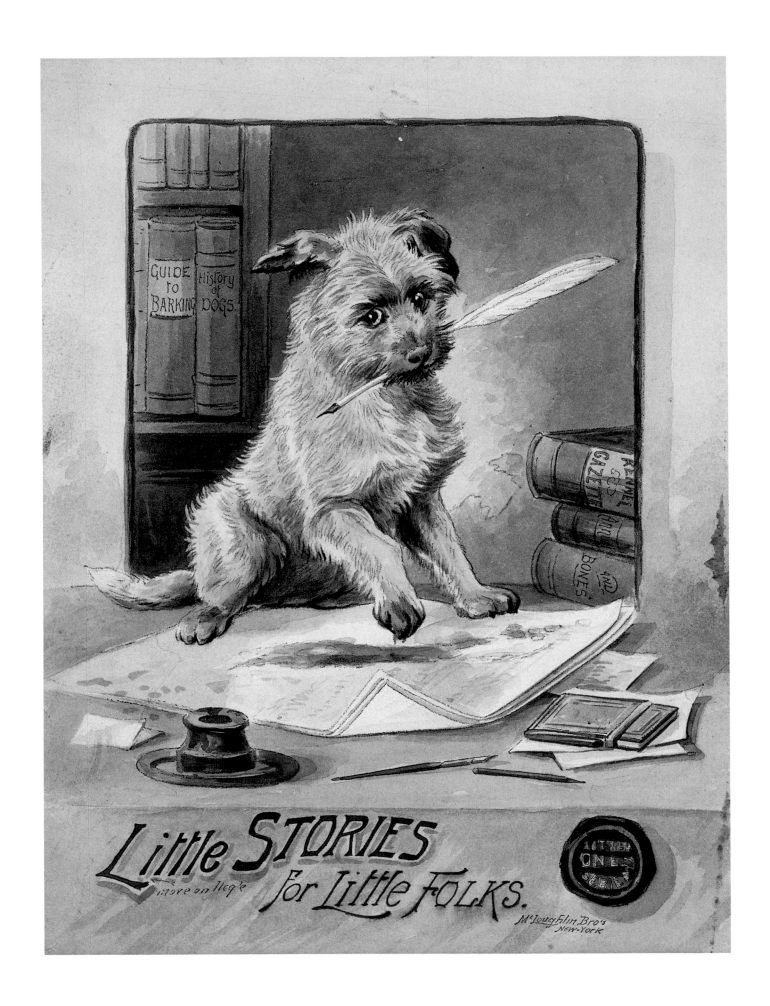

Animated Animals and Other Odd Creatures

The practice of telling moral tales through the guise of animal actors and narrators has been popular for as long as stories have been told. The appearance of editions of Aesop's Fables for widespread audiences, in Europe in the late-fifteenth century, was important in establishing this type of story as an important genre for children's books. The equally popular story of Reynard the Fox, who managed to trick his way out of sticky situations, was a descendant of medieval beast epics. Most of the anthropomorphized creatures in the Shirley collection are much more whimsical successors to these early animals. However, one character in particular, Brer Rabbit, as first depicted by A. B. Frost, then much later by Barry Moser, may be the wiliest of them all.

Some of the animals that populated children's books of the nineteenth and early-twentieth century appeared to be almost human, as seen in the adventures of the fine fellows in *The Wind in the Willows* — wearing clothes and driving automobiles. Others seemed to be only partly evolved, like the menagerie inhabiting the drawings of Anthony Hochstein — some show human gestures, while others hop along on four feet. The only purely animal character among those shown in this section seems to be Frost's scruffy pup, Carlo.

Other inhabitants of children's books are those which might generally be referred to as "little creatures" — part fairy, part elf, part human. They are the cast of such free-for-all comic theaters as created by Palmer Cox and Gelett Burgess. Cox's Brownies, who became one of the first major marketing juggernauts of the modern era, appeared on product endorsements, toys and games, even in a stage review. The Goops, however, those more indistinct creatures, were bent on showing the difference between good and bad behavior.

The most harmonious assemblage of all types of creatures — animal, insect, sub-human — can be found in Harrison Cady's sweet-natured drawings for Carolyn Well's *The Happychaps*, in which creatures with two legs, four legs — even six or eight — get along in their peaceable kingdom, the kind only found in children's books.

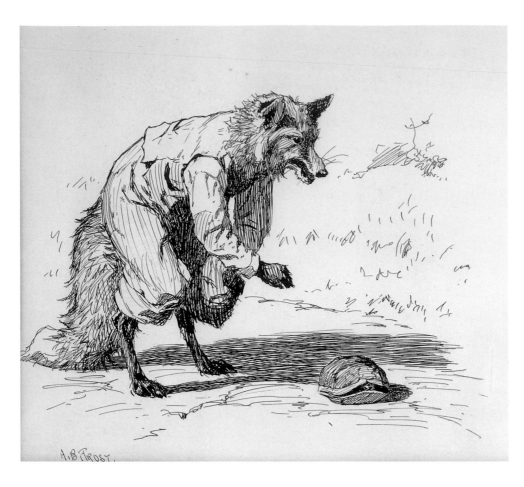

A. B. FROST, 1851–1928

[Brer Fox confronting Terrapin]
"The Writing on the Pane"
"The Deacon"
for *Uncle Remus, His Songs and Sayings:
Folklore of the Old Plantation*
by Joel Chandler Harris
(New York: D. Appleton and Co., 1895)
Pen and ink on paper

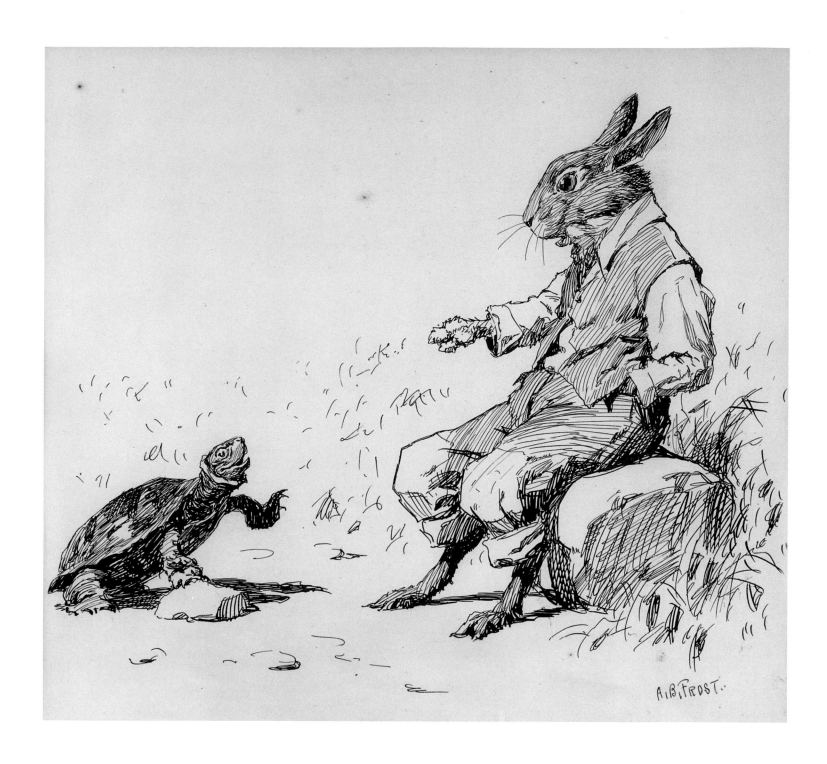

A. B. FROST, 1851–1928

[Terrapin speaking to Brer Rabbit]
for *Uncle Remus, His Songs and Sayings:*
Folklore of the Old Plantation
by Joel Chandler Harris
(New York: D. Appleton and Co., 1895)
Pen and ink on paper

Though Frost is probably best remembered today for his watercolors of hunting scenes, his illustrations for Harris's Uncle Remus series made him one of America's most popular illustrators at the turn of the century. *Uncle Remus, His Songs and Sayings*, the first book in the series, sparked a vogue for dialect literature when it was first published in 1880. Harris's "Uncle Remus" stories were widely popular in the South as invented folklore narrated by the benevolent title character, an elderly former plantation slave. "Brer," an African American (primarily Baptist) colloquialism for "brother," attaches to a family of anthropomorphic animals derived from West African relatives. Frost created 112 drawings for this, the second of six volumes in the series.

BARRY MOSER, b. 1940

"Brer Rabbit Prepares His Plan"
for *Jump! The Adventures of Brer Rabbit* by Joel Chandler Harris,
adapted by Van Dyke Parks and Malcolm Jones
(San Diego: Harcourt Brace Jovanovich, 1986)
Double-page illustration, watercolor and ink on paper

The revered woodcut artist states that his work on *Jump!* was "a great
discovery for me — or rediscovery — and proved to be a turning
point in my art." Moser went on to illustrate two more volumes of
tales featuring the irrepressible rabbit, *Jump Again! More Adventures
of Brer Rabbit* (1987) and *Jump on Over! The Adventures of Brer Rabbit
and His Family* (1989).

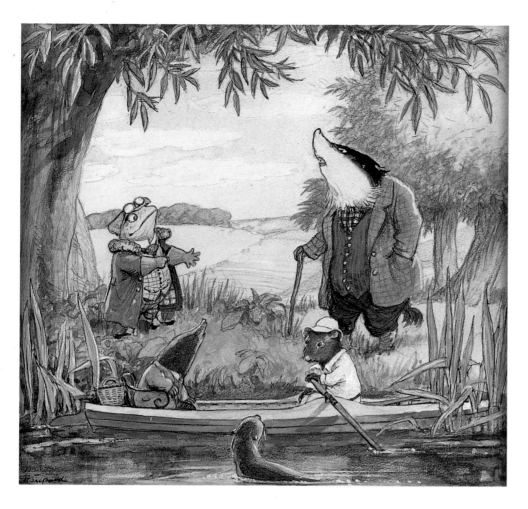

ERNEST H. SHEPARD, 1879–1976

[Badger, Toad, Mole, Rat, and Otter], 1959
for *The Wind in the Willows*,
by Kenneth Grahame
(New York: Charles Scribner's Sons, 1960)
Watercolor on board

Though Shepard originally thought that
The Wind in the Willows was a book that
should never be illustrated, he eventually
agreed to work on images for a 1933 edition
of Grahame's 1908 classic. This watercolor
(left) appeared on the dust jacket of the
1960 edition, and was one of eight new
color illustrations Shepard produced in
observance of the book's 50th anniversary.

This watercolor study (below), a variation
on Shepard's dust-jacket illustration for the
1960 edition, may have been intended as the
wrap-around cover design for a paperback
edition that was never published. A close
look reveals Toad Hall in the background.

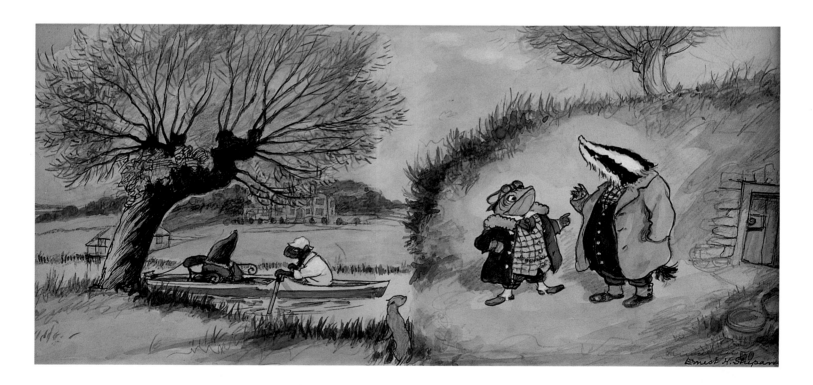

JOSEPH JACINTO MORA, 1876–1947

"'Good news I bring to you,' quoth he,
'The king sets you at liberty.'"
for *Reynard the Fox*
(Boston: Dana Estes & Co., 1901)
Watercolor on paper

Reynard the Fox is a timeworn burlesque narrative in verse that was intended as a lampoon of the Catholic Church when it was first printed in Germany in 1481. For the English translation the settings have moved to the British Isles. Reynard was medieval Europe's trickster figure, a nasty but charismatic character that courted trouble but was always able to talk his way to freedom. This illustration shows the release of two innocents, a wolf ("Growler") and a bear ("Brown") who had fallen victim to Reynard's vulpine machinations.

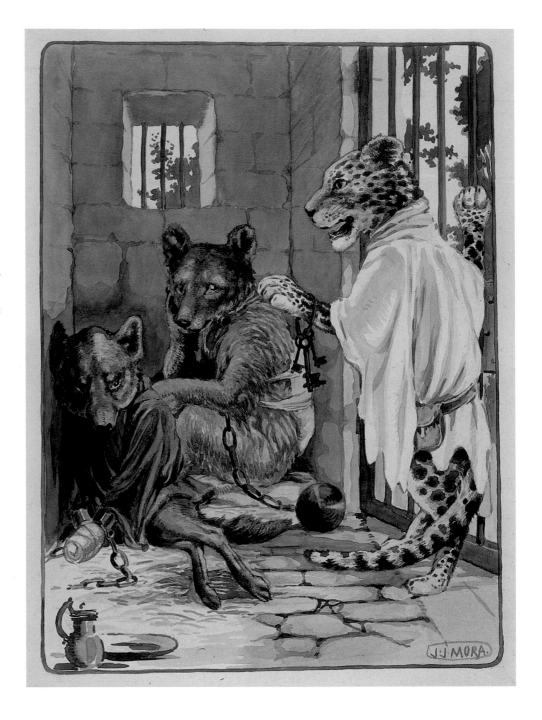

JOSEPH JACINTO MORA, 1876–1947

[Reynard chases the Rabbit]
for *Reynard the Fox*
(Boston: Dana Estes & Co., 1901)
Watercolor on paper

This illustration for Mora's edition appears in Part III, Canto 1 ("The Outlawry"), at which point the King has sent out messengers to issue Reynard a summons. The Rabbit's tale is descriptive of the fox's treachery: "I saw him sitting at his door. /

A pilgrim's dress and hood he wore. / I thought he read his morning pray'r, / And without caution I drew near. / He got up from his seat to meet me / I thought he friendly meant to greet me / But of a sudden with his claw / He gave me such a horrid paw, / That, what with fright, what with the wound, / It brought me nearly to the ground. / Thanks to my legs, I got away, / Or I should not have liv'd this day …"

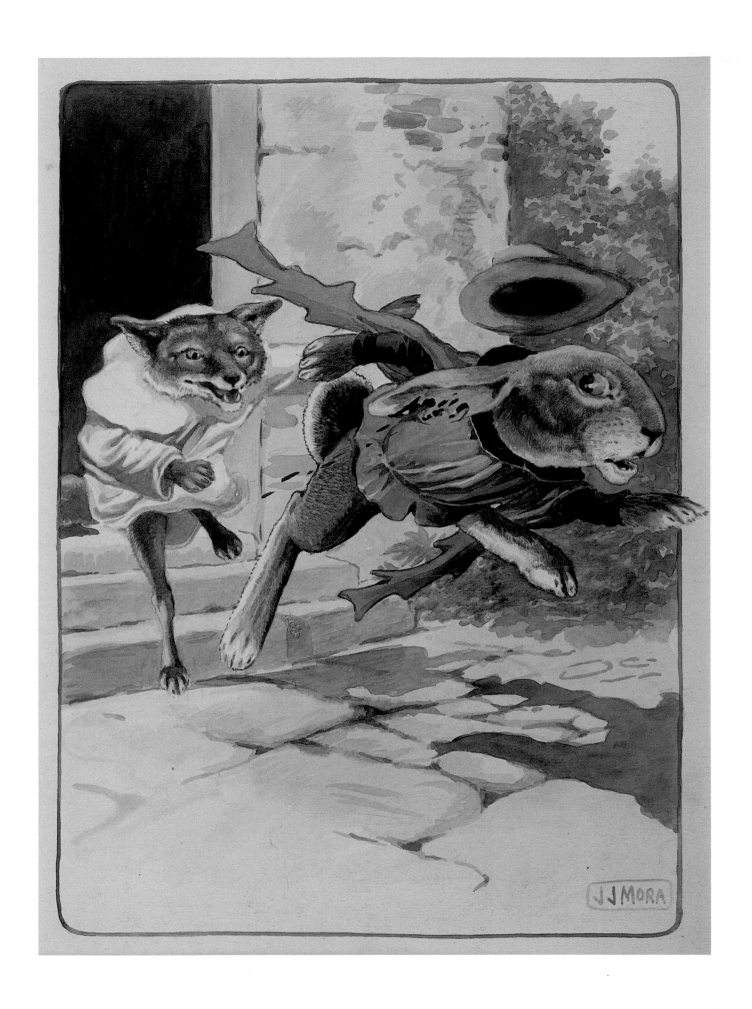

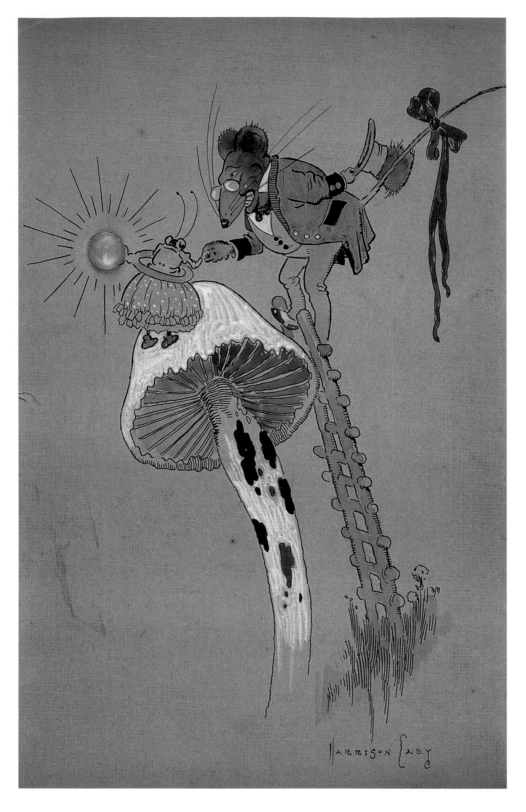

HARRISON CADY, 1877–1970

"Gentleman Mouse"
Watercolor on board, glass

The mouse, dressed in waistcoat and top hat, has climbed a ladder and presented his betrothed ant with a ring bearing an authentic cut-glass gem pasted onto the board. This item appears to have been created as a private keepsake.

HARRISON CADY, 1877–1970

[Hooty the Owl and Little Pete]
for *Little Pete's Adventure*,
by Thornton Burgess
(Springfield, MA: McLoughlin Bros., 1941)
Pen and ink on paper

Cady worked more often with Burgess than with any other author. *Little Pete's Adventure* is one of three books he illustrated for the publisher's "Little Color Classics" series. Here, the title character, a young bunny, narrowly escapes various perils after forgetting his mother's instructions and losing sight of her white tail: "Had Little Pete moved the tiniest bit just then he would have been seen and caught by Hooty the Owl."

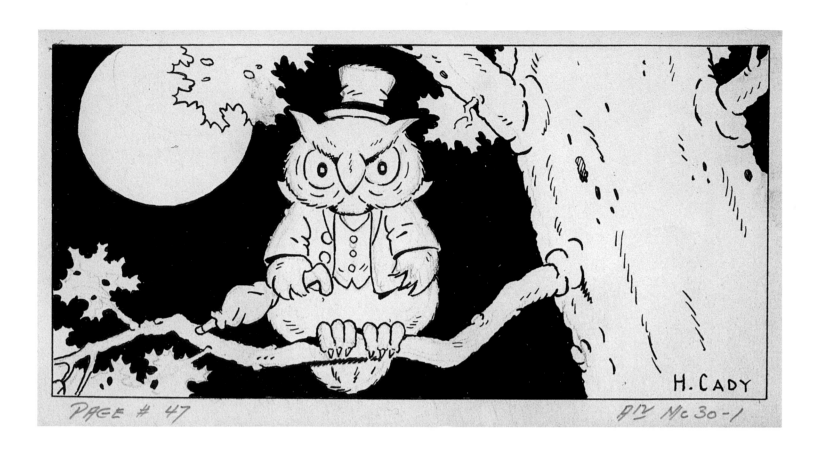

PAGE # 47

H. CADY

AIV MC 30-1

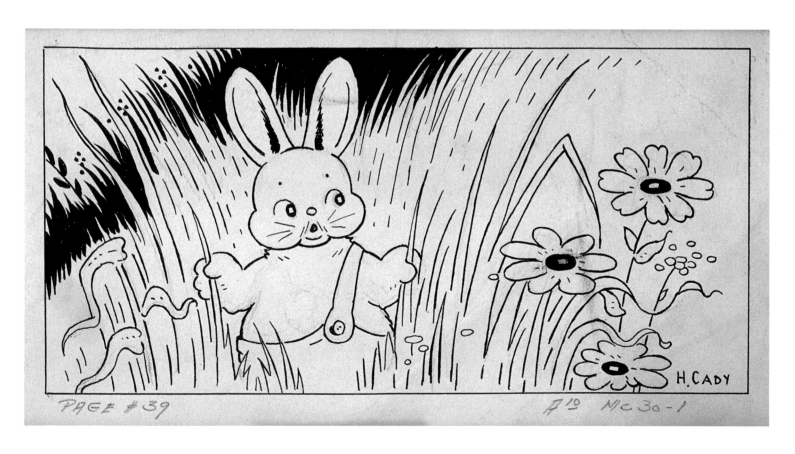

PAGE # 39

H. CADY

AID MC 30-1

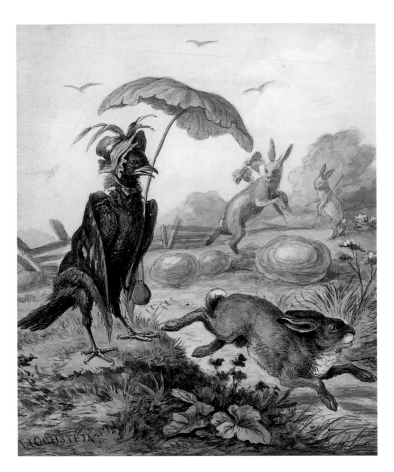

Anthony Hochstein, 1829–1911

"Scare Crow," undated
"A Justice of the Peace," undated
"The (Frog) Concert Unisono," undated
Ink and watercolor on board

These three drawings of playful characters, apparently created for an unidentified title published by McLoughlin Brothers, closely resemble scenes from two other books of children's verse that Hochstein illustrated, *Kaspar Kroak's Kaleidoscope* and *Tell-Tale from Hill and Dale*.

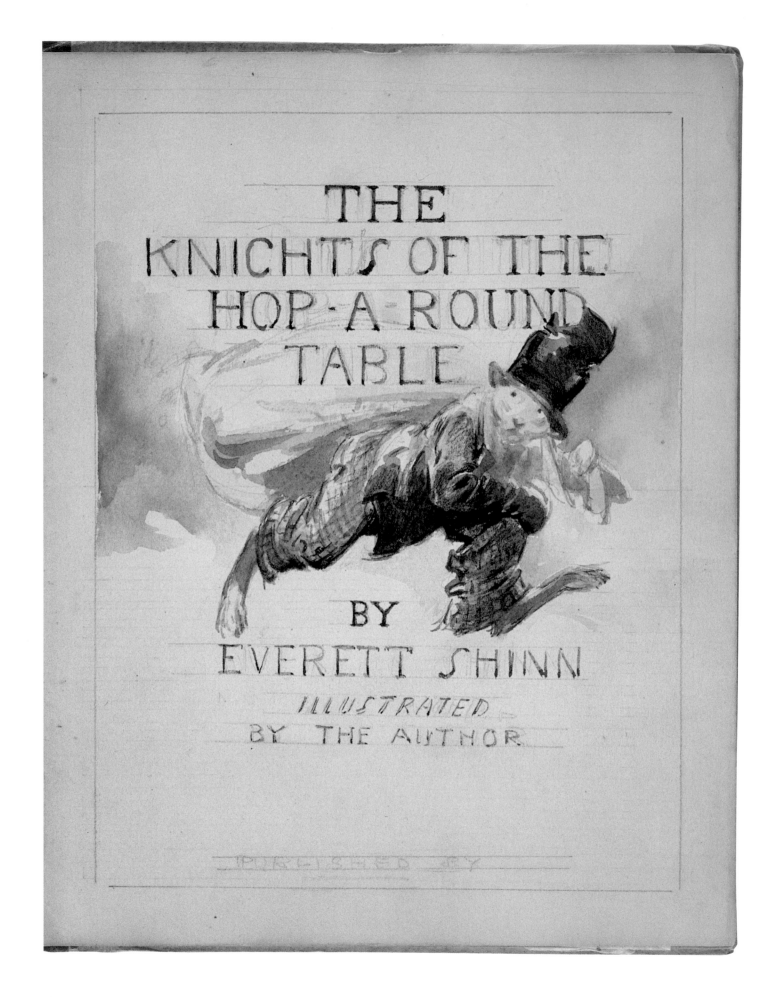

THE
KNIGHTS OF THE
HOP-A-ROUND
TABLE

BY

EVERETT SHINN

ILLUSTRATED
BY THE AUTHOR

PUBLISHED BY

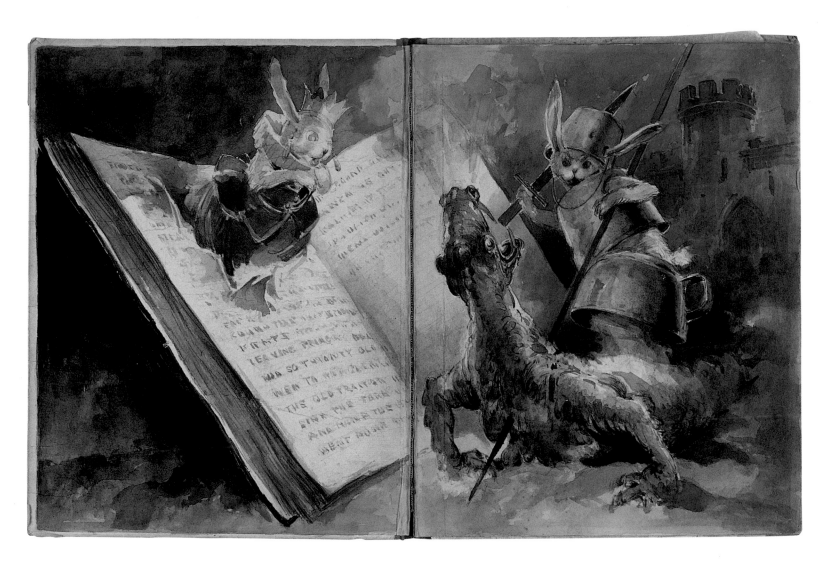

Everett Shinn, 1876–1953

[Title page design]
[Endpaper design]
[Final sketch of characters]
for "The Knights of the Hop-A-Round Table"
Ink and watercolor on paper and board

This set of images comes from an unfinished dummy created by
Shinn in 1941. Who knows what fantastic storyline would have
done justice to these gallant pictures?

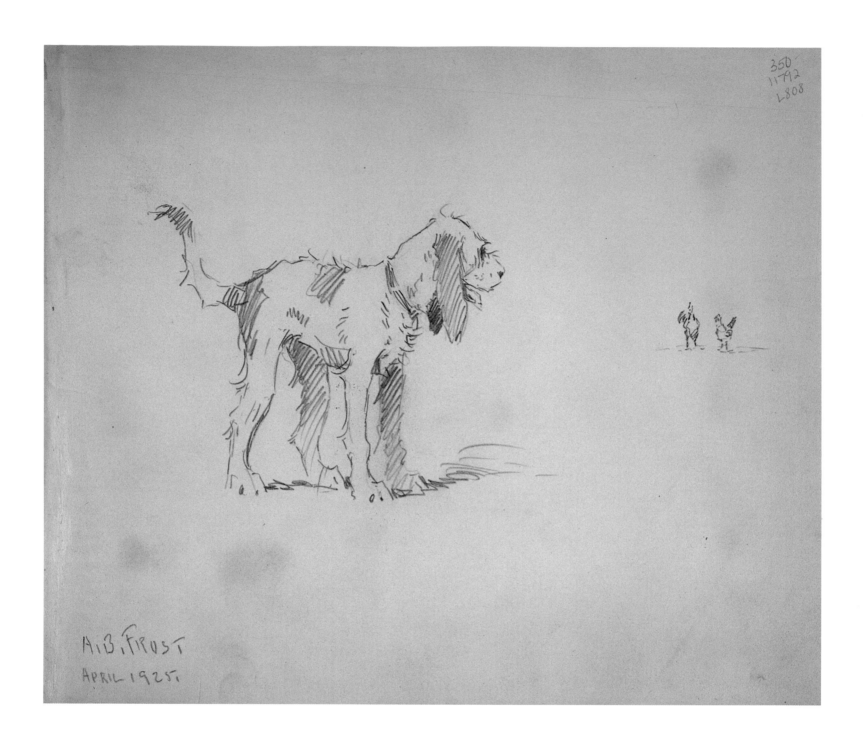

A. B. FROST, 1851–1928

[Carlo with two chickens in the background], 1925
Pencil on paper

This sketch features Frost's comic canine, the scraggly Carlo.
One critic praised the original *Carlo* (1913) as "the truest of picture
books, a natural extension of the comic sheet into folio form …"

HARRISON CADY, 1877–1970

"Jumping Jack," ca. 1908
for *The Happychaps*, by Carolyn Wells
(New York: The Century Co., 1908)
Pen and ink on board

This scene shows the denizens of Jollipopolis showing off their
Christmas presents.

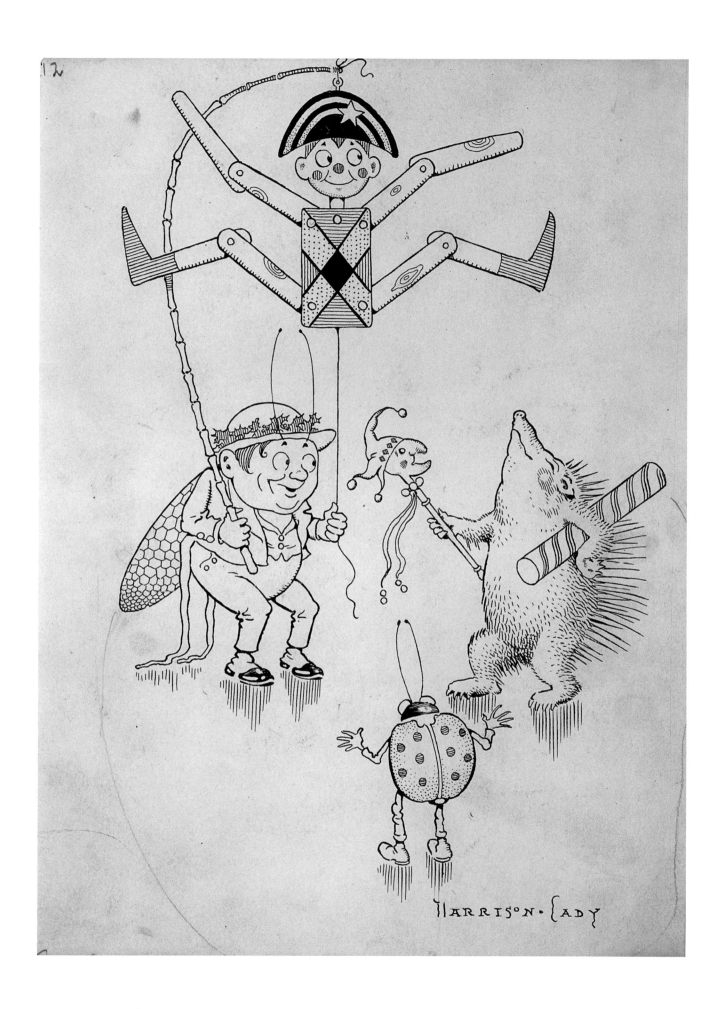

HARRISON · CADY

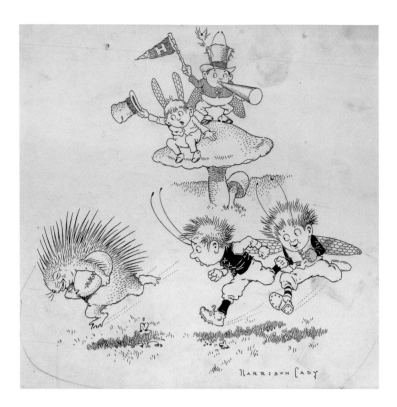

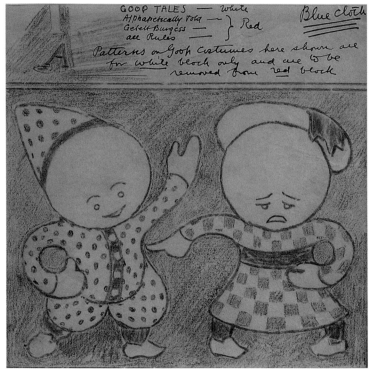

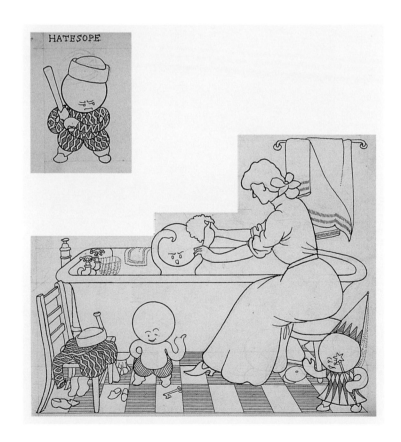

HARRISON CADY, 1877–1970

"Til Percy Porcupine Captured the Ball," ca. 1908
for *The Happychaps*, by Carolyn Wells
(New York: The Century Co., 1908)
Pen and ink on board

In the big football game between the animal "Skiddoodles" and the fairy-like "Happychaps," a porcupine has an advantage.

GELETT BURGESS, 1866–1951

[Blue, red and white drawing of two Goops]
for *Goop Tales Alphabetically Told*
(New York: Frederick A. Stokes Co., 1904)
Colored pencil on paper with ink annotation

The final cover design differs slightly from this study of red, white and blue Goops. Burgess's instructions to his printer are written in ink above the illustration.

GELETT BURGESS, 1866–1951

"Hatesope"
for *Goop Tales Alphabetically Told*
(New York: Frederick A. Stokes Co., 1904)
Pen and ink on paper

Hatesope, loather of baths (smartly suggested by Burgess with an absurd appellation), is joined in his folly by other Goops.

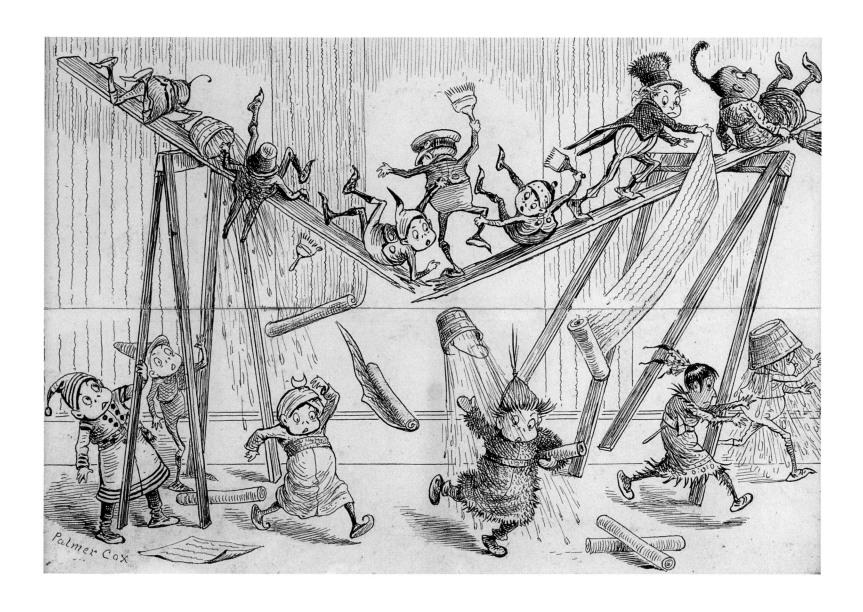

PALMER COX, 1840–1924

[A Brownies wall-papering project gone awry]
for *The Brownies at Home*
(New York: The Century Co., 1893)
Pen and ink on paper

The stories and illustrations for *The Brownies at Home* (the third of
a dozen "Brownies" books) first appeared in a series called "The
Brownies Through the Year," which Cox produced for *Ladies' Home
Journal*. The debacle shown here appears as "The Brownies in May."

Palmer Cox, 1840–1924

[Two of twenty original Brownie watercolors], undated
Pencil, ink, and watercolor on paper

These watercolors, inscribed "To Ms. Kathleen Smith," were possibly studies for Cox's *The Brownies Around the World* (New York: The Century Co., 1894), in which the accident-prone pixies visit cultures from Spain to China.

PALMER COX, 1840–1924

"The Brownies Cutting Ice"
Pen and ink on paper

This scene shows a typically blundering group effort by the happy-go-lucky Brownies. The intended use for this illustration is unknown, but is likely to have been produced in the latter period of Browniemania, circa 1890–1910.

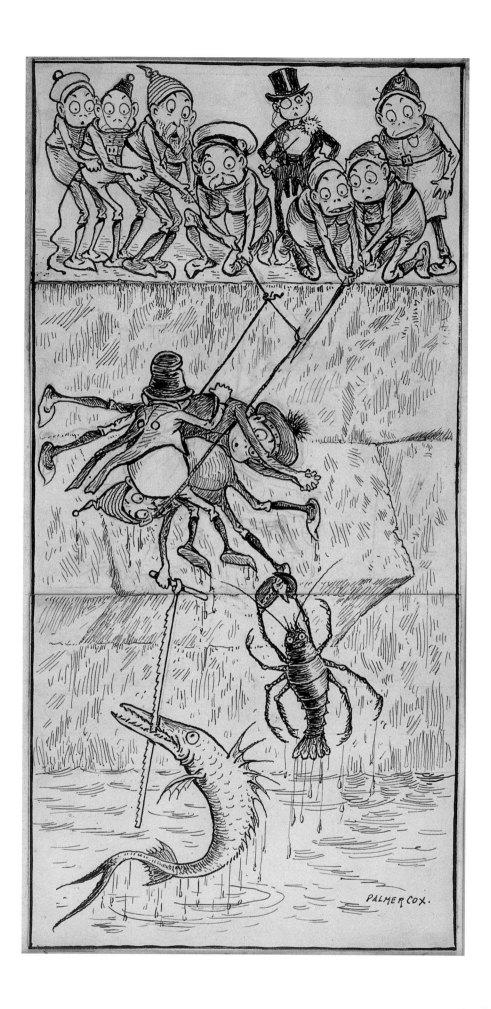

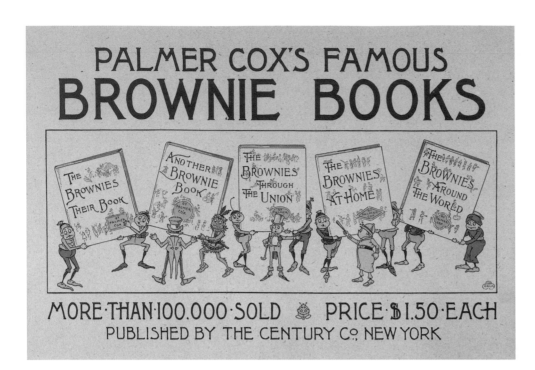

George R. Halm, 1850–1899

"Palmer Cox's Famous Brownie Books"
New York: The Century Company, ca. 1900
Lithographed Poster

This poster, printed more than ten years after the Brownies' first appearance, shows a group of the benevolent sprites holding up five books from Cox's phenomenally successful series. The poster's creation has been mistakenly attributed to Cox because Halm used the distinctive typeface from the covers and title pages of the series itself.

Palmer Cox, 1840–1924

"The Brownie Scroll Puzzles"
New York: McLoughlin Bros., 1891
Watercolor on board

The two scenes pictured here, "Blindman's Buff" and "The Dance," were also used for Cox's "Brownie Blocks," released the same year.

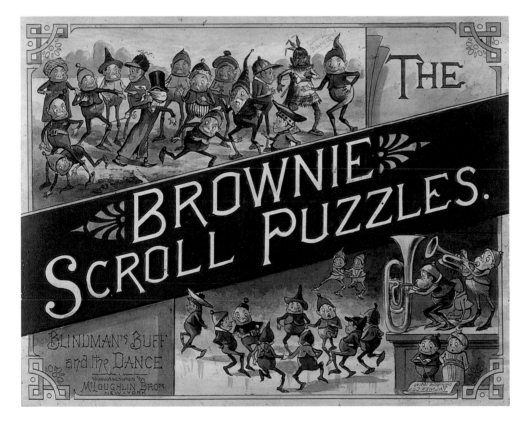

Eugene Field, 1850–1895

"Extinct Monsters," 1895
Pen and ink on paper

Field's last unpublished manuscript, completed just days before he died of heart failure, elicits a rare blend of humor and pathos: "Oh, had I lived in the good old days / When the Ichtyosaurus [sic] romped around … Would I have spent my precious time / At weaving golden thoughts in rhyme?"

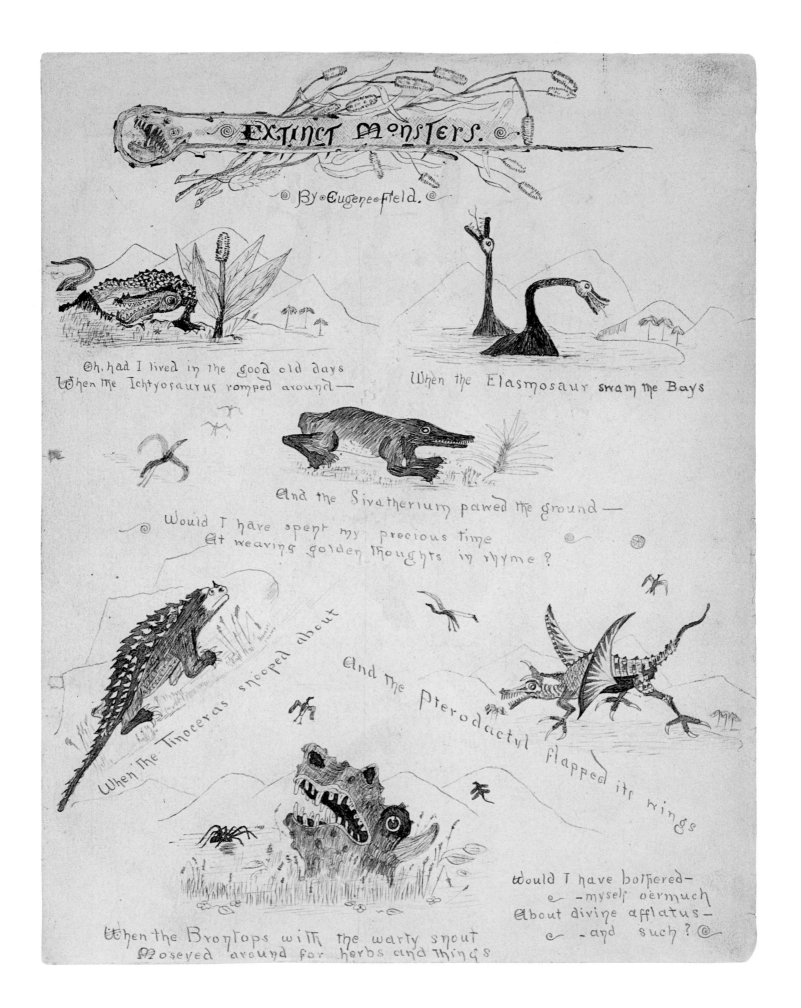

EXTINCT MONSTERS.

By Eugene Field.

Oh, had I lived in the good old days
When the Ichtyosaurus romped around—

When the Elasmosaur swam the Bays

And the Sivatherium pawed the ground—

Would I have spent my precious time
At weaving golden thoughts in rhyme?

When the Tinoceras snooped about

And the Pterodactyl flapped its wings

When the Brontops with the warty snout
Moseyed around for herbs and things

Would I have bothered-
-myself oermuch
About divine afflatus-
-and such?

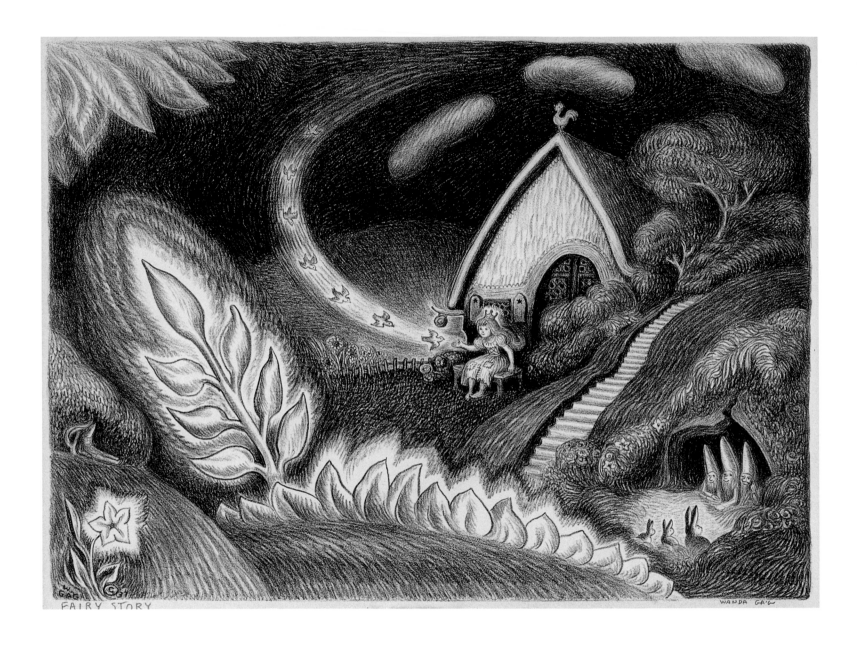

WANDA GÁG, 1893–1946

"Fairy Story," 1937
Lithograph from zinc plate

This rare print (one of forty copies made) was completed the same
year as Gág's first volume of Grimm's fairytales. The image did not
appear in any of Gág's publications, and is possibly the only fine art
print the artist ever made concerning a children's subject.

Fairytales and Fantasy

Fairytales can be soothing or disturbing, scary or light-hearted, weird or wonderful. Whereas myths aim to explain the workings of the natural world, it has been written that fairytales often work to explore the psyche — to provide for children examples of how to think through challenging situations. It is not difficult, though, to see how they have delighted readers young and old for centuries, transporting them to invented lands full of fantastic and magical creatures.

Among the dazzling images in the Shirley collection are scenes from some of the greatest modern fairytales, including Jessie Willcox Smith's painting for *At the Back of the North Wind*, and Frederick Richardson's drawings for editions of Andrew Lang's "Fairy Book" series. The story of Snow White is shown in images by Wanda Gág and the Walt Disney Studio that were executed at almost the exact same time, providing different glimpses into this classic tale.

A group of unique items show the range of the Shirley collection. Hans Christian Andersen's cut-paper picture of two ballerinas exhibits his deft skill, while unrealized works by two of the twentieth century's finest artists make one wonder what could have been: Rockwell Kent's proof for a never-published *Little Red Riding Hood*, and Maurice Sendak's study for *The Hobbit*.

The inhabitants of the Land of Oz, familiar to so many children, are seen as delineated by the series' two best-known illustrators, W. W. Denslow and John R. Neill. H. W. McVickar's fantasy, *Nellie in Dreamland*, shares with the Oz books a tendency towards surreal imagination. The works of Art Young, Margot Zemach, and Maxfield Parrish show even more clever approaches to the making of fantasy worlds.

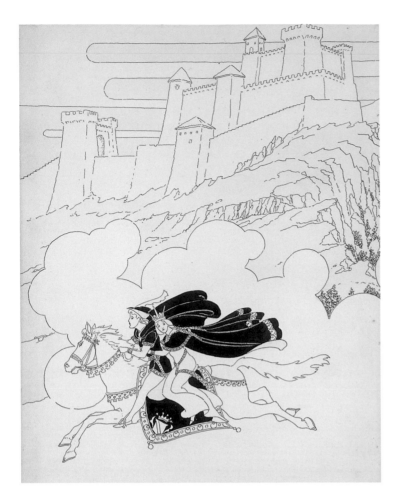

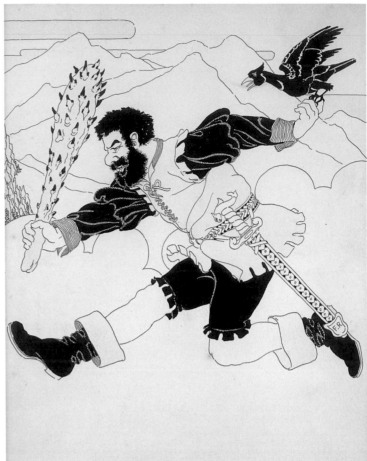

Frederick Richardson, 1862–1937

[Prince and princess on a horse with castle in background]
[Running giant holding a club and a raven]
for *The Blue Fairy Book* and *The Red Fairy Book*, by Andrew Lang
(Philadelphia: The John C. Winston Co., 1930)
Pen and ink on paper

Andrew Lang's *The Blue Fairy Book*, first published in 1889, fed a late-Victorian interest in fairies and fairytales. Lang, a Scottish poet, novelist, and anthropologist, collected enough fables and folktales from cultures around the world to fill eleven more Fairy Books through 1910, each one identified by a color and released in time for Christmas. The popular bedtime series had gone through numerous editions by the time Frederick Richardson illustrated the Blue and Red books (originally the first two) in 1930. The two drawings shown here, inspired by "The Story of Pretty Goldilocks," were combined for the books' endpapers.

Jessie Willcox Smith, 1863–1935

"On the top of the great beech-tree"
for *At the Back of the North Wind*, by George MacDonald
(Philadelphia: David McKay, 1919)
Oil on canvas

Macdonald's *At the Back of the North Wind*, first published in 1871, is the story of Diamond, a poor stable boy in Victorian England, who is visited by a fairy named North Wind. This is the final illustration in the book (from chapter 36, "Diamond Questions North Wind"), showing Diamond in the middle of what he thinks might be a dream: "... she swept with him through the open window in at which the moon was shining, made a circuit like a bird about to alight, and settled with him in his nest on the top of the great beech-tree. There she placed him on her lap and began to hush him as if he were her own baby, and Diamond was so entirely happy that he did not care to speak a word."

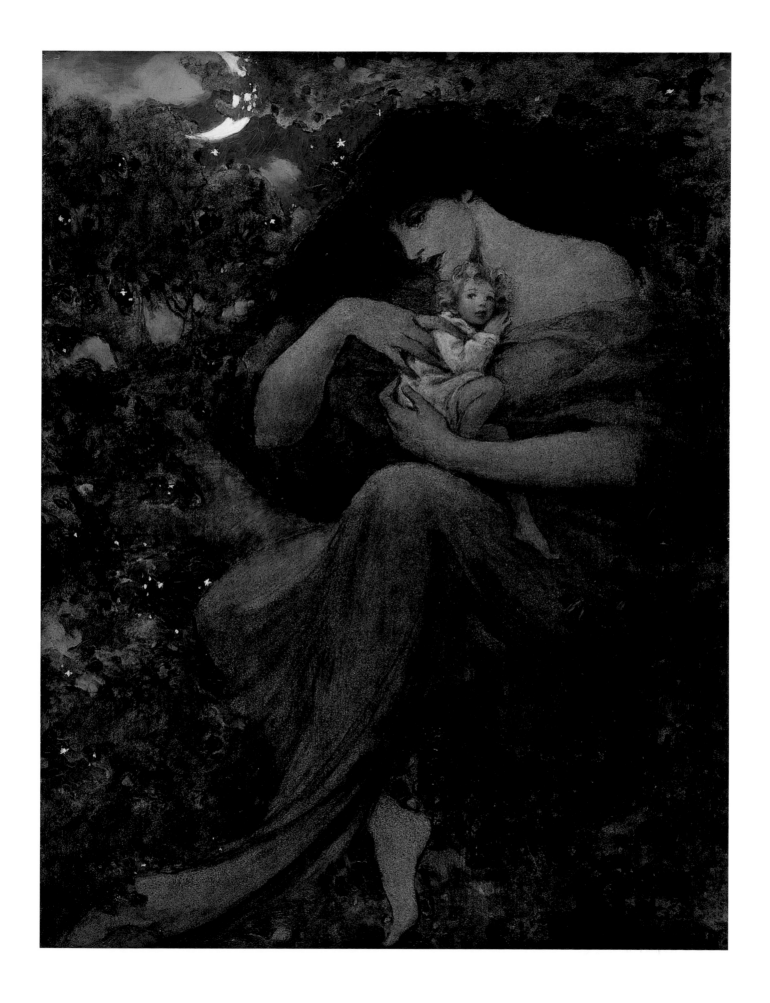

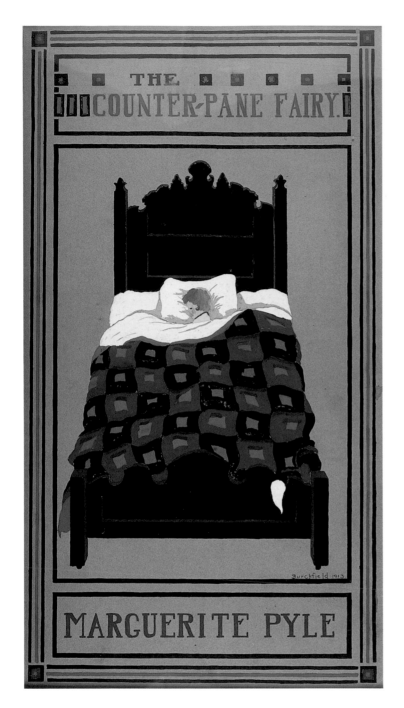

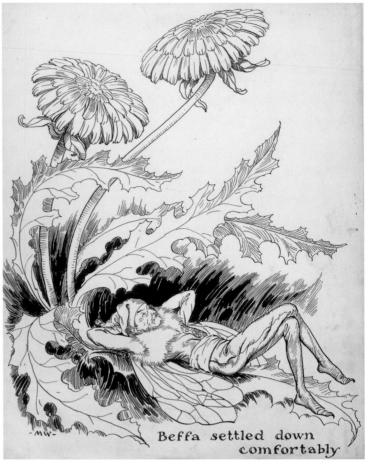

Beffa settled down comfortably

has little in common with his later works, which were often free-form watercolor landscapes — it is the product of an assignment given to the young artist while he studied at the Cleveland School of Art. Apparently his teacher believed Pyle's first name to be "Marguerite."

MILO WINTER, 1888–1956

"Beffa settled down comfortably," undated
Pen and ink on paper

One of Winter's playful fairies beds down for a nap in this winsome sketch.

CHARLES BURCHFIELD, 1893–1967

[Study], 1913
based on *The Counter-Pane Fairy*, by Katharine Pyle
(New York: E. P. Dutton & Co., 1898)
Gouache on paper

The Counter-Pane Fairy was the first children's book Katharine Pyle both wrote and illustrated, and it was a major success. The title and subject were inspired by Robert Louis Stevenson's poem, "The Land of Counterpane," in which he describes a child playing make-believe among the covers of his sickbed. This early painting by Burchfield

FRANCIS GILBERT ATTWOOD, 1856–1900

"Dance of Fairies"
for *The Fairies' Festival*, by John Witt Randall
(Boston: Joseph Knight Co., 1894)
Pen and ink with pencil

Attwood's illustration is for a poem written in dialogue.

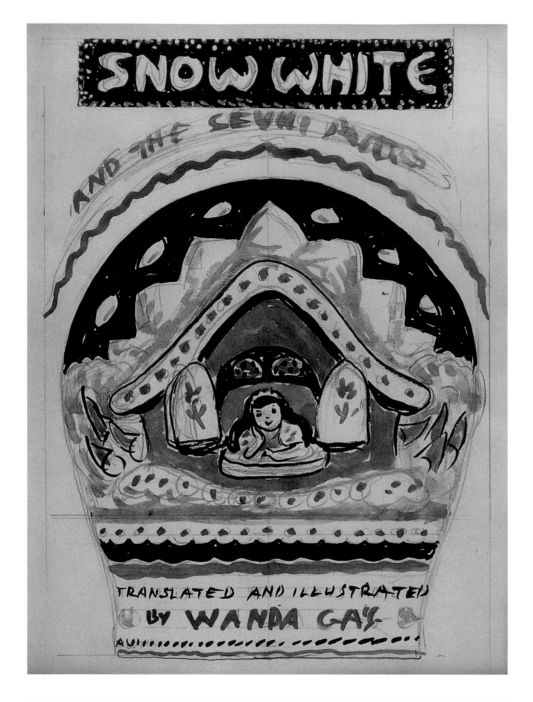

WANDA GÁG, 1893–1946

[Cover design]
for *Snow White and the Seven Dwarfs*
(New York: Coward-McCann, 1938)
Colored pencil and gouache on paper

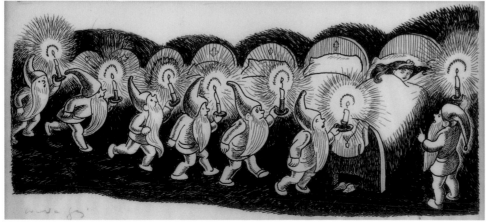

WANDA GÁG, 1893–1946

"The Seven Dwarfs discover Snow White
in their bed."
for *Snow White and the Seven Dwarfs*
(New York: Coward-McCann, 1938)
Pen and ink on paper

Gág, raised in the German/Austrian immi-
grant community of New Ulm, Minnesota,
was steeped at an early age in the tales of
the Brothers Grimm. Her *Snow White* was
a Caldecott Honor Book for 1939.

UNIDENTIFIED ARTIST,
FOR WALT DISNEY PRODUCTIONS

"The Faithful Little Men Watched over
their Princess Constantly."
for *Snow White and the Seven Dwarfs,
adapted from Grimm's fairytales*
(New York: Harper & Brothers, 1937)
Pencil on paper

This image is from the original book adaptation of the familiar Snow White story.
Walt Disney's motion picture, the world's
first full-length animated feature film,
proved the broad appeal of his storytelling
on celluloid.

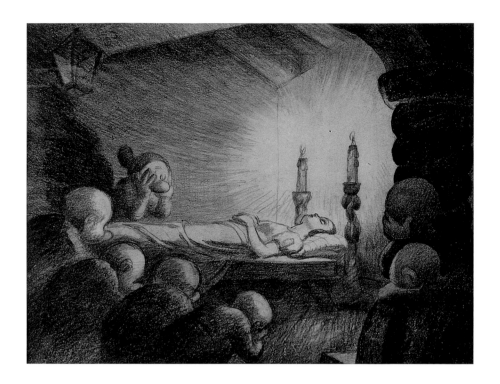

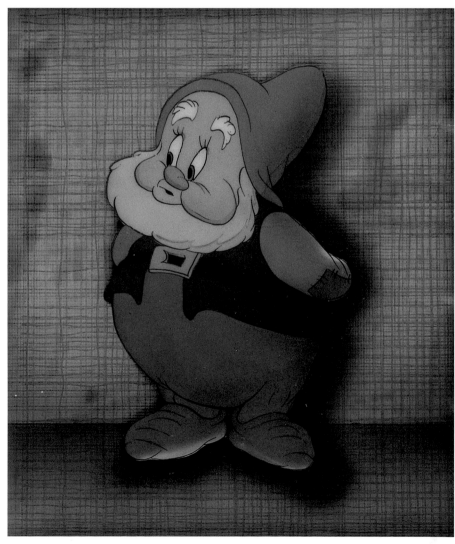

UNIDENTIFIED ARTIST,
FOR WALT DISNEY PRODUCTIONS

[Happy]
for the film "Snow White and the Seven
Dwarfs," (1937)
Paint on celluloid

"Happy" is easily identified by his two-tone
brown tunic and cap, blue trousers, and long
white beard.

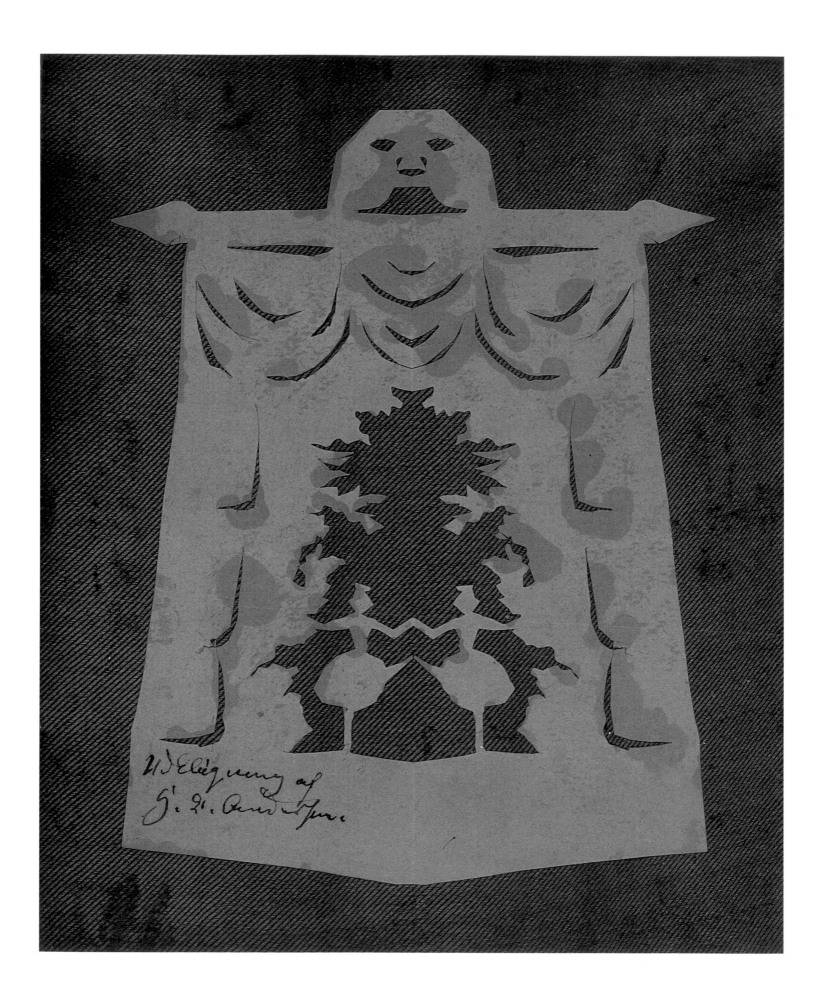

HANS CHRISTIAN ANDERSEN, 1805–1875

[Two ballerinas in a forest], ca. 1860s
Paper mounted on board

Hans Christian Andersen's inimitable paper-cut designs can be considered anti-silhouettes in that the world-famous fabulist invariably constructed scenes from white paper — not black — which faced the viewer directly rather than in profile. It is estimated that between 250 and 1,500 of these works survive, many of them created as impromptu gifts for friends and young admirers while the artist diverted them with a fantastic tale. Ballerinas, fairies and gnomes were, appropriately, Andersen's subjects of choice. The proscenium arch, figured as a ghostly visage above the stage, appears in many of the paper-cuts, reflecting the fact that Andersen's expertise with paper was inspired by childhood visits to the local playhouse in Odense, Denmark.

MAURICE SENDAK, b. 1928

[Study of Bilbo Baggins and Gandalf], 1967 for "The Hobbit"
Pen and ink on paper

Sendak's depiction of Bilbo Baggins and the bearded wizard was intended for an illustrated 1967 edition of Tolkien's fantasy classic, but it was never used. Sendak suffered a heart attack just days prior to meeting with the author, and the commission was subsequently cancelled.

ROCKWELL KENT, 1882–1971

"Little Red Riding Hood Sets Off for Her Grandmother's. 'Good Morning,' said the Wolf," ca. 1920 for "Little Red Riding Hood"
Woodcut proof print

Kent, who used his lithographs and woodcuts to illustrate classic tales (most famously a 1930 edition of *Moby Dick*), here takes on the story of Red Riding Hood. This is one of two known proof illustrations for the book, which was never published. Kent's estate stamp can be seen in the lower right.

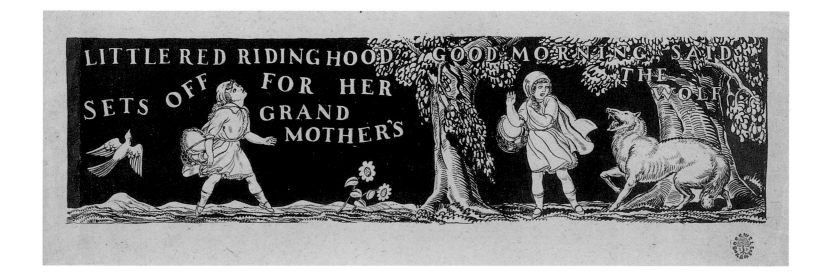

MAXFIELD PARRISH, 1870–1966

[Cover design]
for *The Children's Book: a Collection of the Best and Most Famous Stories and Poems in the English Language*,
chosen by Horace E. Scudder
(Boston: Houghton, Mifflin Co., 1909)
Oil on paper laid down on panel

This lavish image was used for the cover of a 1909 edition of a popular anthology for children, though the notice of a 1908 copyright by *Collier's* indicates that it was most likely used first as a cover or an interior illustration for that magazine.

MAXFIELD PARRISH, 1870–1966

"The Knave of Hearts," 1923
for *The Knave of Hearts*, by Louise Saunders
(New York: Charles Scribner's Sons, 1925)
Oil on paper laid down on panel

The twenty-six opulent illustrations Parrish executed between 1923 and 1925 for the one-act play *The Knave of Hearts* (written by his neighbor Louise Saunders, the wife of editor Maxwell Perkins) represent his last effort for a book project and are widely considered his crowning achievement in this mode. Parrish borrowed some of the intricate architectural elements from his self-designed home, "The Oaks," for the book's castle settings. This illustration of the Manager bowing, used as an end piece in the book, went by the alternative title "The End" when it was reproduced for a cover of *Collier's* in 1929.

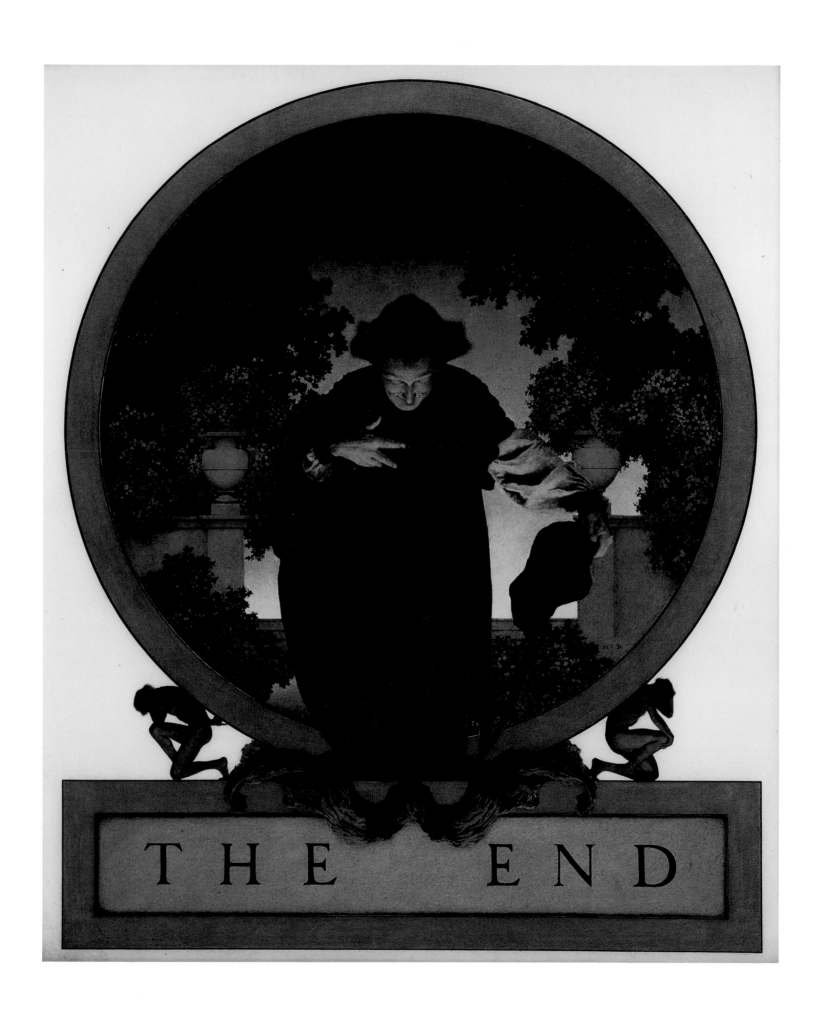

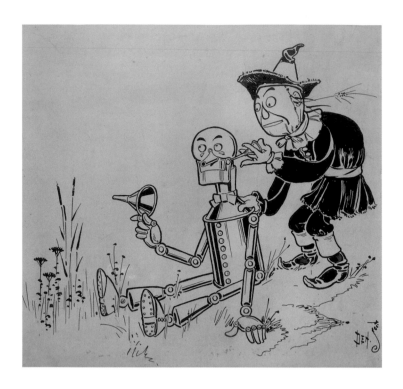

W. W. DENSLOW, 1856–1915

[Scarecrow oiling the Tin Woodsman's jaws]
for *The Wonderful Wizard of Oz*, by L. Frank Baum
(Chicago and New York: George M. Hill Co., 1900)
China-ink on paper

The iconic images Denslow created for Baum's masterwork are
the culmination of planning and building on the appeal of such
earlier works as *Father Goose: His Book*. This scene occurs in chapter
6, "The Cowardly Lion," when the Tin Woodsman is rusted by his
own tears after stepping on a bug: "But the Scarecrow seized the
oil-can from Dorothy's basket and oiled the Woodsman's jaws, so
that after a few moments he could talk as well as before."

W. W. DENSLOW, 1856–1915

"The Wonderful Wizard of Oz," 1900
Four-color letterpress poster

Denslow's success in the picture book format is traceable to the
poster art style he developed earlier in his career. This poster adver-

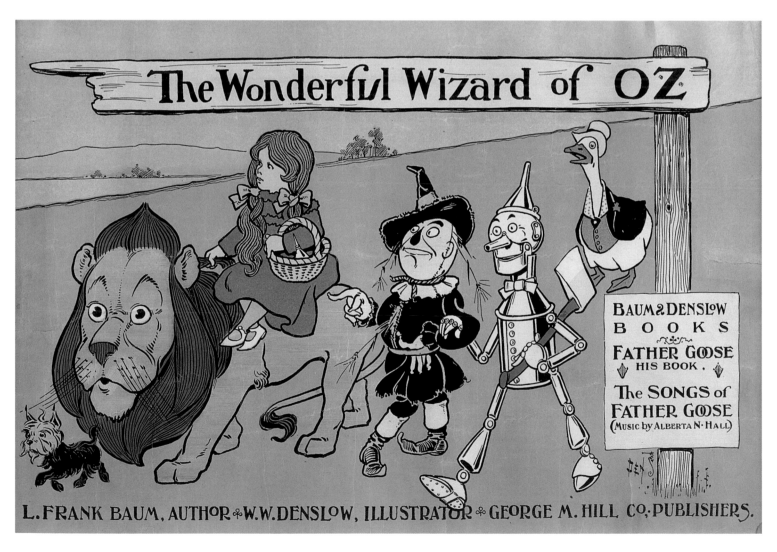

tising Baum's seminal *Oz* tale shows the beloved cast of characters on their way to the Emerald City. Father Goose, a character from Baum and Denslow's successful collaboration from the previous year, waddles along behind.

John R. Neill, 1877–1943

[Study]
for *Tik-Tok of Oz*, by L. Frank Baum (Chicago: Reilly & Britton Co., 1914)
Pen and ink with India ink on board

Tik-Tok of Oz was the eighth of the fourteen Oz books written by Baum, all of which were illustrated by Neill except for the original *The Wonderful Wizard of Oz*, which was illustrated by W. W. Denslow. In this study for the pictorial half-title page, the copper man Tik-Tok (also referred to as "Mechanical Man" and "Clockwork Man") is stuck at the bottom of a well, where he will be recovered by Betsy Bobbin, Shaggy Man, and the fairy-like Polychrome.

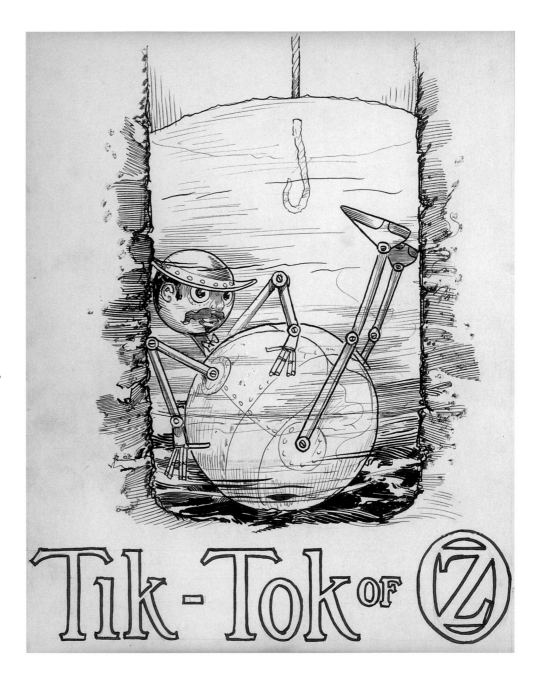

H. W. McVickar, 1860–1905

[Study for cover]
for *Nellie in Dreamland* ([New York: Wemple & Co., 1884?])
Watercolor on board with printer's instructions in pencil (below)
shown with printed copy (right)

Nellie in Dreamland was presented as a gift token to young
riders of the Chicago, Rock Island & Pacific Railway. The names
of both author Davison Dalziel and illustrator McVickar were
omitted from the printed cover and title page [though Dalziel's
name has been added in pencil]. The inquisitive young Nellie,
traveling from Chicago to "Baushee Land," is pictured here
among the "guardian fairies" to which the book is dedicated.

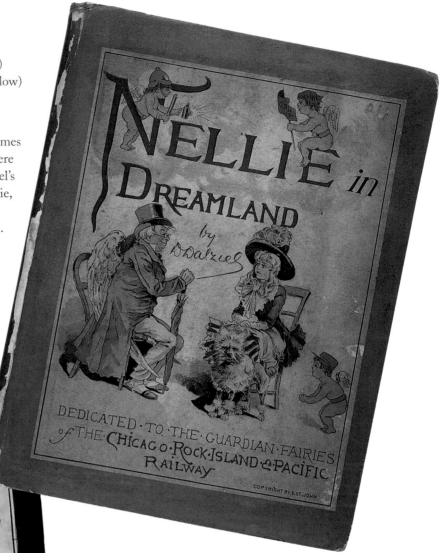

H. W. McVickar, 1860–1905

"They were standing on each others shoulders and the topmost
were supporting the beams of the bridge."
for *Nellie in Dreamland* ([New York: Wemple & Co., 1884?])
Watercolor on board with printer's instructions in pencil

McVickar's illustrations reflect the odd mélange of westward
expansionism and whimsicality brought together in *Nellie in
Dreamland*. The "little old man" featured on the cover is father
to 284 cherubic children, six of whom come to the rescue in this
illustration.

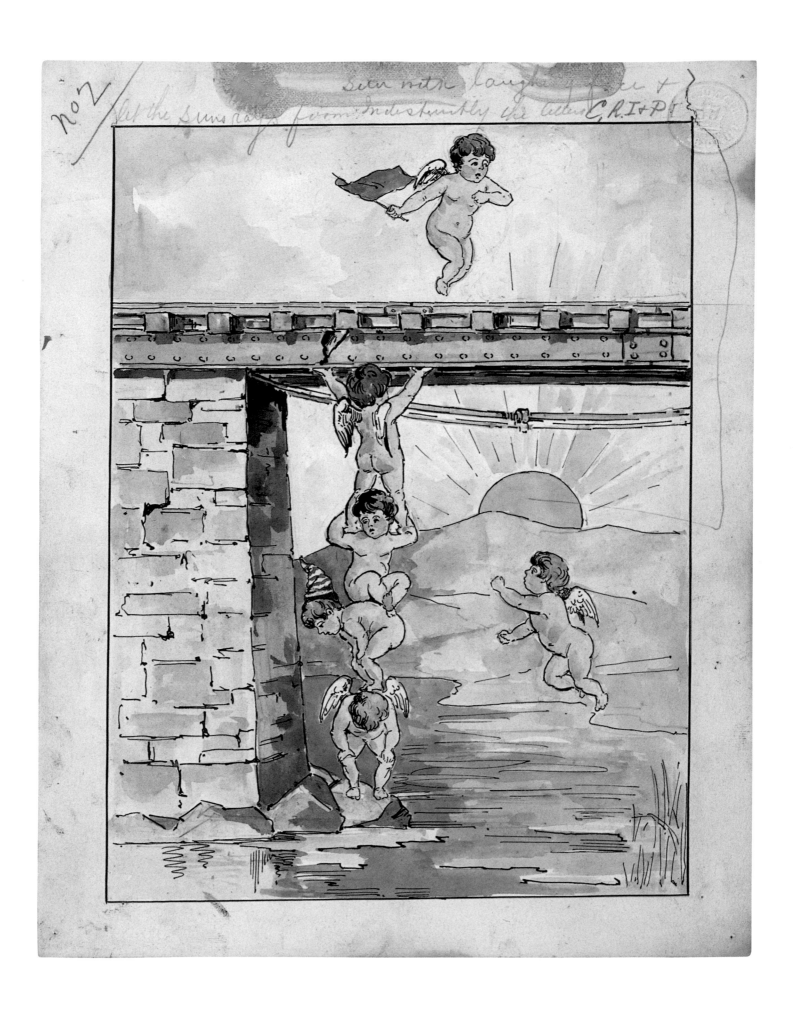

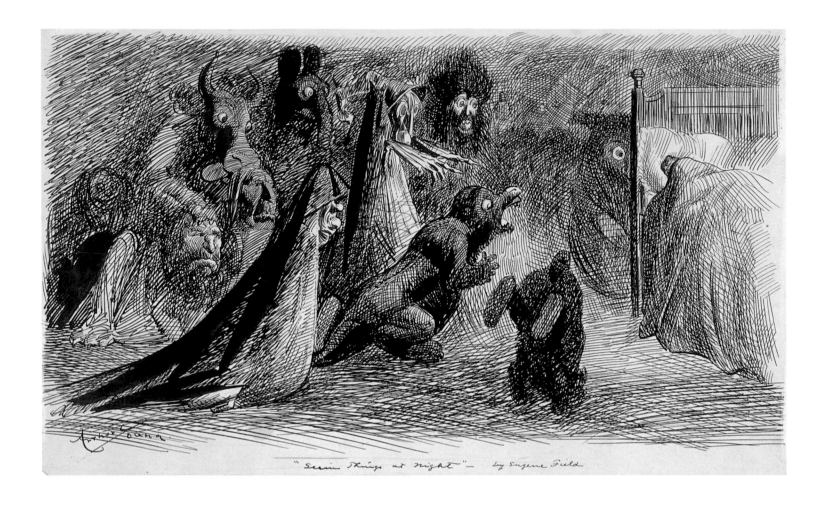

"Seein' Things at night" — by Eugene Field

Art Young, 1866–1943

"I woke up in the dark an' saw things standin' in a row."
for *Authors' Readings*, compiled and illustrated by Art Young
(New York: F. A. Stokes Co., 1897)
Ink on paper

Young's illustration for Eugene Field's poem, "Seein' Things," was
accompanied with life drawings that aimed to show the author in
"characteristic attitude" while reciting his work.

Margot Zemach, 1931–1989

[Jake and Honeybunch]
for *Jake and Honeybunch Go to Heaven*
(New York: Farrar Straus & Giroux, 1982)
Pen and ink with watercolor on board

A variation of this design is used on the first page of the text. This
retelling of a classic African American folktale follows the exploits
of Jake and his ornery mule Honeybunch as they arrive in heaven
and try not to get kicked out.

Adventure Tales and Coming of Age

Stories of adventure and derring-do became an industry in and of itself in the nineteenth century. Series of books, magazines, and "annuals," mainly aimed at juvenile male audiences, were issued in quantity by dedicated publishers in France, England, and the United States. Perhaps the best-known serial publisher was the Stratemeyer Syndicate, remembered for the Hardy Boys, Nancy Drew, and the intrepid Rover Boys.

Home-grown heroes were also on the rise in the nineteenth and early twentieth centuries, as exemplified in Owen Wister's *The Virginian*, a book that eventually launched a genealogy of classic movie versions. To match the likes of an adventurous boy such as Tom Sawyer, children's literature eventually caught up to offer alternative heroes, such as Hitty, the doll whose "biography" won the Newberry Medal.

Among the most magnificent works in the Shirley collection — those which stand alone as fine art — are oil paintings executed by N. C. Wyeth for the covers for two of Robert Louis Stevenson's novels, *Kidnapped* and *Treasure Island*. The work by Lynd Ward for *The Biggest Bear*, while not on such a grandiose scale, shows yet another type of heroic stance.

The character Little Lord Fauntleroy, while known in some quarters for the dubious fashion craze inflicted on children, serves as an example of one type of rags-to-riches story. On the other hand, there is the story of Toby Tyler, a classic in the genre of "runaway fiction." The series of drawings done by W. A. Rogers for the first book edition of that novel show a much more devil-may-care hero learning some of life's hard lessons.

WALTER S. ROGERS, FOR THE STRATEMEYER SYNDICATE

"It did not take Dick long to assist Dora into the launch"
for *The Rover Boys Down East, or, The Struggle for the Stanhope Fortune*,
by Arthur M. Winfield (New York: Grosset & Dunlap, 1911)
Gouache on board

Though most of the writers who penned tales for the Stratemeyer Syndicate were pseudonymous, many artists were completely unknown. Paintings for this, the fifteenth volume in the Rover Boys series, were uncredited, but Walter S. Rogers was acknowledged in later works, including titles in the Hardy Boys series.

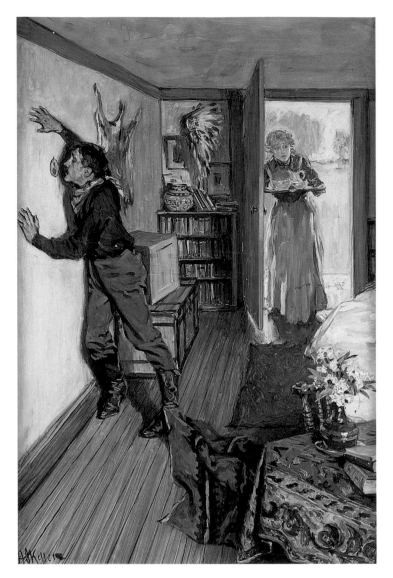

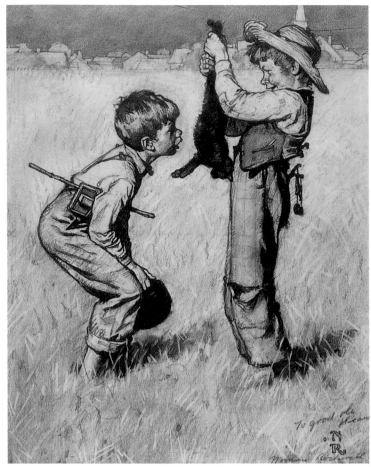

ARTHUR IGNATIUS KELLER, 1866–1924

"'I promise to make your little girl happy,' he whispered," 1902
for Owen Wister's *The Virginian: A Horseman of the Plains* (New
York: The Macmillan Co., 1902)
Gouache on paper

Keller made eight illustrations for *The Virginian*, the novel that
cemented the heroic and elegiac themes of the American romantic
western. The book, which was dedicated to Theodore Roosevelt,
became an instant bestseller and was later adapted for a television
series and several films, the most famous of which starred Gary
Cooper in 1929. This illustration shows the anonymous cow-
puncher — known only as "the Virginian" — interrupted while
making delirious love vows to a miniature daguerreotype.

NORMAN ROCKWELL, 1894–1978

"Lemme see him, Huck. My he's pretty stiff."
for *The Adventures of Tom Sawyer* (New York: Heritage Press, 1936)
Charcoal on paper

This study evolved into an oil painting that was reproduced as one
of eight full-page color illustrations in the published edition.
Rockwell spent long hours in Hannibal, Missouri, Twain's child-
hood home, preparing the illustrations. The final version of this
particular image differs slightly from the study, primarily in that
the background changes from an open field to a greener, more
densely wooded setting.

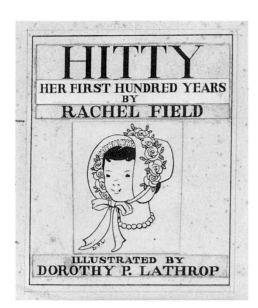

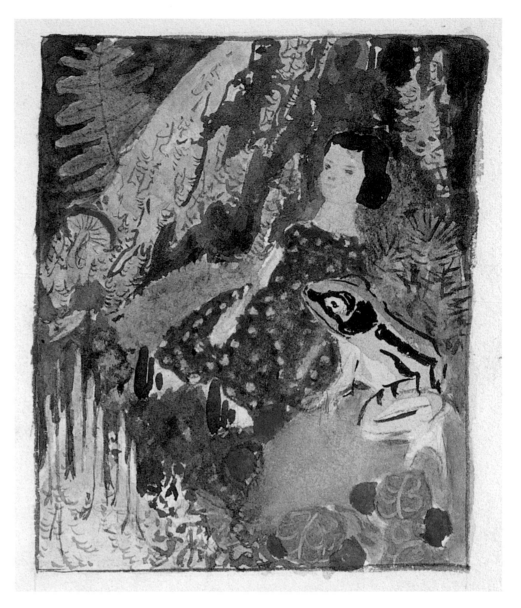

Dorothy Pulis Lathrop,
1891–1980

[Paste-label used on the front cover]
Proof print with lettering

"The surrounding roots made a kind of
deep chair for me"
Watercolor on paper

[Study of Hitty sitting on a toy couch, not
used]
Watercolor on paper

for *Hitty: Her First Hundred Years,*
by Rachel Field
(New York: The Macmillan Co., 1929)

Field's Newbery Medal-winning book was
based on an actual nineteenth-century ash
wood doll that she and Lathrop found in a
Manhattan antique shop. Field embell-
ished on real-life people for the story as
well, especially the historical Preble family
of Great Cranberry Island, Maine. Hitty
(short for Mehitable) and her adventure
memoirs have generated a cult following
among lovers of children's literature.

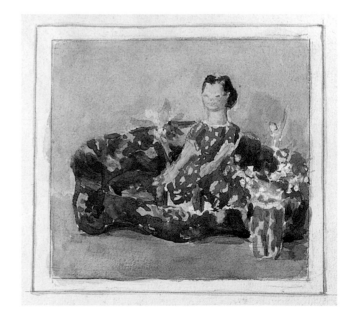

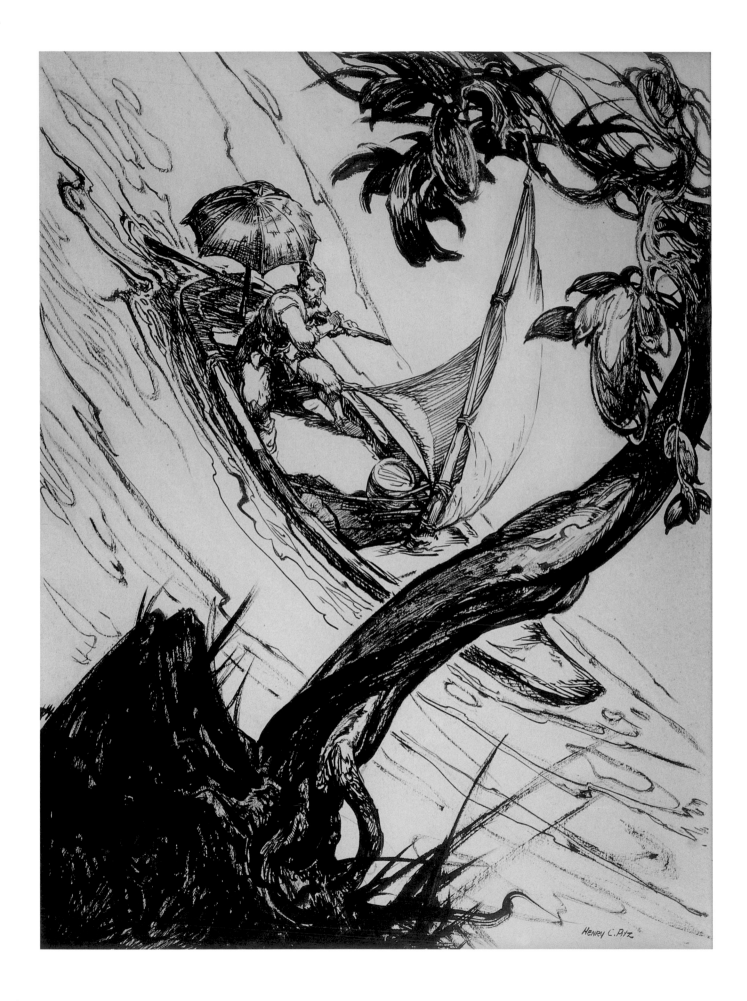

HENRY CLARENCE PITZ, 1895–1976

"I came to a very good inlet or bay"
for *Robinson Crusoe*
(New York: D. Appleton-Century Co., 1936)
Pen and ink with India ink on board

This illustration appears on page 179 of this version of *Robinson Crusoe*, "edited to fit the interests and abilities of young readers by Edward L. Thorndike."

LOUIS RHEAD, 1857–1926

"During that long afternoon Tom sat in his study reading his Bible"
[Decorated initials for chapter headings]
for *Tom Brown's School Days*, by Thomas Hughes
(New York: Harper & Brothers, 1911)
Ink on paper

This illustration and decorations were created by Rhead for the 1911 edition of the popular novel, and were based on the artist's impressions of Rugby School, the setting for the tale. The scene featuring the pensive Tom appears in chapter 6, part 2.

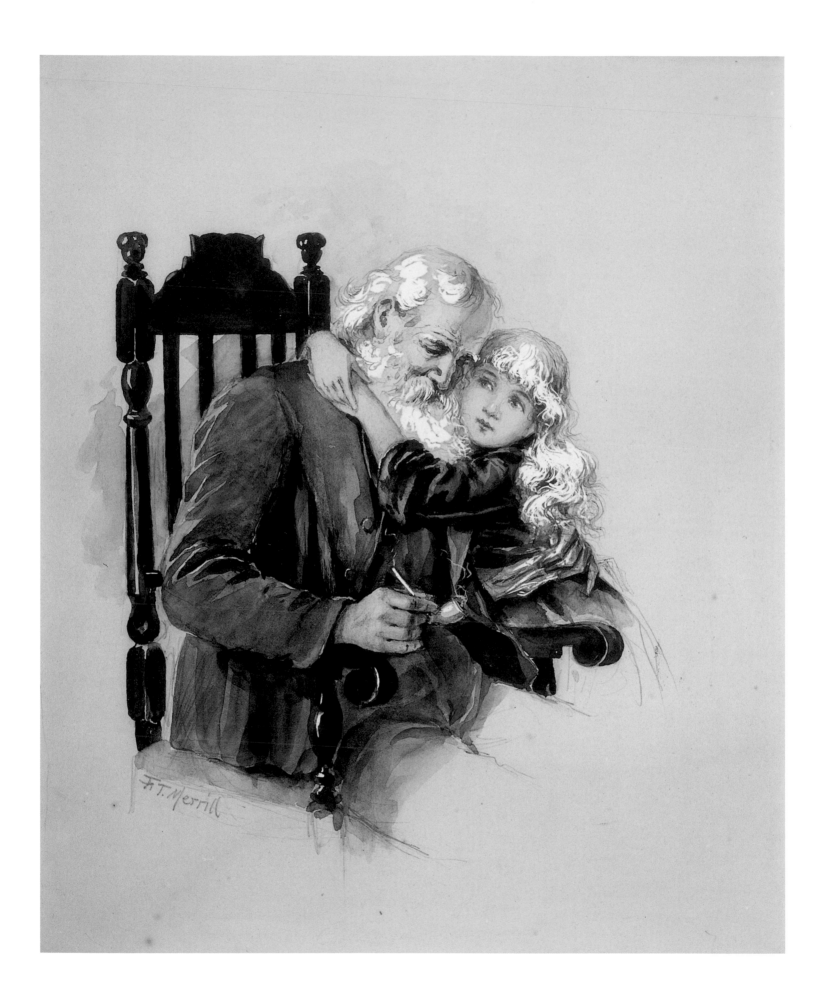

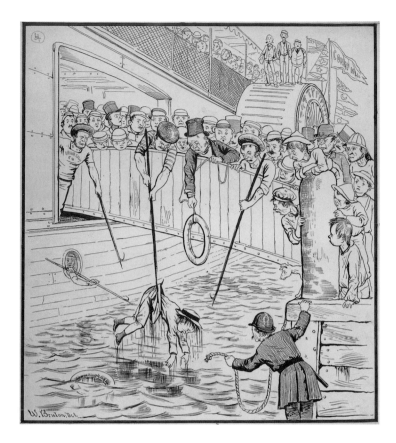

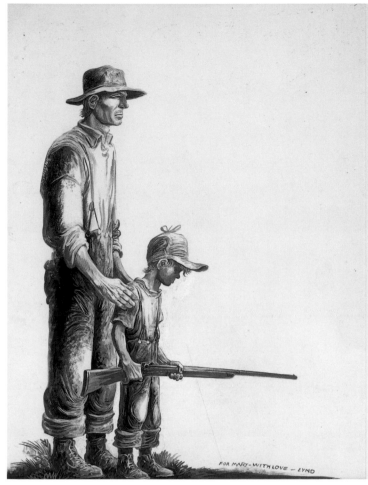

Frank T. Merrill, 1848–1923

"I am here, Daddy, loving you: loving you *all to pieces*."
for *Captain January*, by Laura E. Richards
(Boston: Estes & Lauriat, 1893)
Watercolor and pencil highlighted with china-white on paper

This image, from the first illustrated edition of the often-reprinted and filmed novel, shows Captain January, a lighthouse keeper, with the young girl he saves from drowning, Star Bright. "'Poor Daddy!' murmured the child again, pressing her soft cheek against the white beard. 'It's all over now! Don't think of it! I am here, Daddy, loving you: loving you *all to pieces*, you know!'"

W. Bruton

"And when he to the surface rose, They quickly fished him out."
for *Johnny Headstrong's Trip to Coney Island*
(New York: McLoughlin Bros., 1882)
Pen and ink on artist's board.

Bruton was a prolific illustrator who often worked with McLoughlin Bros. in the late nineteenth century. In this book, the strong-willed young Johnny ignores the advice of his grandfather and ends up in a series of sticky situations while visiting Coney Island, finally going home with a bandaged head.

Lynd Ward, 1905–1985

[Johnny and his father]
for *The Biggest Bear*
(Boston: Houghton Mifflin, 1952)
Gouache on board

The Biggest Bear, the first children's book Ward both wrote and illustrated, was awarded the Caldecott Medal in 1953. The scene is a pivotal moment in the story when Johnny decides he must kill the bear he has raised from a cub: "Johnny and his father talked it over and they decided there was only one thing to do. Johnny said he would do it."

and his Wife," this study was redrawn and titled "Winter" to illustrate December in *Appleton's Illustrated Almanac for 1870*.

FELIX OCTAVIUS CARR DARLEY, 1822–1888

[Man leaning back in chair with a stein, and a servant girl]
for *The Old Curiosity Shop*, by Charles Dickens
(New York: Sheldon and Co., 1861)
Pen, brush and wash on paperboard

Over a period of ten years, from 1861–1871, Sheldon and Co. published fifty-five volumes of Dickens's works, employing Darley among an array of illustrators. This image is one of three Darley composed for *The Old Curiosity Shop*. It precedes the third (and final) volume of the novel and is accompanied by the following caption: "Marchioness, your health. You will excuse my wearing my hat but the palace is damp and the marble floor is — if I may be allowed the expression — sloppy." A marchioness, in this case, refers to a female servant.

JAMES WELLS CHAMPNEY, 1843–1903

"The Civilized Fox"
for *Being a Boy*, by Charles Dudley Warner
(Boston: J. R. Osgood & Co., 1878)
Pen and ink on paper

This scene, from chapter 4 of Warner's series of humorous essays on bucolic farm life, shows the narrator as a boy reading from *Exodus* with his "civilized fox" close at hand: "It is a mistake to suppose the fox cannot be tamed. Jacko was a very clever little animal, and behaved, in all respects, with propriety. He kept Sunday as well as any day, and all the ten commandments that he could understand."

FELIX OCTAVIUS CARR DARLEY, 1822–1888

"Old Pastor and Wife from Judd's *Margaret*"
for *Margaret: A Tale of the Real and the Ideal*, by Sylvester Judd
(New York: Redfield, 1856)
Pencil on paper

This sketch for *Margaret*, originally published in 1845, tells the story of a girl raised in the backwoods by a hard-drinking foster family. Darley's edition consists of thirty plates accompanying short chapters or vignettes. Captioned in the book: "Parson Wells

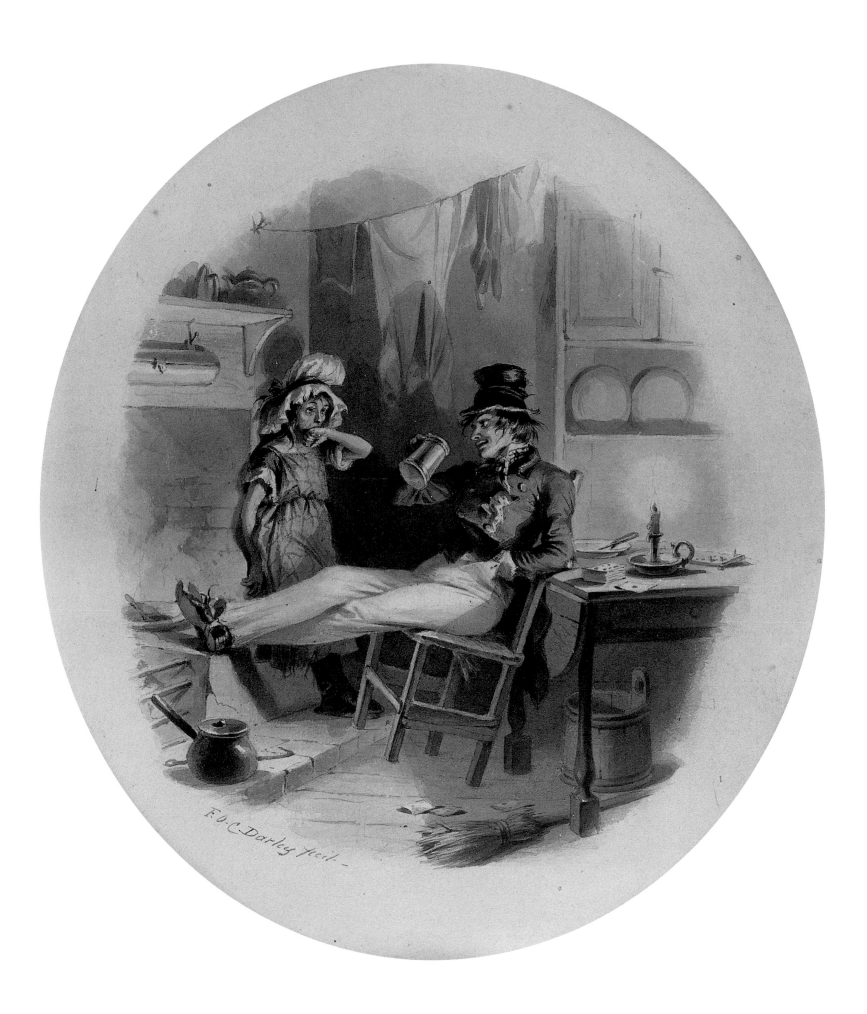

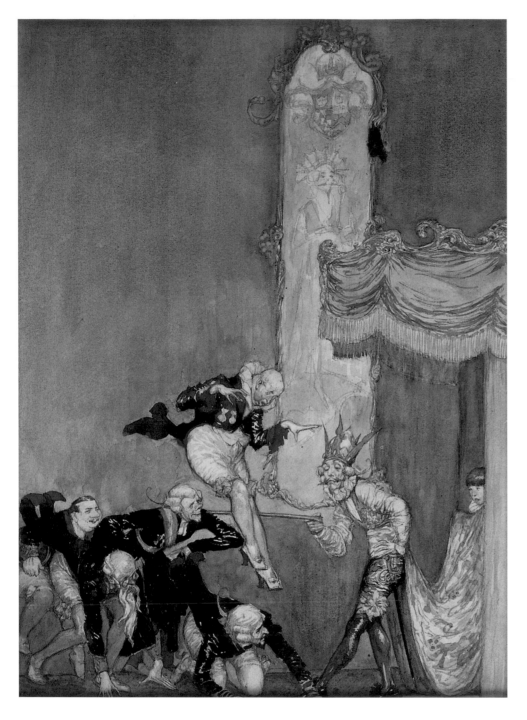

WILLY POGÁNY, 1882–1955

"The Emperor holds a stick …"
for *Gulliver's Travels*, by Jonathan Swift
(New York: Macmillan Co., 1917)
Watercolor on paper

The full title for this picture, on the facing
page 30, is: "The Emperor holds a stick in
his hands while the candidates sometimes
leap over the stick, sometimes creep under
it backwards and forwards several times,
according as the stick is advanced or
depressed."

N. C. WYETH, 1882–1945

"On the Island of Earraid"
for *Kidnapped: The Adventures of David
Balfour*, by Robert Louis Stevenson
(New York: Charles Scribner's Sons, 1913)
Oil on canvas

Wyeth illustrated eighteen volumes in
Scribner's Illustrated Classics series.
"Scribner said that he never … knew of
anyone who could catch the spirit of a
theme and push it through with such vim
and consistent strength as I can," the artist
remarked in *The Wyeths* (1971). This illus-
tration of the young Scottish hero David
Balfour finds him stranded after his ship
has sunk: "But the second day passed; and
as long as the light lasted I kept a bright
look-out for boats on the sound or men
passing on the Ross."

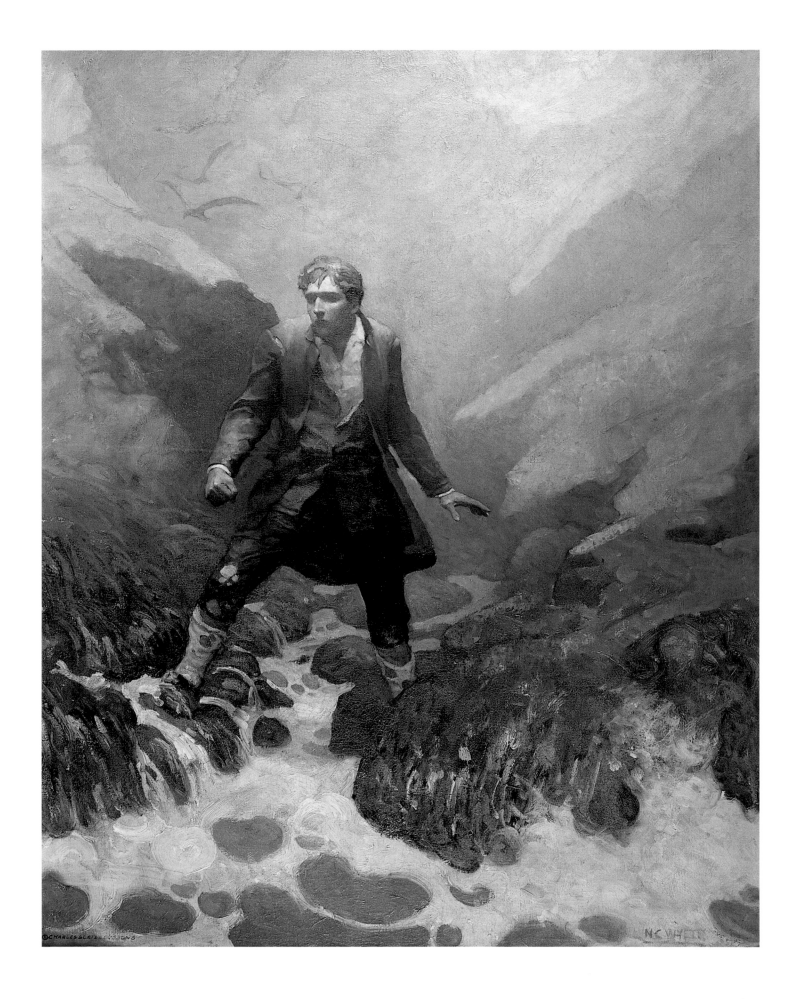

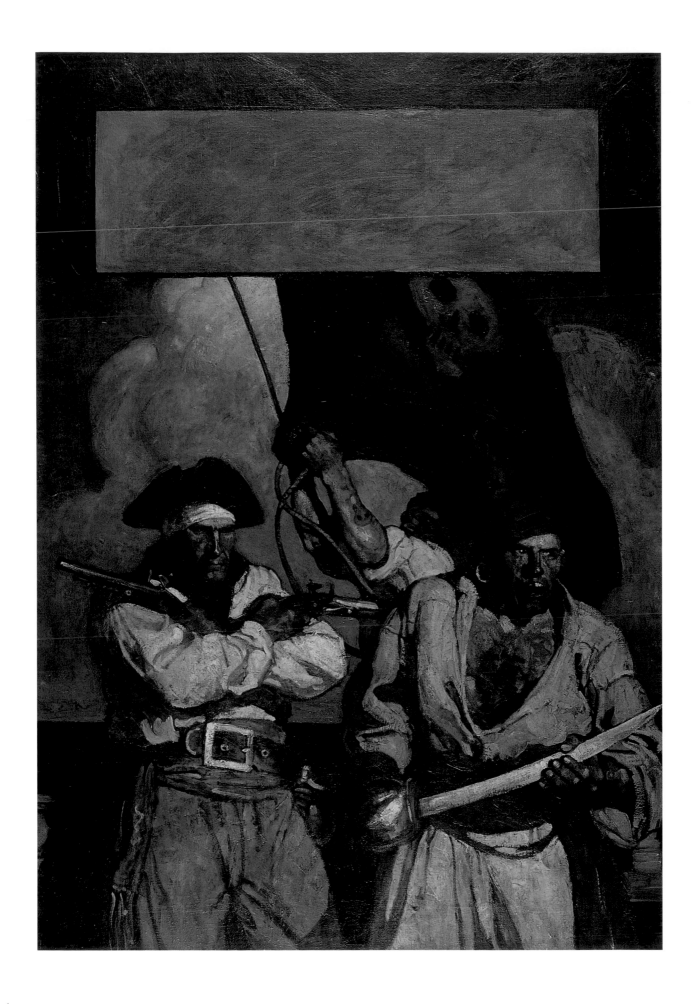

N. C. Wyeth, 1882–1945

"The Pirates"
for *Treasure Island*,
by Robert Louis Stevenson
(New York: Charles Scribner's Sons, 1911)
Oil on canvas

Treasure Island was the first book Wyeth
illustrated for Scribner's. Later books in the
series included novels by Jules Verne and
James Fenimore Cooper. This painting,
used for the cover illustration, has been
widely reproduced and is one of Wyeth's
most recognized works.

Reginald Bathurst Birch,
1856–1943

"'I've a great deal to thank your Lordship
for,' said Higgins."
for *Little Lord Fauntleroy*,
by Frances Hodgson Burnett
(New York: Charles Scribner's Sons, 1886)
Black ink over pencil, heightened with
white, on wove paper

Burnett, author of *A Little Princess* and
The Secret Garden, first published this story
(with this illustration) in the May 1886
issue of *St. Nicholas*. The first book edition
was published later that year, featuring the
illustration in chapter 7. While it met with
great approval from the older generation,
Fauntleroy was not without its detractors
among the youth, some of whom resented
having to wear the lace collars and velvet
knickers made stylish by the little lord.

Reginald Bathurst Birch,
1856–1943

"Mr. Mordaunt held the small hand in his
as he looked down at the child's face."
for *Little Lord Fauntleroy*, by Frances
Hodgson Burnett
(New York: Charles Scribner's Sons, 1916)
Watercolor on paper

The velvet-clad, blond Fauntleroy was
Birch's most beloved illustrated character,
and the subject of several film adaptations.

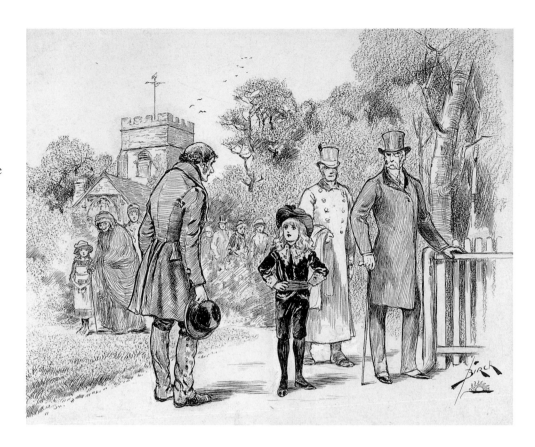

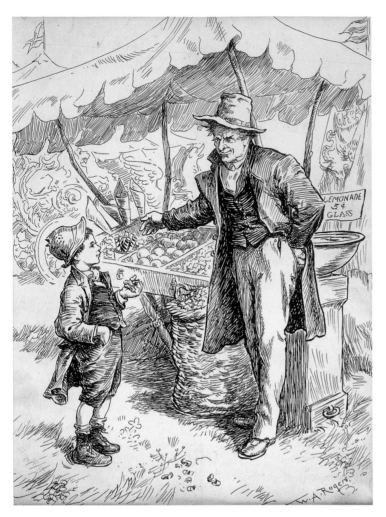

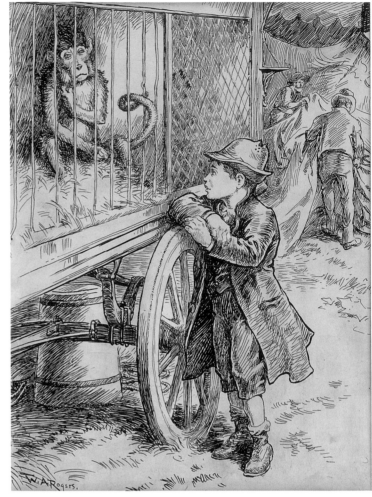

W. A. ROGERS, 1854–1931

"Toby Strikes a Bargain"
for *Toby Tyler, or, Ten Weeks with a Circus*, by James Otis
(New York: Harper & Brothers, 1881).
Pen and ink on paper

Originally serialized in *Harper's Young People*, the story "Toby Tyler" featured illustrations by Rogers, who had already made a name for himself as a political cartoonist with *Harper's Weekly*. This drawing appeared in the first installment of the serialized story, published in the December 7, 1880, issue of *Harper's Young People*, which began

with Toby haggling over the price and quality of peanuts with a candy vendor. The image was used again in what became Otis's first published book.

"Toby and His New Friend"
Pen and ink on paper

The third illustration in the book shows young Toby getting to know the monkey Mr. Stubbs, whose antics will eventually get Toby in trouble. It appeared in chapter 2, "Toby Runs Away from Home," but was first published in the serialized version.

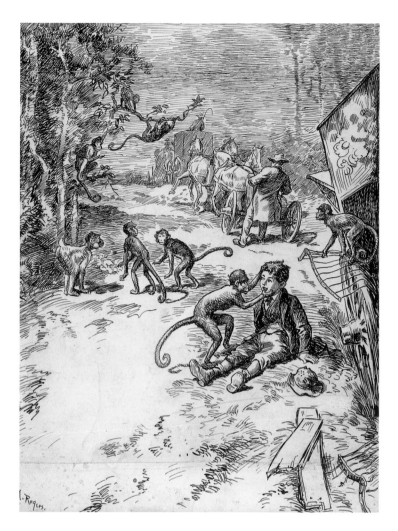

"The Break-Down, and Escape of the Monkeys"
Pen and ink on paper

"… he lay senseless by the side of the road, while the wagon became a perfect wreck, from out of which a small army of monkeys was escaping." This illustration was in chapter 7, "An Accident and Its Consequences," and in the January 25, 1881, issue of *Harper's Young People*.

"The First Lesson"
Pen and ink on paper

First seen in *Harper's Young People* for March 15, 1881, it appeared again in the book's chapter 14, "Mr. Castle Teaches Toby to Ride," to illustrate the phrase "Toby kicked, waved his hands, and floundered about generally, but all to no purpose …"

Comics and Humor

What makes a children's tale comic? Maybe when the stories and pictures are just a bit too silly or a bit too absurd. Certainly the works of Edward Lear are counted among the most beloved of modern light verse. Gelett Burgess, he of the unseen Purple Cow, earned an equally devoted following, especially with his 1901 compilation, *The Burgess Nonsense Book*. And who but the extremely silly Mrs. Peterkin could have caused young readers to guffaw at such goofy antics?

The dividing point for what constitutes a comic book might be the format: a truly sequential graphic story in which the images hold equal presence with words. Grace Drayton's character Dimples was featured in several of the first cartoon-strip styled storybooks, with each scene annotated by the adorable girl's commentary. The works of Fontaine Fox and Walt Kelly, however, are what you would call straight-forward cartoons — and as such, are beloved by generations of readers, even if Kelly's observations often sailed over the heads of his younger fans.

Francis Gilbert Attwood, 1856–1900

"Mrs. Peterkin Puts Salt into Her Coffee"
for *The Peterkin Papers*, by Lucretia P. Hale (Boston: James R. Osgood and Co., 1880)
Pen and ink on paper

The Peterkin Papers was a forerunner of modern American children's nonsense literature. Attwood, the noted cartoonist, provided illustrations for Lucretia P. Hale's collection of twenty-two absurd domestic tales, the first of which were originally published in the juvenile magazine *Our Young Folks*, beginning in April 1868 with "The Lady Who Put Salt in Her Coffee." In this story the family seeks help from a chemist, an "herb-woman," and finally a "wise lady from Philadelphia" who advises Mrs. Peterkin to simply pour another cup. This image served as the frontispiece illustration for the book edition.

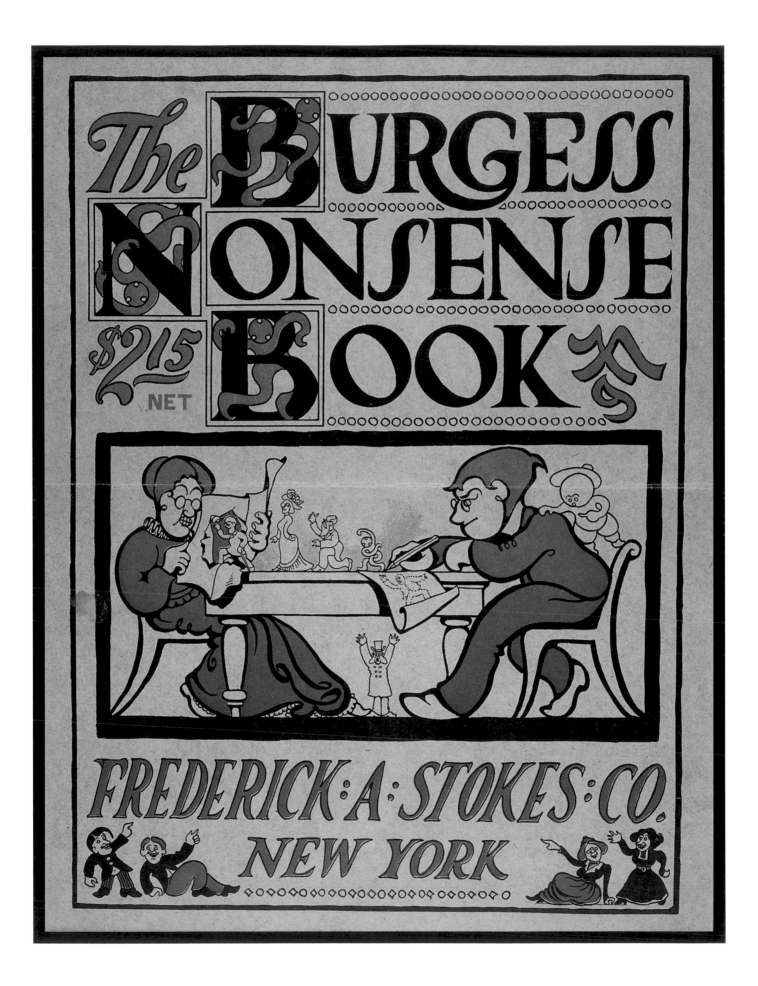

GELETT BURGESS, 1866–1951

The Burgess Nonsense Book
(New York: Frederick A. Stokes Co., 1901)
Color lithograph poster

"Nonsense is the fourth dimension of literature," declares this jesting anthology of "Humorous Masterpieces," including Burgess's oft-quoted nonsense quatrain of the day, "The Purple Cow." The published cover design differs markedly from this study, though the volume's contents remain "Carefully Expurgated of all *Reason, Purpose,* & *Verisimilitude* by a *Corps* of Irresponsible *Idiots*."

GELETT BURGESS, 1866–1951

"Fishing for Mermaids"
for *The Burgess Nonsense Book*
(New York: Frederick A. Stokes Co., 1901)
Pen and ink with watercolor on paper

A black-and-white version of this drawing appears under the category of "Rare Sport and Other Fantasies," which also includes "Trapping Fairies" and "Shooting Witches." This illustration is accompanied by a short rhyming couplet: "Fishing for Mermaids in the Pacific: / Lord! Ain't these Naiad Shapes Terrific?"

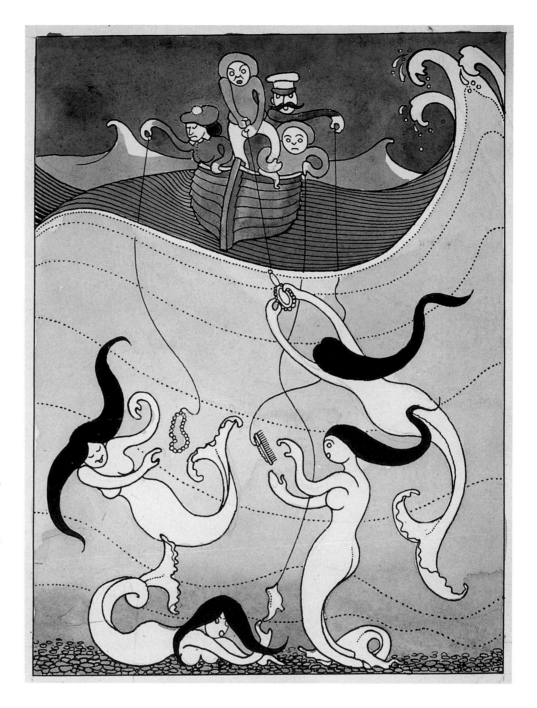

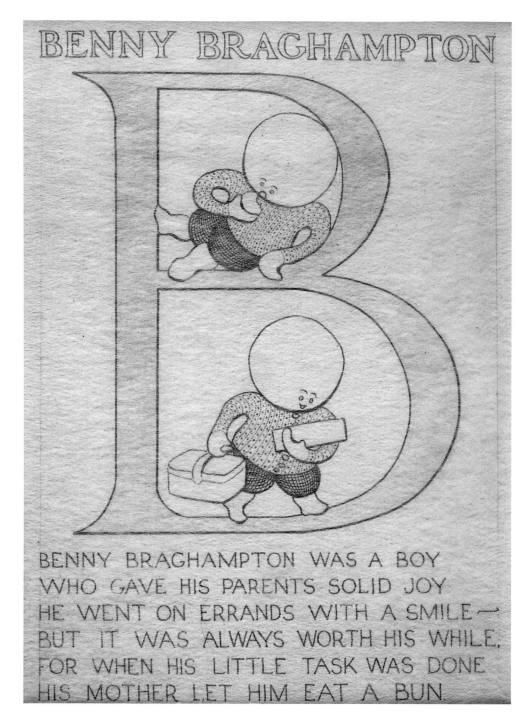

BENNY BRAGHAMPTON WAS A BOY
WHO GAVE HIS PARENTS SOLID JOY
HE WENT ON ERRANDS WITH A SMILE —
BUT IT WAS ALWAYS WORTH HIS WHILE,
FOR WHEN HIS LITTLE TASK WAS DONE
HIS MOTHER LET HIM EAT A BUN.

GELETT BURGESS, 1866–1951

"Benny Braghampton"
for *The Burgess Nonsense Book*
(New York: Frederick A. Stokes Co., 1901)
Pen and ink with watercolor on artist's
board

The Burgess Nonsense Book, his most famous
collection of comic verse, came two years
after the author introduced the Goops in
book form. It appears that "Benny Brag-
hampton" was replaced by a Goop named
"Bohunkus" to illustrate the letter "B" in the
final version of "An Alphabet of Famous
Goops." Burgess introduces it with a bit of
rhyme: "An Alphabet of Famous Goops /
Which you'll Regard with Yells and
Whoops. / Futile Acumen! / For you Your-
selves are Doubtless Dupes / Of Failings
Such as Mar these Groups — / We all are
Human!"

NANCY EKHOLM BURKERT, b. 1933

"The Scroobious Pip from the top of a
tree …"
for *The Scroobious Pip*,
by Edward Lear and Ogden Nash
(New York: Harper & Row, 1968)
Watercolor and ink on paper

Nash completed Lear's unfinished text for
the story-rhyme "The Scroobious Pip,"
which first appeared in Lear's self-illus-
trated *Teapots and Quails, and Other New
Nonsense*, published quite posthumously in
1953. Burkert's illustration accompanies the
verse, which begins: "The Scroobious Pip
from the top of a tree / Saw the distant
Jellybolee — / And all the birds in the
world came there, / Flying in crowds all
through the air." The Pip is a mysterious
gallimaufry of a creature that none of the
animals in the story can identify. Their
refrain, "For as yet we have neither seen
nor heard If you're fish or insect, beast or
bird!" draws the Pip's reply: "Pliffity Flip;
Pliffety Flip; My only name is the
Scroobious Pip."

GRACE GEBBIE DRAYTON,
1877–1936

[Study for Dimples character]
for *Dimples* syndicated cartoon strip, Hearst
Newspaper Feature Service, ca. 1913–1914
Pen and ink with watercolor on board

This image is from a unique scrapbook of
forty-four original drawings used in the
Sunday newspaper strips from 1913–1914,
that depict typical adventures of Dimples,
an adorable little girl who manages to get
into trouble despite her best intentions.

JOSEPH GREENE FRANCIS,
1849–1930

[Commercial scrapbook cover]

Francis' scrapbook of comic sketches of
"cheerful cats and other animals" was
finished in January 1884, and comprises
works from 1879 to 1884. Sixteen pen and
ink drawings are included.

[Scrapbook page with cats], undated
Pen and ink with pencil on paper

Francis's playful felines were the main fea-
ture of his *Book of Cheerful Cats and Other
Animals* (1892). The three smaller illustra-
tions grouped together at the bottom of the
page were also reproduced for "The Three
Little Kittens," a story in verse from Clara
Doty Bates' collection, *On the Tree Top*
(1881).

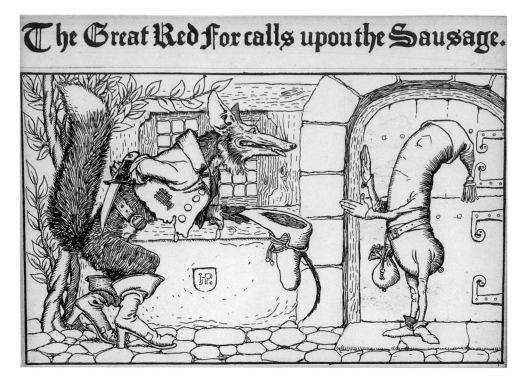

The Great Red Fox calls upon the Sausage.

HOWARD PYLE, 1853–1911

"The Great Red Fox calls upon the Sausage."
for *The Wonder Clock; or, Four and Twenty Marvellous Tales, Being One for Each Hour of the Day*
(New York: Harper & Brothers, 1888)
Pen and ink on board

Howard Pyle's illustrations appeared with verses written by his sister, Katharine Pyle, in self-styled calligraphy. A cautionary tale for those thinking of going into "the big wide world," the narrator confirms at the end: "The way of the world is the way of the world, even in the deep forest." Thus, the Fox eats the Sausage. The illustration first appeared in the periodical *Harper's Young People*, on December 29, 1885.

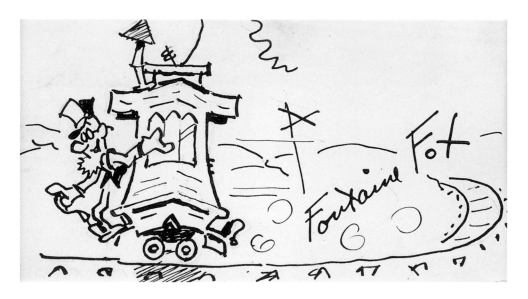

FONTAINE FOX, 1884–1964

["Toonerville Trolley" and the Conductor], undated
Pen and ink with pencil on paper

Fox based his nationally popular syndicated cartoon strip, "Toonerville Folks," begun in 1915, on a comically unreliable Louisville, Kentucky, trolley line and populated it with characters based on people he had known as a boy. Fox eventually replaced the trolley with a gas-powered bus in 1953, reflecting post-World War II America's growing suburban culture and dependence on automobiles. Tradition prevailed, however, when Fox soon reinstated the popular locomotive.

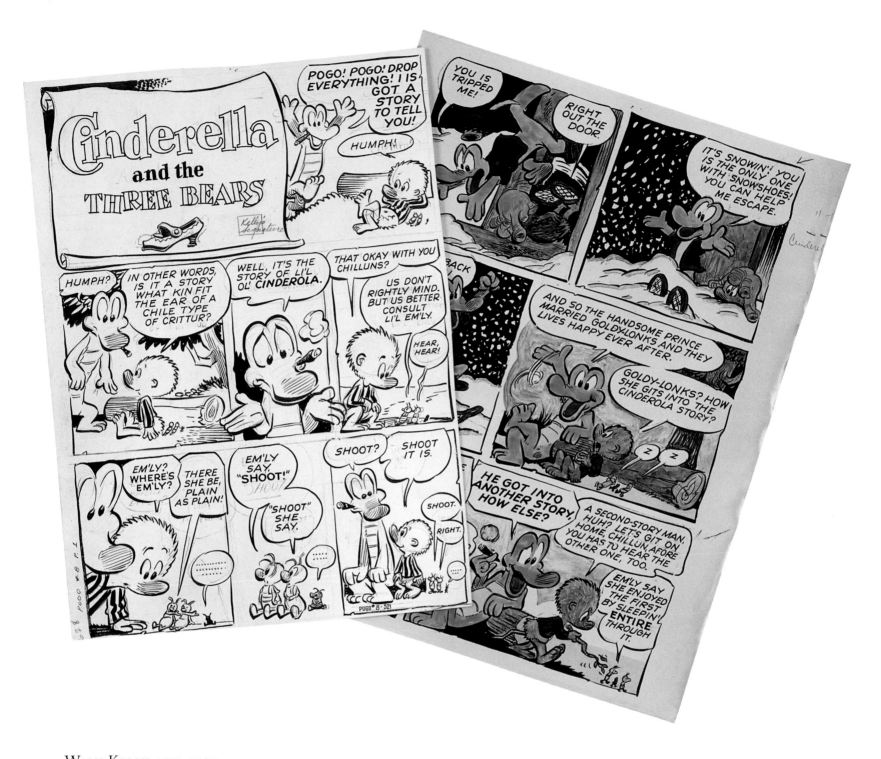

Walt Kelly, 1913–1973

"Cinderella and the Three Bears," 1951
for *Pogo Possum*, no. 8, January–March 1952
Ink and watercolor on board

Pogo first appeared in Kelly's *Animal Comics* (1941–1947), a feature
inspired by the anthropomorphic cast of Joel Chandler Harris's
"Uncle Remus" stories. Set in Okefenokee Swamp, the hilarious
adventures of Pogo and the ravenous alligator Albert, along with a
cast of many other characters, are reminiscent of comical vaudeville
routines.

The Creative Process

The beauty of a great collection of artwork created for books can be seen not only in finished products, but as well in working drafts and sketches. The Shirley collection includes a number of preliminary drawings that show the beginning stages of many well-known books. These materials can be a boon to researchers, who treasure the experience of tracing the changes that occur from conception to publication.

The earliest example shown in this section is Richard André's watercolor for a page for a McLoughlin title, *By Land and Water*. The mock-up for the Petersham's *The Book of Trains* shows only slight variations, but changes are much more evident in *The Castle Number Nine*, one of Ludwig Bemelmans' least-known (but perhaps funniest) books. Helen Sewall's treatment of the lives of saints show how line drawings become illuminated in the final published version while Symeon Shimin's book dummy with original art reflects the passage from cut-and-pasted ideas to a finished, immaculate storybook.

R. ANDRÉ, 1834–1907

Front cover
Printed image from *By Land and Water* (New York: McLoughlin Bros., 1888)

"Lapland: The Rein-deer Sledge"
for *By Land and Water* (New York: McLoughlin Bros., 1888)
Watercolor on board

"Lapland: The Rein-deer Sledge"
Printed image from *By Land and Water* (New York: McLoughlin Bros., 1888)

A comparison on the following pages between the sketch version of a page by Richard André and the final printed version shows changes that incorporated a stronger background, more texture, and fully-toned colors.

By Land

:A Trip Personally Conducted by McLoughlin Bros.

Broadway
New York:

Water:

:Copyrighted 1888

Lapland : The Rein-deer Sledge :

The Laplander tucks himself in a sledge
With plenty of warm robes o'er him,
And over the snow and ice he glides
As he drives the reindeer before him.

: Lapland : The Rein-deer Sledge :

1.

2 color

MAUD FULLER PETERSHAM,
1890–1971, and
MISKA PETERSHAM, 1888–1960

[Title page mock-up]
for *The Story Book of Trains*
(Chicago, Philadelphia, Toronto:
The John C. Winston Co., 1935)
Colored pencil, ink, and gouache on paper

The Petershams worked together on a series
of twenty-four titles in the "Story Book"
series published by John C. Winston in the
1930s, on subjects ranging from food to
ships to rayon. This mock-up of the title
page for *The Story Book of Trains* is part of
the artists' clothbound dummy, replete
with multimedia illustrations and mounted
text on tissue paper.

[Title page]
Printed image from *The Story Book of Trains*
(Chicago, Philadelphia, Toronto:
The John C. Winston Co., 1935)

Minor alterations from the original mock-up are evident in this published version of the title page for *The Story Book of Trains*.

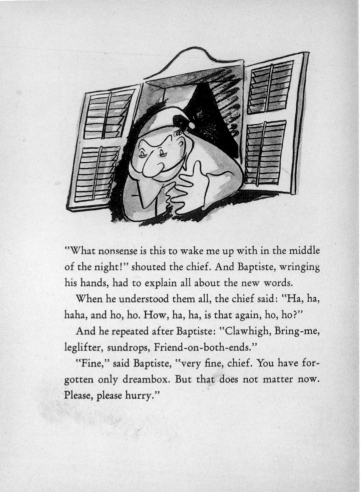

"What nonsense is this to wake me up in the middle of the night!" shouted the chief. And Baptiste, wringing his hands, had to explain all about the new words.

When he understood them all, the chief said: "Ha, ha, haha, and ho, ho. How, ha, ha, is that again, ho, ho?"

And he repeated after Baptiste: "Clawhigh, Bring-me, leglifter, sundrops, Friend-on-both-ends."

"Fine," said Baptiste, "very fine, chief. You have forgotten only dreambox. But that does not matter now. Please, please hurry."

LUDWIG BEMELMANS, 1898–1962

"The fire chief could not see the castle from his window …"
for *The Castle Number Nine* (New York: The Viking Press, 1937)
Pencil and wash on paper with text

"What nonsense is this to wake me up in the middle of the night!"
Printed image from *The Castle Number Nine*
(New York: The Viking Press, 1937)

Bemelmans' story of the good and finely liveried servant Baptiste is set in Tyrol, the author's native region. The book was originally going to be titled "The Castle Number One." In one of the studies, the fire chief is roused from sleep by Baptiste, who has come to report a blaze at the Castle Number Nine. The absurd jargon imposed by Count Hungerburg-Hungerburg makes a farce out of Baptiste's plea. Another is a close-up of the king's fingers. The published versions of the two drawings show significant changes to the images and to their accompanying texts.

When he understood them all , the chief said -

Ha ha haha and ho ho -

 how , ha ha , is that again , ho ho ?

and he repeated after ?abtiste ,

 Clawhigh , , Bringme , Leg lifter , Sundrops ,

Friend on both ends ,

 Fine said Baptista , very fine Chief , you have

only forgotten Dreambox , but that does not

matter now , please , please hurry .

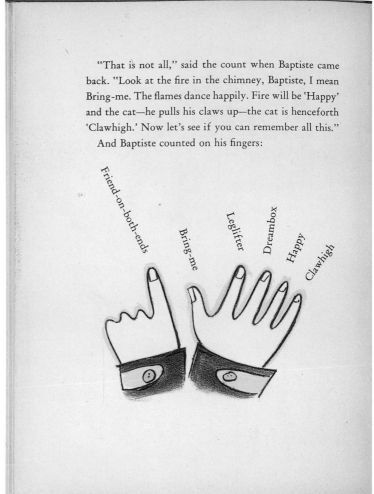

"That is not all," said the count when Baptiste came back. "Look at the fire in the chimney, Baptiste, I mean Bring-me. The flames dance happily. Fire will be 'Happy' and the cat—he pulls his claws up—the cat is henceforth 'Clawhigh.' Now let's see if you can remember all this."
And Baptiste counted on his fingers:

"When he understood them all …"
for *The Castle Number Nine* (New York: The Viking Press, 1937)
Pencil and wash on paper with text

"And Baptiste counted on his fingers …"
Printed image from *The Castle Number Nine*
(New York: The Viking Press, 1937)

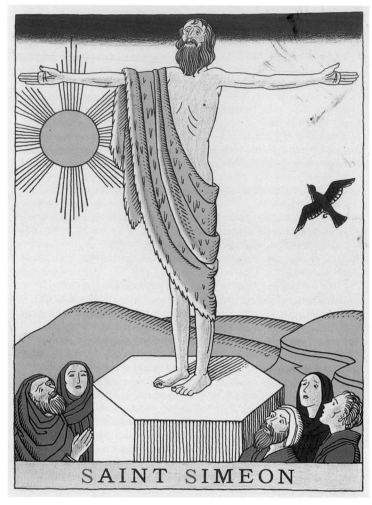

SAINT SIMEON

HELEN SEWELL, 1896–1957

"Saint Simeon"
for *Ten Saints*, by Eleanor Farjeon
(London: Oxford University Press, 1936)
Pen and ink

"Saint Simeon"
Printed image from *Ten Saints*, by Eleanor Farjeon
(London: Oxford University Press, 1936)

British writer Farjeon's chronicle of ten Christian saints was issued in Protestant and Catholic editions. Sewell's cleanly delineated illustrations present key scenes in tableaux. These studies depict Saint Simeon atop the pillar to which he confined himself for thirty years in the fifth century.

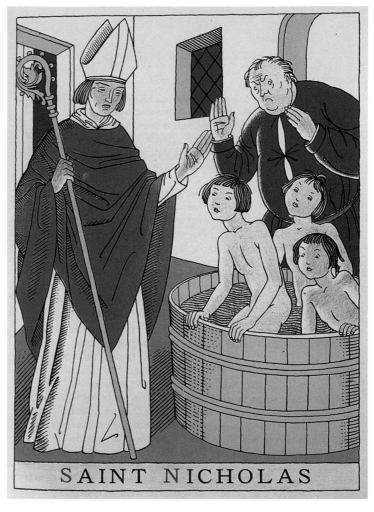

"Saint Nicholas"
For *Ten Saints*, by Eleanor Farjeon
(London: Oxford University Press, 1936)
Pen and ink

"Saint Nicholas"
Printed image from *Ten Saints*, by Eleanor Farjeon
(London: Oxford University Press, 1936)

Nicholas, the patron saint of children and sailors, is shown here "arrayed in his mitre and robes" while he saves three boys from being pickled by an innkeeper.

SYMEON SHIMIN, 1902–1984

[Artist's dummy for title page]
watercolor for *Dance in the Desert*,
by Madeleine L'Engle
(New York: Farrar, Straus & Giroux, 1969)

"At the crest of a dune stood a magnificent
lion …"
for *Dance in the Desert*,
by Madeleine L'Engle
(New York: Farrar, Straus & Giroux, 1969)
pencil on paper, with printed text pasted on

Dance in the Desert was the first book Shimin
illustrated in full color. His evocative illus-
trations strike a balance between light and
dark that mirrors L'Engle's parable of a

Christ-like child in peaceful yet rapturous communion with a host of creatures, both real and fantastic. These two scenes, shown in their mock-up stage and in the final printed versions demonstrate how some images grow directly on the page.

[Title page]
Printed image from *Dance in the Desert*,
by Madeleine L'Engle
(New York: Farrar, Straus & Giroux, 1969)

"At the crest of a dune stood a magnificent lion …"
Printed image from *Dance in the Desert*,
by Madeleine L'Engle
(New York: Farrar, Straus & Giroux, 1969)

Picturing America . . .
and Historical Subjects

Betsy Shirley's collection was intended, from the start, to encompass the experience of the child reader in the United States. While she ventured outside American borders to add a few favorite titles, she remained true to her goal of amassing a research collection that recorded how American children were entertained and educated. This section shows a number of gems detailing life in the United States — while drifting over to some broader historical themes.

The colonial era comes to life in a somber scene from Andrew Wyeth, paired with a much more tongue-in-cheek vision from the pen of Peter Newell. Two lithographed items from the mid-nineteenth century demonstrate a growing passion for recording history: a chart of American presidents and an ornate genealogical tree.

Memorable historical incidents were captured by the likes of Gustaf Tenggren, E. Boyd Smith, and James Henry Daugherty. Walter Crane's personal take on waiterly customs serves as a much less serious view of culture and E. B. Lewis's treatment of an American rite of passage — the first day of school — reminds us of the everyday events that make up our communal history.

The Shirley collection includes a significant group of materials documenting Native American history in the form of original documents, printed works, or artworks. Three images here represent two modes of display — the first is an artist's view of Indian life, while the remaining pair is of drawings done by young Indian children showing personal views of reservation living.

The detailed sketches of the child Asaph Young expand the view of history pictures to include biblical themes, as do Amos Doolittle's engravings illustrating the story of the prodigal son. Finally, two saints, Joan of Arc and Francis of Assisi, appear in modern treatments by two of the most skilled artists who created for young readers, Howard Pyle and Louis-Maurice Boutet de Monvel.

CAROLINE HAYDEN

"A Map of the United States of America"
Bath, England, 1820
Ink and watercolor on paper

This hand-drawn work, most likely a schoolgirl exercise, shows the minute detailing of the young artist who created the map.

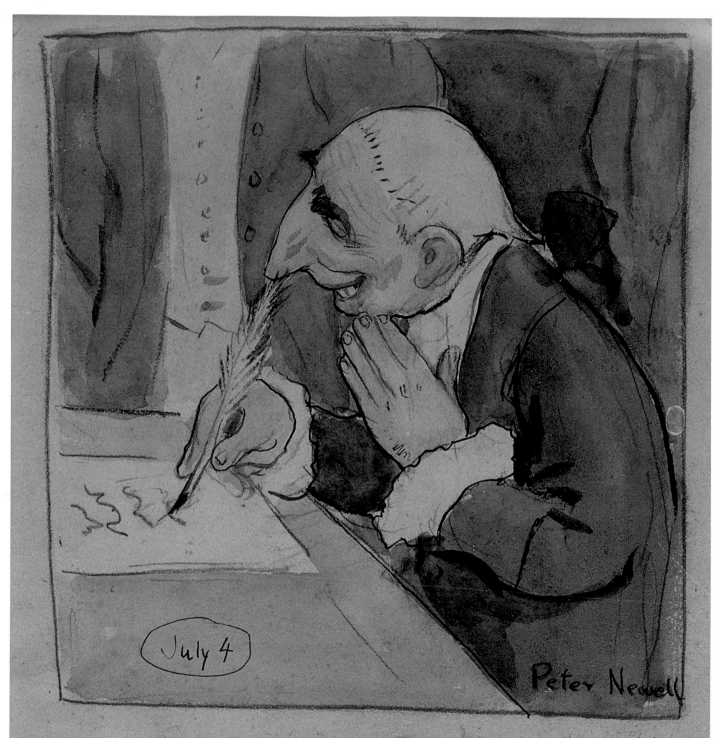

July 4

Peter Newell

Signing the Declaration of Indipendence with Apparent Levity

He broadly smiles as from his nib the ink, it glibly flows.
Because, forsooth, his frowsy pen, it tickles – heh! – his nose.

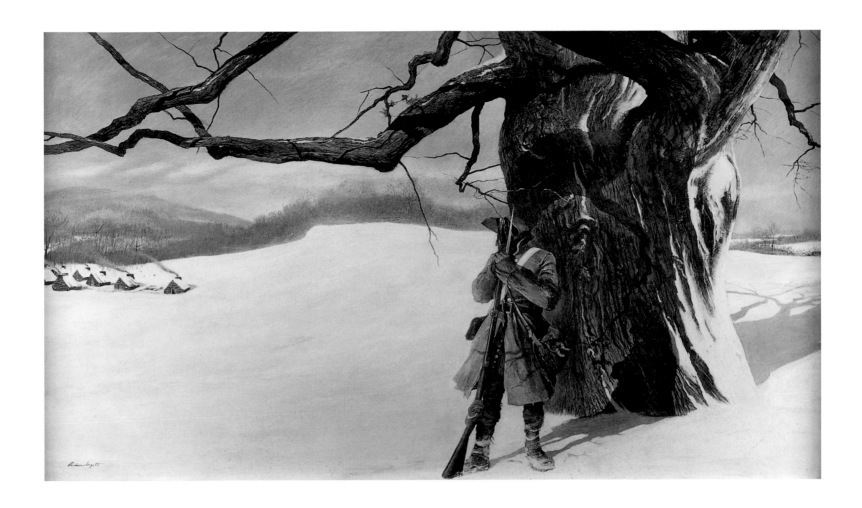

PETER NEWELL, 1862–1924

"Signing the Declaration of Indipendence [*sic*] with Apparent Levity"
Pencil, ink, and watercolor on paper

This image, dated "July 4," was likely never published, though Newell may have intended it for the July 1894 issue of *Harper's New Monthly Magazine*. Another cartoon by the artist, "An Incident of the War of Independence," appeared in the "Editor's Drawer" for that month. Newell's irrepress-ible iambs accompany this study nonethe-less: "He broadly smiles as from his nib the ink, it glibly flows. / Because, forsooth, his frowsy pen, it tickles—eh!—his nose."

ANDREW WYETH, b. 1917

"The Sentry, Valley Forge, 1777"
for *Hearst's International Combined with Cosmopolitan*, February 1950
Tempera painting on canvas

This painting, made for *Cosmopolitan* during its incarnation as a widely-read compendium of fiction and essays, shows Wyeth's signa-ture scene-setting, applied to a historical vignette that illustrated the article "What Freedom Means to Me" by Carlos P. Rumolo.

GENEALOGICAL TREE.

TO TRACE AND PRESERVE A FAMILY HISTORY FOR FIVE OR MORE GENERATIONS.

GEORGE G. HEIFS

"Genealogical Tree to Trace and Preserve a Family History for Five or More Generations"
Designed by Rev. Edwin M. Long, drawn and lithographed by George Heifs
Philadelphia: A. R. Swartz, Daughaday & Becker, [1869]

A popular type of nineteenth-century broadsheet was the genealogical tree. This blank example has room to fill in the names of several generations of ancestors.

UNIDENTIFIED ARTIST

"Presidents of the United States"
New York: H. Phelps, 1846
Lithograph with hand-colored decorative borders

This instructional print, intended for either classroom or private use, was the type of nineteenth-century broadside meant to instruct and entertain. (Though having only eleven names to memorize made the learning part much simpler!)

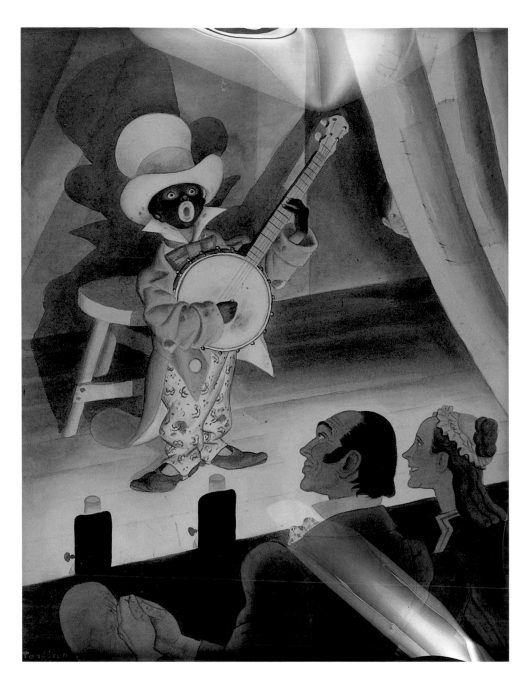

GUSTAF TENGGREN, 1896–1970

"My Old Kentucky Home"
for *Sing for America*, by Opal Wheeler
(New York: E. P. Dutton & Co., 1944)
Pencil and watercolor on board

This illustration of a young minstrel in blackface is one of many Tenggren created for Wheeler's collection of scored national folk songs and spirituals. *Sing for America* followed on the success of *Sing for Christmas*, a round of Christmas carols published by the author and illustrator team the previous year.

MAXFIELD PARRISH, 1870–1966

"The Blacksmith," July 1899
for *A History of New York from the Beginning of the World to the End of the Dutch Dynasty, by Diedrich Knickerbocker*,
by Washington Irving
(New York: R. H. Russell, 1900).
Stippled ink on paper

Irving's comic rendering of New York abounds with Dutch caricatures from traditions of New Amsterdam. This illustration from chapter 7 shows a blacksmith who, along with the cobblers and tailors, began to grown restive with the government: "blacksmiths suffered their fires to go out, while they stirred up the fires of faction."

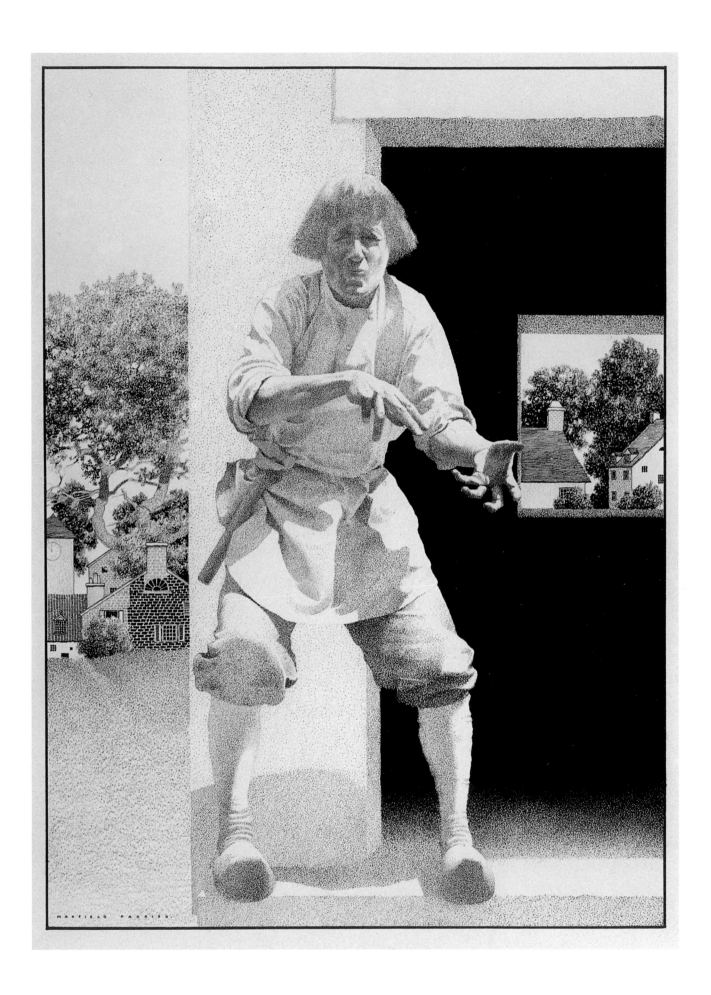

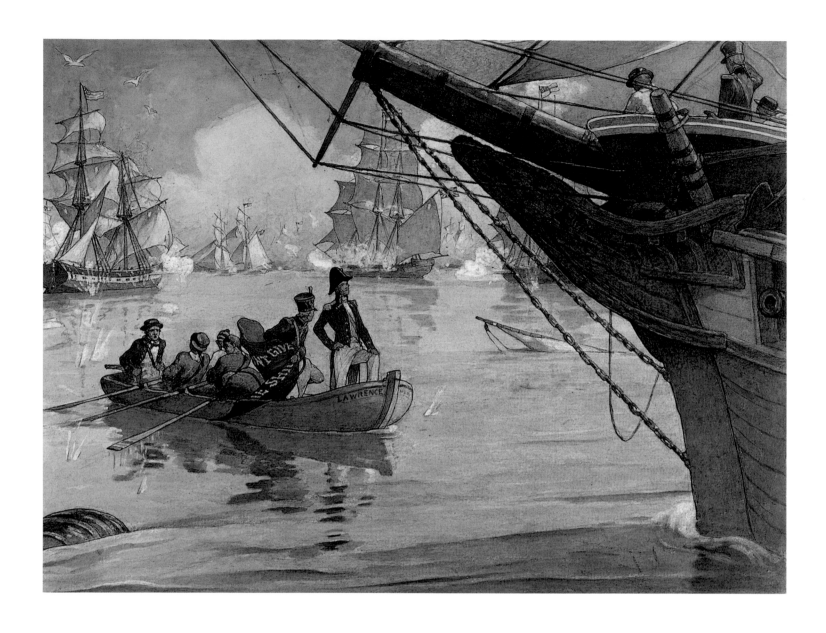

E. Boyd Smith, 1860–1943

"The Battle of Lake Erie"
for *The Story of Our Country*
(New York and London: G. P. Putnam's Sons, 1920)
Watercolor and ink drawing

After They Came Out of the Ark and *The Story of Our Country* became
Smith's best-known works and followed other popular historical
works for children.

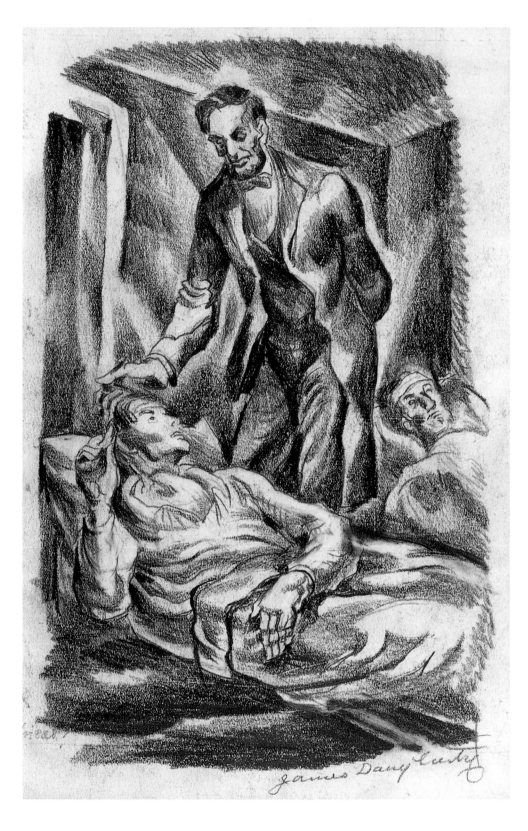

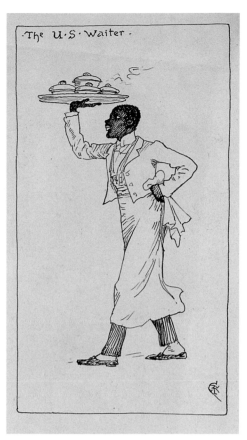

JAMES HENRY DAUGHERTY,
1889–1974

"Abraham Lincoln Comforting the Wounded
at Gettysburg"
for *Abraham Lincoln*

(New York: Viking Press, 1943)
Pencil and charcoal

Daugherty's illustrations were reproduced as
two-color lithographs for the book. This
illustration is part of a section called "Father

Abraham," in which Lincoln's frequent visits
to the Soldiers' Home are described: "… he
would walk bareheaded down the long aisles
between the cots, stopping to talk, to listen
to a heroic story, or to hold the hand of a
dying man."

WALTER CRANE, 1845–1915

"The U.S. Waiter," ca. 1891
Pen and ink on paper

Crane came to the United States in 1891 to
lecture while touring with an exhibition of
his oil and watercolor paintings in Boston,
Chicago, and St. Louis. The following
year he illustrated *Columbia's Courtship:
a Picture History of the United States in
Twelve Emblematic Designs in Color with
Accompanying Verses*. Though this drawing
does not appear in the book, it was probably
a study composed by Crane while he sur-
veyed this side of the Atlantic.

E. B. LEWIS, b. 1956

[Mama Pearl and Cliff]
for *Little Cliff's First Day of School*, by Clifton L. Taulbert
(New York: Penguin, 2001)
Watercolor on paper

"She reached down and gave little Cliff a big, big hug …" captions
this scene from a tale about one of childhood's defining moments.

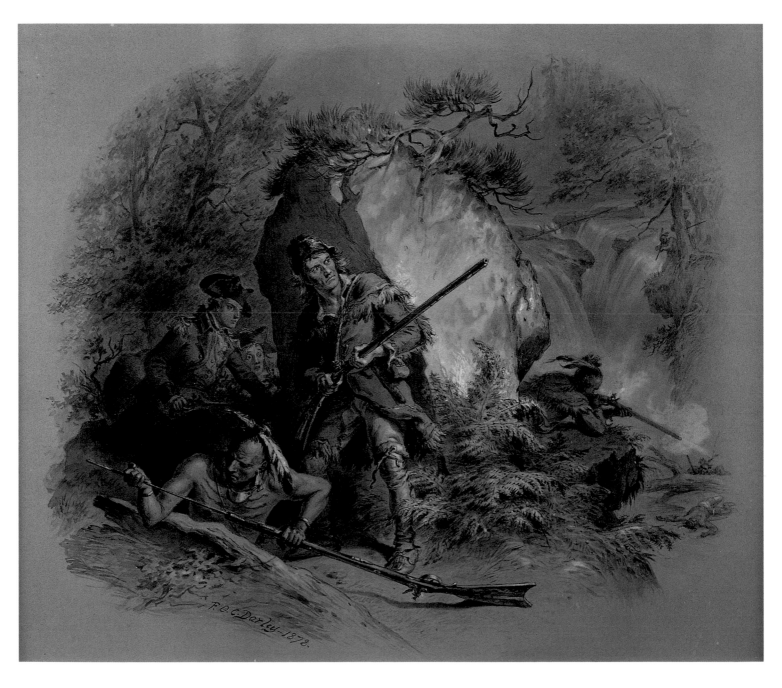

Students of the Toadlena Boarding School

[Cowboy on horse]
Watercolor on paper, ca. 1930

[Hogan]
Watercolor on paper, ca. 1930

These drawings appear in a wood-covered volume compiling images of everyday life in the community of Toadlena, part of the Navajo Reservation in northwestern New Mexico. Though the artist of the first image is unidentified, the picture of the hogan is signed Betty H. Nezbegay.

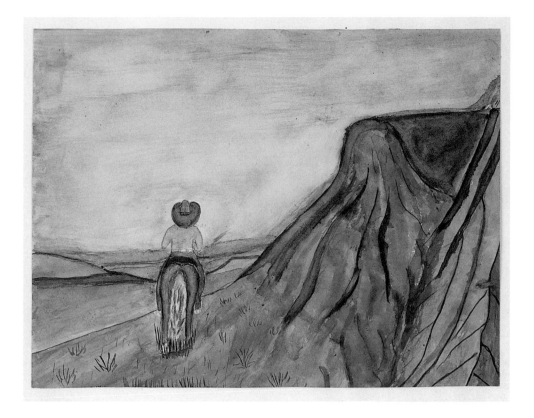

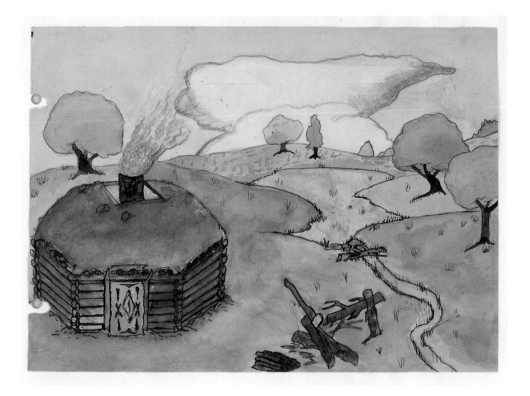

Opposite:

Felix Octavius Carr Darley, 1822–1888

[Two Indians, scout and officer], 1878
India ink on board

This action scene depicting two Indians with long rifles, a buckskin-clad scout, and a young uniformed officer against a background of yet more Indians and a waterfall, may have been an illustration for a book relating to the French and Indian War. Darley's attribution of the year 1878 may be apocryphal, as he often signed and dated his work long after it was finished.

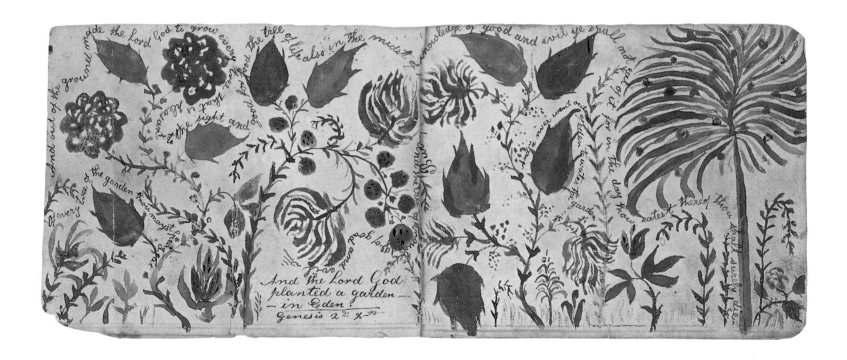

ASAPH YOUNG

"A window shalt thou make to the ark …"
Watercolor on paper, 1826

"And the Lord God planted a garden in Eden …"
Watercolor on paper, 1826

Asaph Young's precociously detailed drawings provide their own narration.

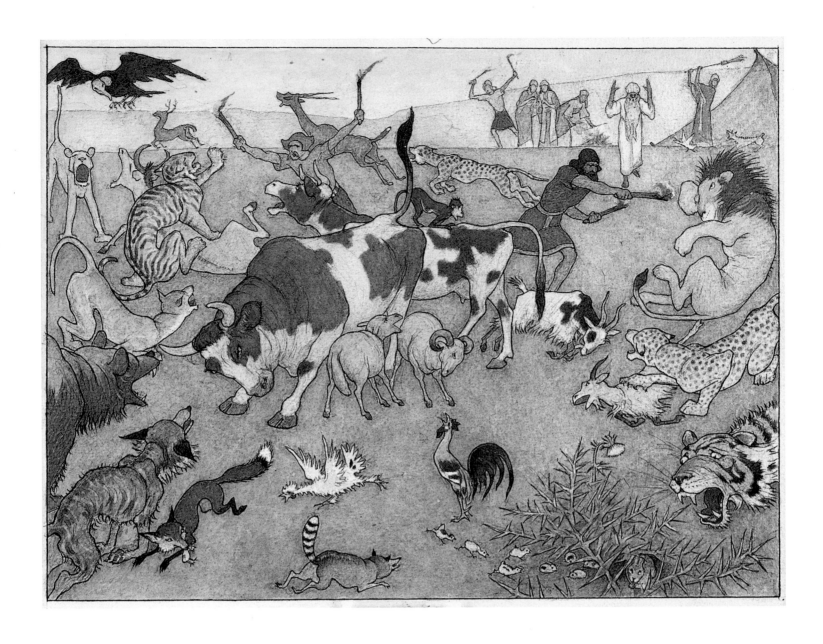

E. BOYD SMITH, 1860–1943

"Trouble"
for *After They Came Out of the Ark*
(New York: G. P. Putnam's Sons, 1918)
Watercolor with gouache highlights over pencil on paper

This scene, from Smith's book that continues the story of Noah's Ark, shows the imagined fracas that results when the animals are set free.

The PRODIGAL SON revelling with HARLOTS

He wasted his Substance with Riotous Living.

S.t Luke. 15 .Chap. 13. v.

Published and Sold by Shelton & Kensett, Cheshire, Con. October 24. 1814.

"The Prodigal Son Revelling with Harlots."
Published and sold by Shelton & Kensett, Cheshire, Connecticut, October 24, 1814
Hand-colored engraving

This is one of four engravings Doolittle reproduced from prints published in 1799 by Haines & Son, London. They follow the course of the prodigal son as he receives his patrimony, associates with harlots, undergoes misery and finally returns, repentant, to his father. The caption to this print is from Luke 15:13: "He wasted his Substance with Riotous Living." Though Doolittle was mostly true to the originals, he did make a minor but significant change in this one. In the background, the painting on the left was changed from a reclining nude woman to a cupid-like cherub.

AMOS DOOLITTLE, 1754–1832

"The Prodigal Son in Misery"
Published and sold by Shelton & Kensett,
Cheshire, Connecticut, October 24, 1814
Hand-colored engraving

The famous parable of the Prodigal Son,
from the Gospel of Luke, emphasizes
God's forgiveness and the importance of
responsibility. Doolittle's reproduction
shows the self-indulgent younger son of a
wealthy landowner after he has wasted his
inheritance and has been hired to tend
pigs: "He would fain have filled his Belly
with the husks that the swine did eat"
(Luke 15:16).

The PRODIGAL SON in MISERY.
St Luke 15 Chap. 16. V.
He would fain have filled his Belly with the husks that the swine did eat.
Published and Sold by Shelton & Kensett, Cheshire Con. October 24. 1814

Drawn by M. Boutet de Monvel. Half-tone plate engraved
by R. C. Collins

FRANCIS BERNARDONE, AS A CHILD, WALK-
ING WITH HIS PARENTS IN THE
NEIGHBORHOOD OF ASSISI

LOUIS-MAURICE BOUTET DE MONVEL, 1851–1913

"Francis Bernardone, as a child, walking with his parents in the neighborhood of Assisi"
for *Everybody's St. Francis*,
by Maurice Francis Egan
(New York: The Century Co., 1912)
Engraving on half-tone plate

In his lifetime, Boutet de Monvel's superb depictions of children drew comparisons to the English illustrator Kate Greenaway. A cropped version of this illustration of the young St. Francis was used for the critically acclaimed juvenile biography by author and diplomat Egan. It was later reproduced in full for Louisa Meigs Green's *Brother of the Birds: A Little History of Saint Francis of Assisi* (1929). The nineteen "St. Francis" illustrations — the last of Boutet de Monvel's career — reprise the spiritual subject matter of the artist's widely acknowledged masterpiece, his children's biography *Jeanne d'Arc* (1895).

HOWARD PYLE, 1853–1911

"The triumphal entry in Rheims"
for *Saint Joan of Arc,* by Mark Twain
(New York: Harper and Brothers, 1919)
Oil on canvas

Pyle's illustrations for Twain's essay on the legendary French martyr first appeared alongside the text in the December 1904 issue of *Harper's Monthly Magazine* magazine. Twain had a lifelong intellectual obsession with Joan of Arc, calling her "the most extraordinary person the human race has ever produced." *Saint Joan of Arc* was preceded by Twain's critically panned novel, *Personal Recollections of Joan of Arc,* from 1896 (which he published under the pseudonym Sieur Louis de Conte). Pyle died in 1911, making the 1919 edition of *Saint Joan of Arc* one of the last books to feature his original illustrations.

Magazines and Rhymes

The Victorian vogue for magazines detailing the ways and means towards civilized living was not limited to adults. Children's periodicals began to appear in increasing numbers towards the end of the nineteenth century, as monthly printed installments filled with stories of adventure and humor, puzzles, jokes, and activities. Perhaps the most widely distributed of these magazines was *St. Nicholas*, a Scribner's publication that ran from 1873 to 1943, along the way incorporating many of its competitors, including *Wide Awake* and *The Little Corporal*. Another successful title, *Harper's Young People,* had a wide readership, but didn't last nearly as long as its rival.

Many famous authors worked on the pages of *St. Nicholas* which was edited for many years by Mary Mapes Dodge, author of the beloved tale of Hans Brinker. The stock-in-trade of *St. Nicholas*, aside from serialized stories, were limericks, games and poems; Christina Rossetti's *Alphabet from England* was matched with illustrations by Henry Louis Stephens. Having left behind the earlier nineteenth century mode of moral tales associated with children's magazines, *St. Nicholas* was free to explore the sillier side of childhood with such rhymes as John Ames Mitchell's "Uncle Jehosaphat" and Walter Bobbett's "The Little old Man of Dyre".

Other items present in Mrs. Shirley's collection related to magazines are original artworks for puzzles, such as the Pictorial Anagram Puzzle from the April 1878 issue of *St. Nicholas*. "The Ballad of the Oysterman" was intended for an in-home "Shadow-Pantomime" and Livingston Hopkins' drawings for "The Sylvan Party" by Alice H. Harrington sum up perfectly the playful mood of *St. Nicholas* and other magazines of its style.

THEO HAMPE

"The Midsummer Number" *St. Nicholas,* August 1896
Color lithograph poster (printed by G. H. Buek and Co., New York)

It is likely that this much sought-after poster — the only one Hampe is known to have produced — was also the artist's honorable mention-winning entry to a design contest sponsored by the Century Company.

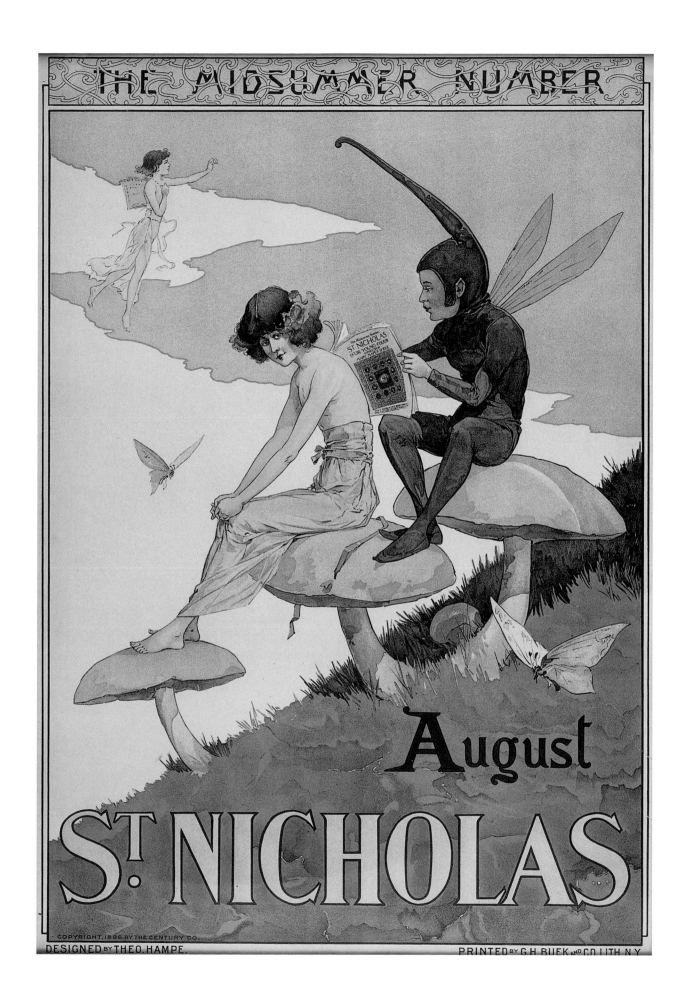

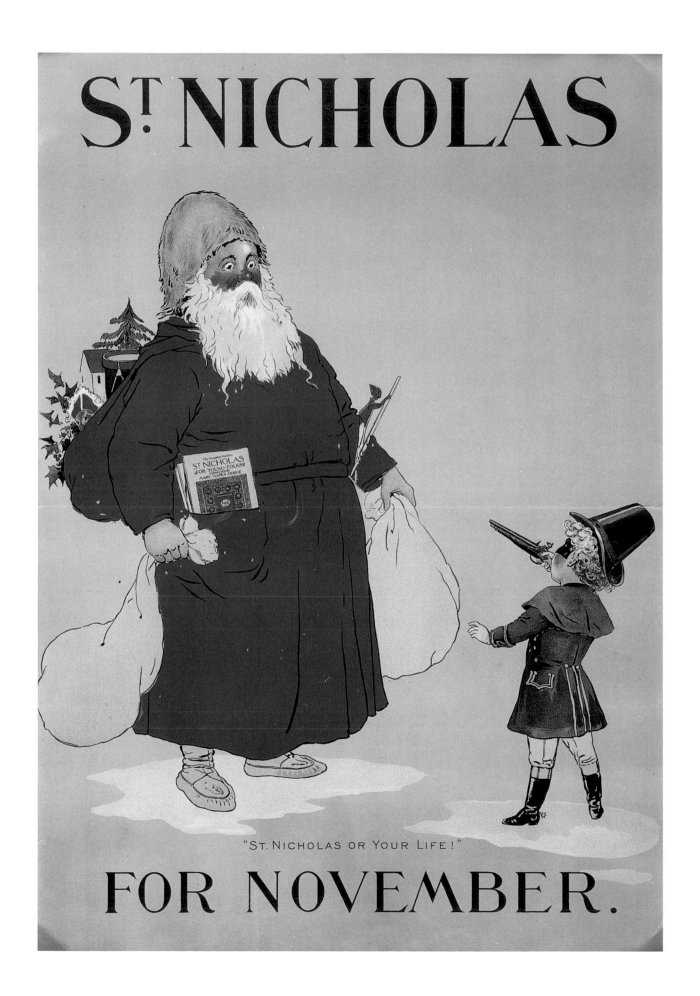

"The Leading Paper for Juvenile Readers"

HARPER'S YOUNG PEOPLE
SUBSCRIPTIONS RECEIVED HERE

UNIDENTIFIED ARTIST

"St. Nicholas or Your Life," undated
Color lithograph poster (printed by G. H. Buek and Co., New York)

The issues of *St. Nicholas* in Santa's pocket most likely date from before November 1878, when the magazine's format was changed.

UNIDENTIFIED ARTIST

Harper's Young People, undated
Color lithograph poster

This advertisement for one of the most popular juvenile periodicals of the nineteenth century shows a gang of young boys sharing a laugh.

H. L. STEPHENS, 1824–1882

[Boys marching with a military band]
for "An Alphabet From England,"
by Christina G. Rossetti, in *St. Nicholas*,
November 1875
Pen and ink on board

Stephens, a well-known nineteenth century
caricaturist, created this drawing to accompany twenty-six alliterative couplets written
by Rossetti intended to inculcate each letter
of the alphabet to young readers: "A is the
Alphabet, A at its head; / A is an Antelope,
agile to run …"

JOHN AMES MITCHELL, 1845–1918

"Uncle Jehosaphat"
for *St. Nicholas*, January 1876
Pen and ink on paper

"And they both rode to town on the
brindled calf, / To carry it home to its
mother." Mitchell's spirited drawing
illustrates a short comical poem.

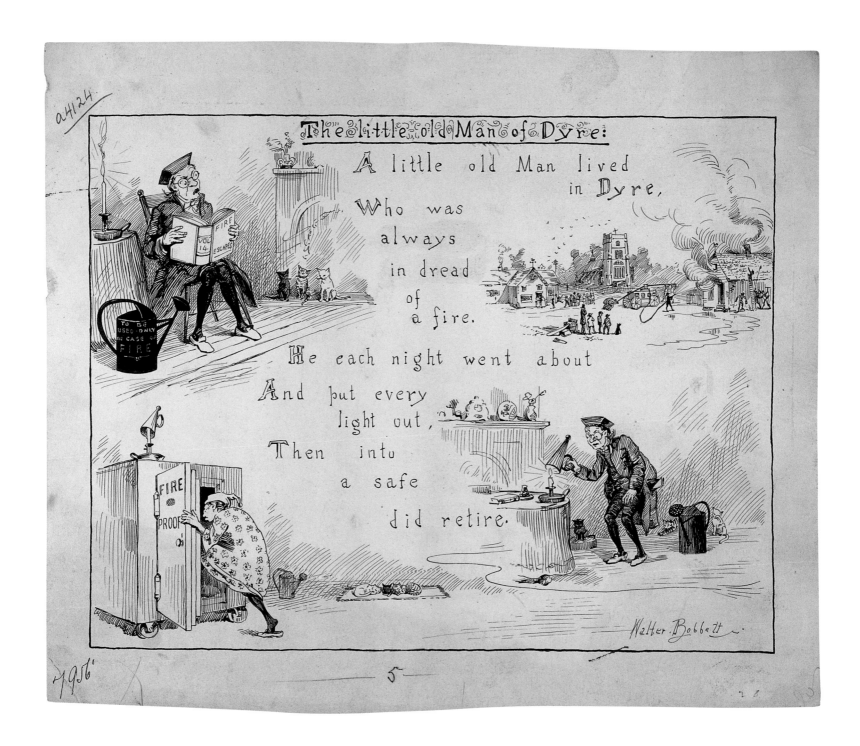

Walter Bobbett

"The little old Man of Dyre"
for *St. Nicholas*, December 1884
Pen and ink on board

A simple limerick could tickle readers young and old.

H. S. STALKNECHT

"Pictorial Anagram Puzzle"
for *St. Nicholas*, April 1878
Pen and ink on board

"From the letters of the word which describes the central picture
['frigates'], form words describing the remaining ten pictures [stag,
gate, rats, fist, etc.]." This puzzle appeared in "The Riddle-Box"
section of the magazine.

UNIDENTIFIED ARTIST

[Rebus], undated
for *St. Nicholas* [unidentified issue]
Colored pencil on paper

This complicated story-rebus, which presented a challenge to its
original nineteenth-century audience, will surely continue to con-
fuse present day readers!

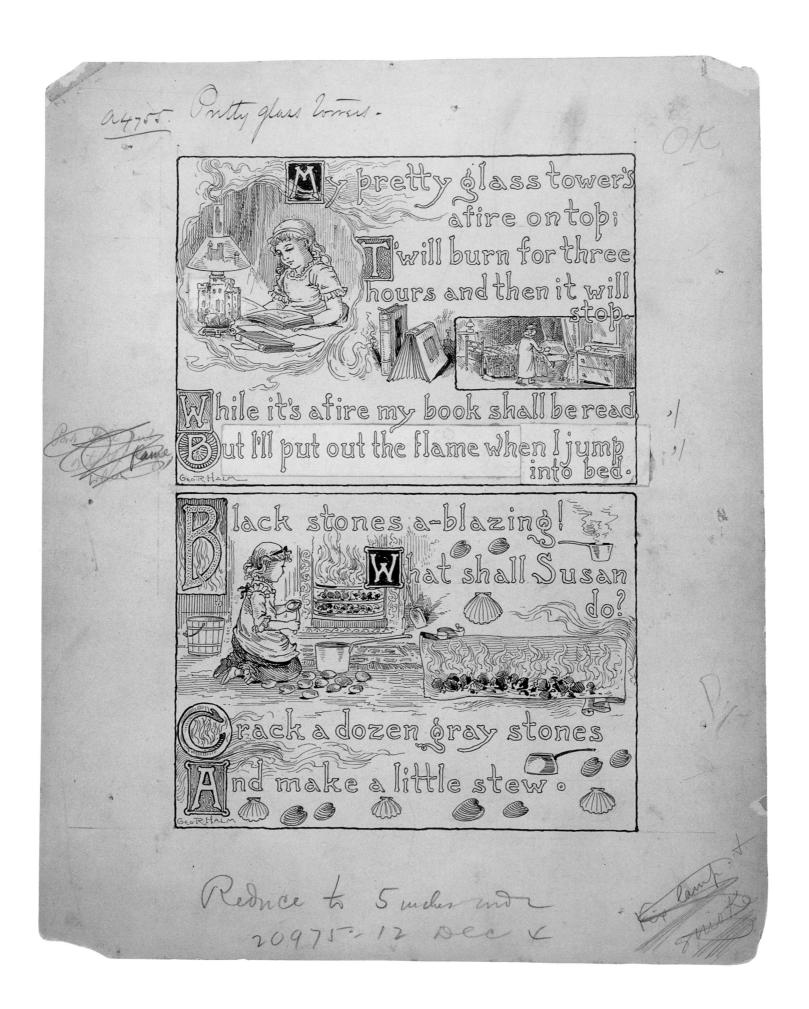

Alas for those true lovers twain; she waked not from her swound,
And he was taken with the cramp, and in the stream was drowned,
But Fate has metamorphosed them in pity of their woe,
And now they keep an oyster-shop for mermaids down below.
(Chorus) With a Rook-chee-took-wheetook-chee-took-chee, Whack! fol-lol-diddle-lol-lay-day.
The End.

GEORGE R. HALM, 1850–1899

"Pretty glass tower's"
for *St. Nicholas*, February 1886
Pen and ink on board with lettered verse

Halm's drawings appeared in the "Answered Riddle Jingles" section of *St. Nicholas*. The artist's and printer's notations are in pencil.

H. H. BIRNEY

"XIV" [End Scene] for "The Ballad of the Oysterman"
by Oliver Wendell Holmes, in *St. Nicholas*, August 1888
Ink on paper

This image was featured as the last in a series of "Shadow-Pantomimes" adapted to the Holmes poem. Children were instructed to act behind a screen, in front of a lantern or candle, so that they could approximate the Birney images and cast their own "distinct, characteristic shadows."

One moonlight night in balmy June,
The animals, forsaking
Their various haunts in wood and field,
Met for a merry-making

The frogs with trombones and bassoons
Came trooping from the sedges;
The whip-poor-will and nightingale
Brought cornets from the hedges

The night-hawks came with fifes and drums,
And swelled the cheerful clatter;
The lizard peeped from out his den
To see what was the matter.

The band struck up a lively tune,
The dancers took their places;
The solemn crow led out the mink,
Who aired her youthful graces.

The simpering squirrel swung the toad,
And looked so very winning.
The 'coon and woodchuck joined their paws,
And in a waltz went spinning.

The 'possum danced a Highland fling,
The fun grew fast and furious;
The rabbit cut a pigeon wing

That really was quite curious.
The fox and owl beneath a tree
Of art and science twaddled;
While up and down the promenade
The goose and cattle waddled.

The bull-frog sang a bass solo,
Although his cold was frightful;
The weasel who stood by entranced
Pronounced the song delightful.

At last the sun began to rise,
And Brindle homeward wended
Her way right through the festive scene,
And so the party ended.

6 Illus.

ALICE HARRINGTON

Manuscript of "The Sylvan Party"
For *St. Nicholas*, July 1879
Pencil on paper

Harrington's fanciful poem of a woodland idyll is reproduced here
in Hopkins' hand. It was published in *St. Nicholas*, accompanied by
six of the artist's illustrations, two of which are shown here at top
of the facing page.

LIVINGSTON HOPKINS, 1846–1927

"The simpering squirrel swung the toad"
"The 'coon and woodchuck joined their
paws, / And in a waltz went spinning"
"The fox and owl, beneath a tree"
for "The Sylvan Party,"
by Alice H. Harrington, in *St. Nicholas*,
July 1879
Pen and ink on paper.

Hopkins made seven illustrations for this
versified tale, six of which were published
to illustrate the "merry-making" of several
woodland animals "one moonlit night in
balmy June." The image of the raccoon and
the woodchuck was omitted from the final
publication.

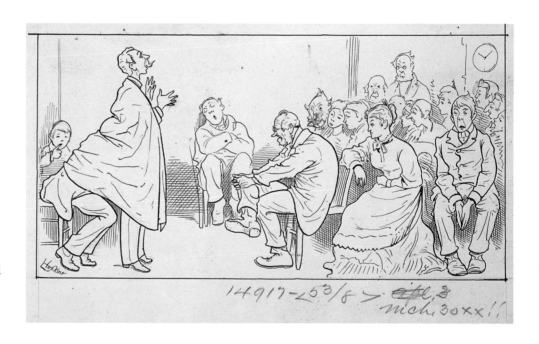

LIVINGSTON HOPKINS, 1846–1927

"I Did My Prettiest to Declaim."
for "Dumb Orator,"
by Christopher Pearse Cranch,
in *St. Nicholas*, July 1877
Pen and ink on paper

Hopkins, who later made his name as a
humorist for the Sydney *Bulletin*, here
illustrates a poem by Cranch, a regular
contributor to *St. Nicholas* in the 1870s and
1880s. Cranch's verses satirize the prim, the

stiff, and the humorless: "So when you
joke, there will be folks / Suspect the craft
you sail in. / They *will* not feel the point,
although / You drive it like a nail in."

Beatrix Potter, 1866–1943

"A Happy Christmas to You"
for *A Happy Pair* (London: Hildesheimer & Faulkner, 1890)
Pencil and watercolor on yellow-toned tissue paper

This very early sketch by Potter appeared in a gift book, accompanying poems by Frederic E. Weatherly. Likely published as a Christmas keepsake, and today exceedingly rare, the book is one of only a few collaborations undertaken by Potter. This image was made three years before Peter Rabbit first came to life, and presages Potter's delicacy and humor with animal characters.

Christmas-Time

Any children's bookcase must have a special section reserved for holiday favorites — and it seems that the most celebrated holiday in the Betsy Shirley collection is Christmas. As a collector, she tried, with great success, to find books and artworks that documented the stories, songs, and visions of that special day that comes but once a year. It's no surprise to find images of both the Brownies and the Goops preparing for the holiday — along with Eloise, who is on her best behavior.

One of Beatrix Potter's earliest known artworks is a true gem in the collection, made for a holiday greeting book early in her career. George Cruikshank's view of revelry is, however, from the point of the artist as wizened observer. Thomas Nast and Hendrik Van Loon's pictures show their unique takes on Christmas, while Chris Van Allsburg's image created for *The Polar Express* is perhaps the most haunting.

Two suites of drawings show different takes on the story of Santa Claus. Everett Shinn's illustrations were made for his version of the evergreen poem, "The Night Before Christmas." Richard André's original tale intends to expand the reader's imagination and explain exactly the home life of the jolly old man when he isn't piloting his sleigh full of presents.

GELETT BURGESS, 1866–1951

[Unpublished Christmas design of "Goops"], 1904
Pen and ink with watercolor on board

In the seventh issue of his magazine *The Lark* (November 1, 1895), Burgess published a strange narrative: "An Englishman named John was buried and became a skeleton. Other skeletons joined him in a country called Goupville." Thus the first precursors of the

Goops arose. Illustrated antecedents were also to be found in *The Lark*, with Goop-like figures depicting absurd scenes and rhymes. By the time of this image, a Christmas gift to his friends from the artist, the Goops had evolved into their most recognizable form, as instructors on proper behavior: "They have Manners stranger still; / For in Rudeness they're Precocious, / They're Atrocious, They're Ferocious! / Yet you'll learn, if you are Bright, / Politeness from the Impolite."

GEORGE CRUIKSHANK, 1792–1878

[Santa Claus with revelers], undated
Pencil and watercolor on paper

The source for this illustration, showing Father Christmas raising his wassail cup among various festive vignettes, has not been identified. It is likely that it was completed before Cruikshank's temperance conversion, probably in the early- to mid-1840s.

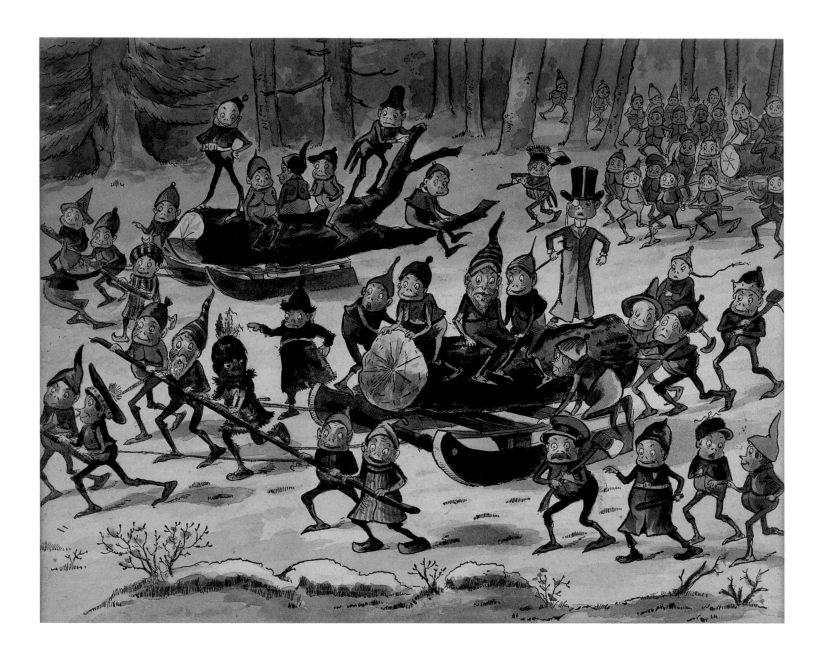

PALMER COX, 1840–1924

"The Brownies bringing home the Yule Log"
for "The Brownie Blocks" (New York: McLoughlin Bros., 1891)
Watercolor on paper

The Brownies' creator, Palmer Cox, provided a succinct definition of
his creatures for the uninitiated: "Brownies, like fairies and goblins,
are imaginary little sprites, who are supposed to delight in harmless
pranks and helpful deeds. They work and sport while weary house-
holds sleep, and never allow themselves to be seen by mortal eyes."
Cox's acumen for product development led to the creation of the
popular set of twenty cubes covered with lithographed images that
can be arranged into six different scenes.

HILARY KNIGHT, b. 1926

"Eloise"
for *Eloise at Christmastime* (New York: Random House, 1958)
Watercolor and gouache on board

Knight's reification of Kay Thompson's rambunctious Eloise, resident
of New York's famed Plaza Hotel, became a favorite of adults and
children over a series of four original books, published in the 1950s.
This study appeared on the front and rear covers of the book, and
was inscribed by the artist.

THOMAS NAST, 1840–1902

"The Dear Little Boy That Thought
Christmas Came Oftener."
for *Thomas Nast's Christmas Drawings for
the Human Race*
(New York: Harper & Brothers, 1890)
Artist's proof, with redrawing in ink and
minor retouches in thin white paint, on
linen-backed paper, with printed signature
re-inked

Nast's comic illustration of a disillusioned
youth at the close of the holiday season first
appeared on the cover of *Harper's Weekly* on
January 1, 1881. It was later reproduced with
slight alterations for this compilation of
Nast's famous Christmas drawings.

HENDRIK WILLEM VAN LOON, 1882–1944

"Caspar, the eldest of the three, carried
the golden star of Bethlehem …"
for *The Message of the Bells: or, What
Happened to Us on Christmas Eve*
(Garden City: New York, 1942)
Pen and ink with watercolor on paper

Van Loon's heartwarming Christmas Eve
tale avoids sentimentality with its sobering
impressions of Hitler's march on Europe.
"We heard the sound of the chimes of the
Tower of Veere," says the mystified Dutch
narrator from his American sanctuary.

Classical pianist Grace Castagnetta
(1909–1996), who had previously collabo-
rated with Van Loon on *Folk Songs of
Many Lands* (1938), provided music for the
book's "The Prayer of Thanksgiving."

CHRIS VAN ALLSBURG, b. 1949

for *The Polar Express*
(Boston: Houghton Mifflin, 1985)
Oil pastel on board

The Polar Express, Van Allsburg's story of a
little boy who is whisked away to the North
Pole to receive a special gift from Santa,
won the artist the Caldecott Medal in 1986
and has sold over five million copies. This
painting was used as a double page illustra-
tion. The text accompanying the illustra-
tion reads: "Soon there were no more lights
to be seen. We traveled through the cold,
dark forests, where lean wolves roamed and
white tailed rabbits hid from our train as it
thundered through the quiet wilderness …"

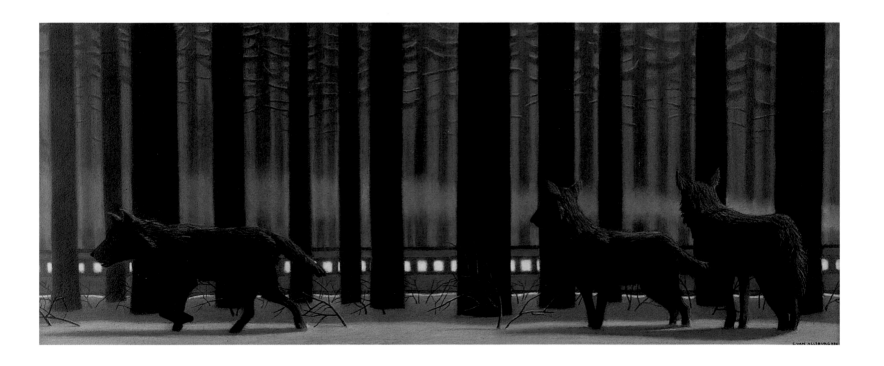

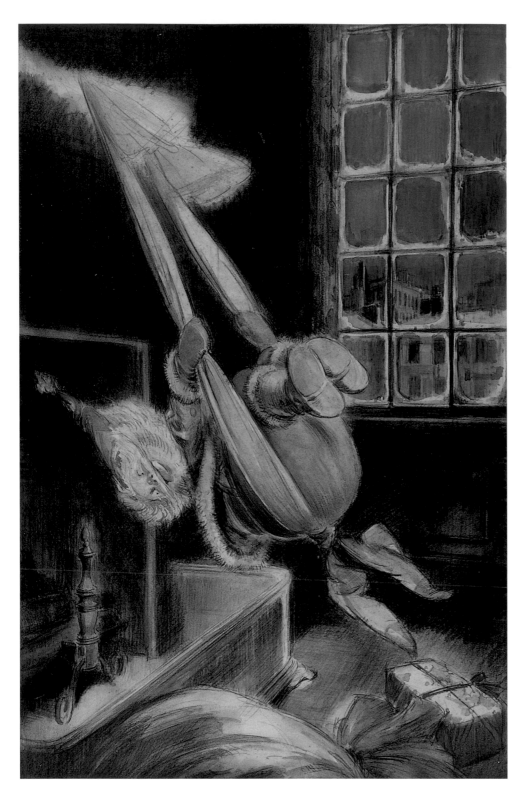

EVERETT SHINN, 1876–1953

"Santa on a Swing"
for *The Everett Shinn Illustrated Edition
of The Night Before Christmas*,
by Clement C. Moore
(Philadelphia: John C. Winston Co., 1942)
Pencil, charcoal and watercolor on board

This study showing Santa Claus at play
did not find a place in Shinn's final version
of Moore's time-honored Christmas poem.
The artist created classic illustrations for
Dickens's *A Christmas Carol* and Wilde's
The Happy Prince as well.

EVERETT SHINN, 1876–1953

"The Children were nestled all snug in
their beds …"
for *The Everett Shinn Illustrated Edition
of The Night Before Christmas*,
by Clement C. Moore
(Philadelphia: John C. Winston Co., 1942)
Ink and wash on paper

"While visions of sugarplums danced in
their heads." The initials "R C" in this and
the following studies stand for Ransley
Conklyn, Shinn's nom de plume that incor-
porates his mother's and father's names.

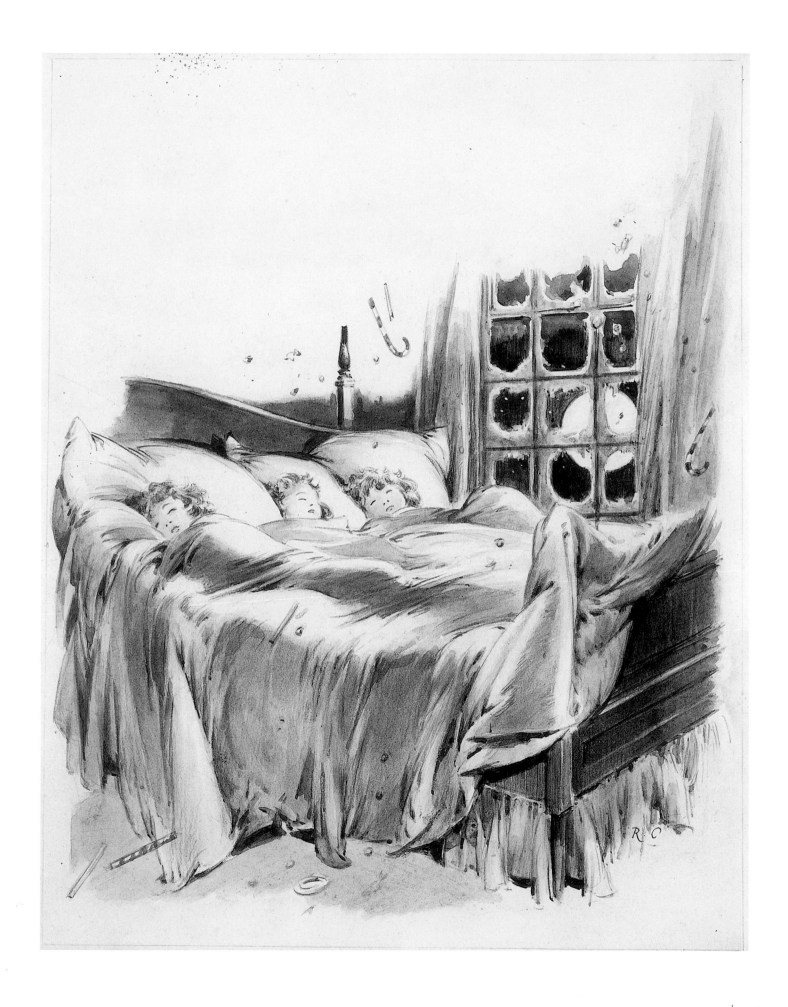

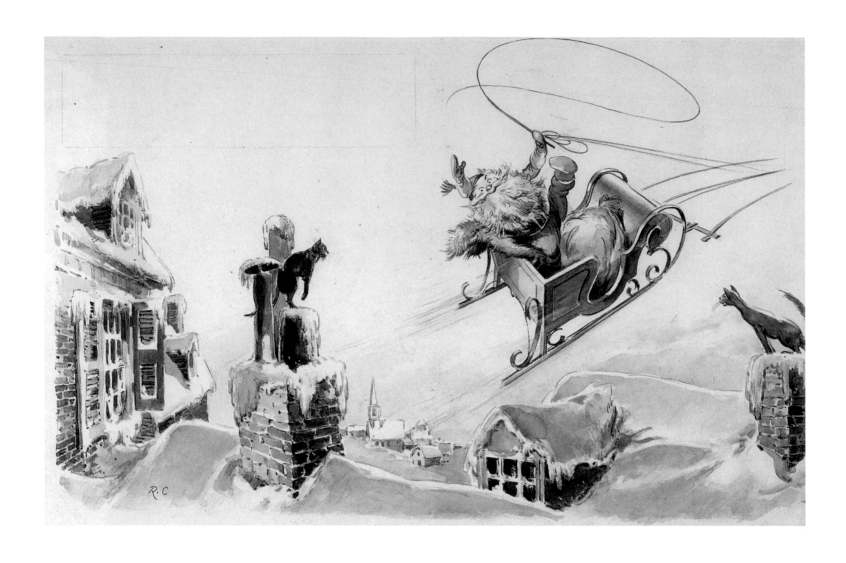

EVERETT SHINN, 1876–1953

[Santa's sleigh over rooftops]
for *The Everett Shinn Illustrated Edition of The Night Before Christmas*,
by Clement C. Moore
(Philadelphia: John C. Winston Co., 1942)
Ink and wash on paper

This study of Santa driving his sleigh was broken up into five pictures before being sold at auction, allowing for the escape of Dasher and Dancer into another collection.

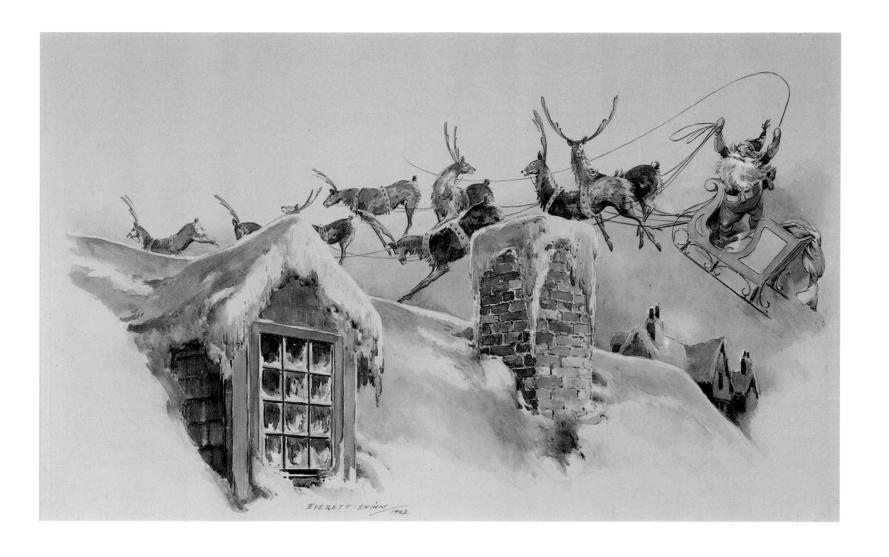

EVERETT SHINN, 1876–1953

"He sprang into his sleigh, to the team gave a whistle …"
for *The Everett Shinn Illustrated Edition of The Night Before Christmas*,
by Clement C. Moore
(Philadelphia: John C. Winston Co., 1942)
Watercolor on paper

This study was reproduced in a slight variation as the final illustration
of the book's text, in which Santa Claus guides his sleigh over the
snowy rooftops: "Happy Christmas to all, and to all a good night!"

R. ANDRÉ, 1834–1907

"In the Stable"
for *Where Santa Claus Lives, and What He Does*
(New York: McLoughlin Bros., 1895)
Watercolor on paper

This study showing Santa Claus preparing his reindeer for the Christmas journey appeared as one of four color illustrations in André's holiday shape-book.

"Santa Claus in His Work Shop"
Watercolor on paper

"His work-shop, is oh! such a wonderful place, / With heaps of gay satins, and ribbons and lace."

"Santa Claus in His Library"
Watercolor on paper

"He knows where the good children live beyond doubt, / He knows what the bad boys and girls are about, / And writes down their names on a page by themselves, / In books that he keeps on his library shelves."

Classics of the 20th Century

Building a collection of children's literature means combining delicate and rare tokens of childhood past with cultural juggernauts memorized by every five-year old. Many of the great successes of twentieth century children's books are based on characters — lovable, memorable, imaginary, adventurous characters. Betsy Shirley's bookshelves were home to a world of happy animals and people. Curious George frolicked next to Otto and Elizabeth. Stuart Little shared a (very tiny) niche with Mr. Small. Madeline lived upstairs from the Cat in the Hat.

Earnest readers will recognize many other famous faces in the Shirley collection — from the hard-working Little Toot to Valenti Angelo's resolute donkey to Amos Mouse, the first of Robert Lawson's animal biographers. Scenes from three of Maurice Sendak's ageless treatments of the anxieties of childhood will surely evoke memories for many readers. Such illustrations, even seen apart from the texts they accompany in the printed books, surely fit the definition of modern classics.

Ludwig Bemelmans, 1898–1962

"And every place a dog might go."
for *Madeline's Rescue* (New York: Viking Press, 1953)
Watercolor on board

This watercolor study for Bemelmans' 1954 Caldecott Medal-winning book (the second of six in the Madeline series) was reproduced in black and yellow for the book. The story begins when Madeline falls into the Seine and is rescued by a dog named Genevieve. This illustration of Paris's famous Les Deux Magots café highlights one of the places Madeline and her friends search when her beloved new pet goes missing. On the awning is an inscription, "To Marshall," who was Bemelmans' publisher at Viking Press.

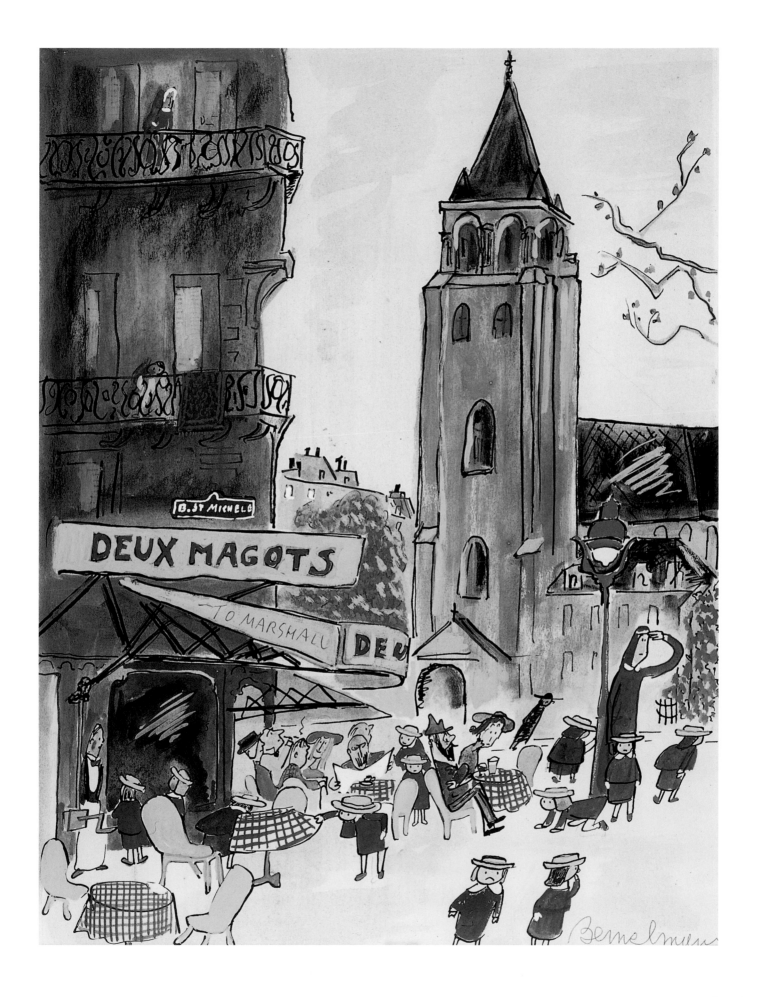

Hans Augusto Rey, 1898–1977

[The monkey Johnny on Cecily Giraffe's back]
for *Cecily G. and the 9 Monkeys*
(Boston: Houghton Mifflin Co., 1942)
Watercolor and pencil on board

Hans and Margret Rey's 1939 book *Rafi et les 9 Singes* was published as *Cecily G. and the 9 Monkeys* in the United States. It features the first appearance of the character the Reys initially named Fifi, but who would come to be known as Curious George. This illustration, appearing on page 20 of the book, shows the rescue of one of George's lesser-known brothers ("Johnny who was brave"). In the right margin are printer's instructions written lightly in pencil.

William Pène du Bois, 1916–1993

[Dust jacket design]
for *Elisabeth the Cow Ghost*
(New York: T. Nelson, 1936)
Watercolor on board

Elisabeth was the writer-illustrator's first children's book. It tells the story of a cow who was famous for being sweet and gentle, but imagines that she might be wild and fierce — and so decides she must return as a ghost and scare her owner.

WILLIAM PÈNE DU BOIS, 1916–1993

[Giant Otto pulled by a tugboat]
for *Giant Otto* (New York: The Viking Press, 1936)
Watercolor and ink on board

"But Otto was also too big for the boat which sailed to Africa, so he traveled on a barge which was pulled by a tugboat." *Giant Otto*

was du Bois's second self-illustrated work, but his first in a comical series featuring a gigantic hound and his owner, Duke (predating *Clifford* by more than two decades). In this book, Otto joins the French Foreign Legion and successfully wards off an Arab invasion by wagging his tail to stir up a sandstorm.

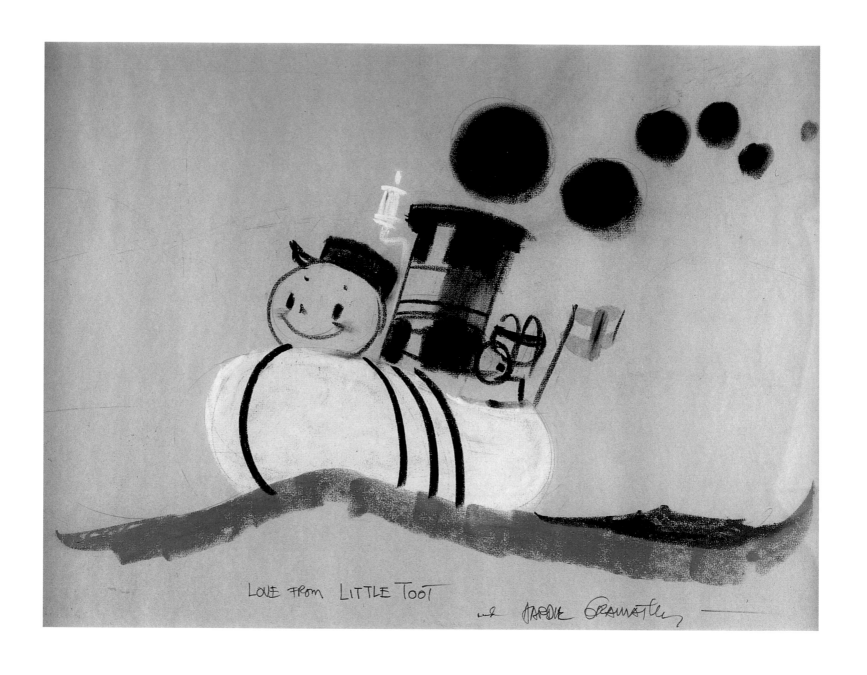

LOVE FROM LITTLE TOOT

HARDIE GRAMATKY, 1907–1979

[Little Toot chugging along in open sea]
Charcoal and tempera on toned paper.

This presentation drawing of Gramatky's best-loved character was
made sometime after 1939, when *Little Toot* was published.

VALENTI ANGELO, 1897–1982

"He discovered a box of mildewed corn and poked his nose into it."
for *The Tale of a Donkey* (New York: The Viking Press, 1966)
Pen and ink on paper

Angelo's last self-illustrated book is the story of Cherubino, a hapless Tuscan donkey who is sold at auction to three abusive owners before being rescued by the young Carlo. The cruel woodcutter lurking in the background of this illustration will get his comeuppance when Cherubino makes a dramatic courtroom appearance at the story's climax.

CAMPBELL GRANT, 1909–1992

[Text and two illustrations showing Pinocchio, Gideon, Foulfellow, and Jiminy], 1947
for *Walt Disney's Pinocchio* (New York: Simon and Schuster, 1948)
Pencil on paper with text

The text pasted into this dummy version was simplified before the book was printed. Some of Grant's illustrations were rearranged (including these two), while others were omitted altogether. In 1947, Disney began adapting material for Simon & Schuster's Little

Golden Book series, helping to make the now familiar children's hardcover a classic. Over two billion of the Little Golden Books have been printed since 1942.

He took Pinocchio's arm and began to lead him. Jiminy Cricket did his best to whistle the puppet back, but it was no use. Little Wooden Head was listening to the sly old fox.

"Why, Pinocchio, you'll be famous . . . you'll be rich! Think of it—a puppet without strings! You'll be a great actor. The people will love you. They'll throw money on the stage. . . ."

Gideon, the cat, took Pinocchio's other arm and together they danced him up the street. Jiminy Cricket whistled and chirped, but the little puppet never listened to the warning. In a wink the two scoundrels had sold him to Stromboli, a greedy man who went from town to town putting on a puppet show.

FULL COLOR

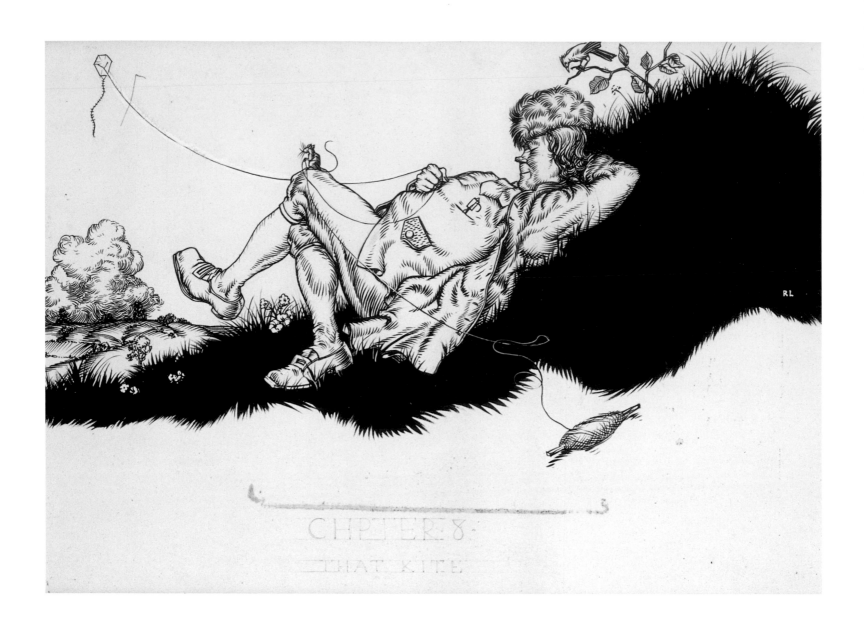

ROBERT LAWSON, 1892–1957

"Chapter 8: That Kite"
for *Ben and Me: A New and Astonishing Life of Benjamin Franklin
as Written by His Good Mouse Amos*
(Boston: Little, Brown and Co., 1939)
Pen and ink on paper

Lawson took his publisher's advice in choosing a historical figure
and his pet for the subject of his first self-illustrated children's book.
The lighthearted *Ben and Me* proved its appeal to readers of all ages,
which led Lawson to produce three more of his innovative biogra-
phies as told from the perspective of Christopher Columbus's parrot,
Paul Revere's mare, and Captain Kidd's cat.

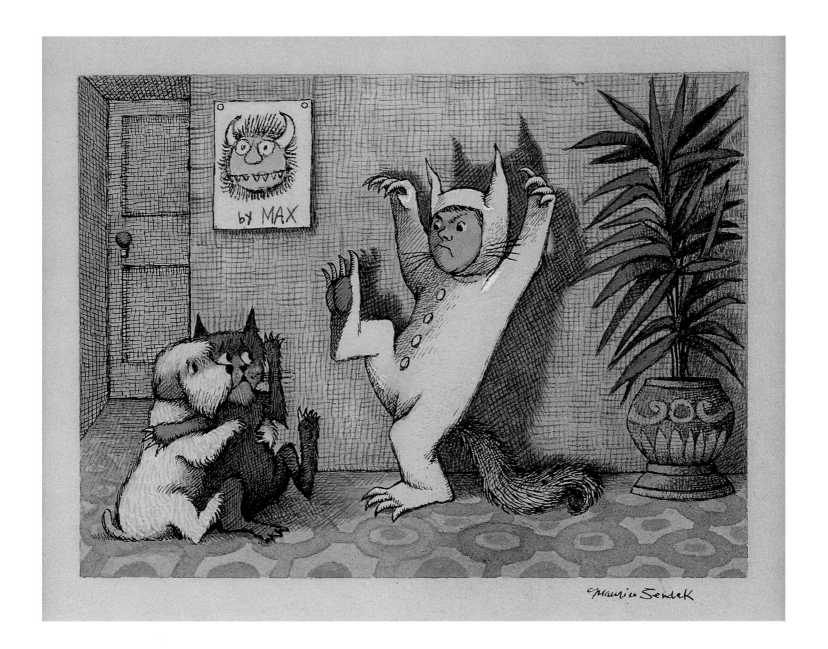

MAURICE SENDAK, b. 1928

"The night Max wore his wolf suit and made mischief of one kind and another"
for *Where the Wild Things Are* (New York: Harper and Row, 1963)
Ink and watercolor on paper

This study for the second image in Sendak's best-known work, *Where the Wild Things Are*, shows the main character, young Max, trying to frighten his already vexed pets. In the published version, only the dog appears. *Wild Things*, which was awarded the Caldecott Medal for 1964, shows the influence Sendak took from the work of George Cruikshank in preparing his crosshatched drawings. This classic had sold more than 7.5 million copies through 2004 and has been translated into thirteen languages.

These are uncorrected, advance proofs. Please do not use them as the basis for a review.

For Betsy and Carl Shirley!
with my very, very best wishes!
Maurice Sendak
Nov. 93

WE ARE ALL IN THE DUMPS

WITH

JACK and GUY

MAURICE SENDAK, b. 1928

Study for the cover medallion and pictorial half-title page for *In the Night Kitchen* (New York: Harper & Row, 1970)
Pen and ink on paper

Sendak considers this book the second in a loose trilogy, between *Where the Wild Things Are* and *Outside Over There*. As the author has explained, these books "are all variations on the same theme: how children master various feelings." Sendak wrote this book after suffering a heart attack and losing both of his parents, so it was his way of saying "goodbye to New York … and … to my parents." Sendak inscribed this drawing, "For Betsy Shirley with pleasure!" in December 1977.

MAURICE SENDAK, b. 1928

"We Are All in the Dumps with Jack and Guy"
for *We Are All in the Dumps with Jack and Guy: Two Nursery Rhymes with Pictures*
(New York: HarperCollins, 1993)
Proof page

We Are All in the Dumps with Jack and Guy adapts two obscure Mother Goose rhymes into a story based on real-life children who live in cardboard shanties beneath the Brooklyn Bridge. The orphan featured on this advance proof for the half-title page is rescued by Jack and Guy, who bring the story to a poignant ending when they resolve to "bring him up / as other folk do."

A Collector's Miscellany

In a collection as diverse as Betsy Shirley's, there are bound to be a few curiosities that appear from the margins and document fascinating private worlds. Her collector's eye for time-proven classics was equally adept at seeking out diamonds in the rough, resulting in a fascinating miscellany of memorable finds.

Among the beauties one first notices is a page of Victorian decals — a collage from a Beinecke family keepsake. Another category of interest is personal sketches by artists such as Tony Sarg, Maxfield Parrish, F.O.C. Darley, and Oliver Herford. Though slightly out of context in this volume, perhaps researchers will one day be able to divine their stories. The Ludwig Bemelmans sketch of a Madeline-esque coquette was acquired along with a collage for his book *Italian Holiday*, perhaps hinting at another unfinished adventure.

Other categories under which to file these curiosities might be: Strange Portraits (a silhouette of Mark Twain, a relief carving by Peter Newell), Posters, Instruction Manuals, and Various Entertainments (Brownie blocks and harlequinades).

One remaining group points out another strength of the Shirley collection: archival items. Among the unique materials preserved are letters by well-known artists such as Frederick Stuart Church and a manuscript book by the architect, Hammatt Billings.

KATHERINE SPERRY BEINECKE

[Scrapbook page: collage of animals and people], ca. 1903

This vibrant group of paper stickers that show a favorite Victorian craft that flourished in a form of sticker-mania toward the latter part of the nineteenth century into the early twentieth is from an album handed down in Betsy Shirley's family.

To my friend Bobby from Tony SARG

TONY SARG, 1880–1942

[Elephant dancing], undated
Pencil with brown and red wash on paper

Sarg, master puppeteer and illustrator, seemed particularly fond of elephants, especially the performing kind.

TONY SARG, 1880–1942

[Elephant with a balloon tied to its tail],
December 3, 1932
Pencil on paper

This humorous animal sketch may possibly
have been created as a presentation piece.

Maxfield Parrish, 1870–1966

[A policeman]
Pencil on paper

This unsigned piece by Parrish, possibly done early in his career, is reminiscent of the work of the prolific artist and designer, Will H. Bradley.

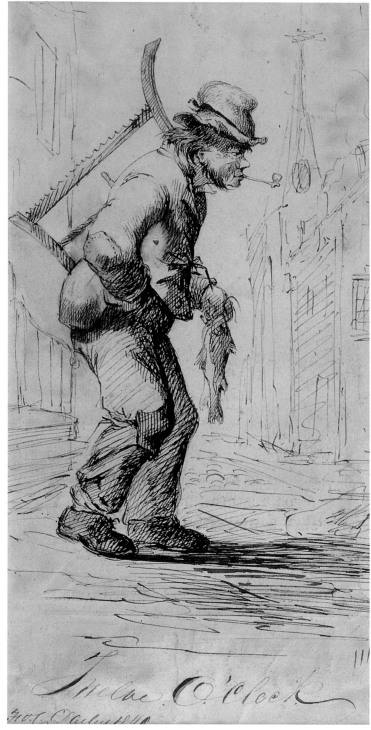

Felix Octavius Carr Darley, 1822–1888

"Twelve O'Clock," 1840
Pen and ink on paper

This picture of a hobo with a saw over his shoulder, carrying a fish, represents one of Darley's earliest works. It may be one of a few designs Darley published in a Philadelphia newspaper edited by Edgar Allan Poe, *The Saturday Museum*, in 1840.

FELIX OCTAVIUS CARR DARLEY, 1822–1888

[Soldiers and children marching], 1840
Ink, wash, and pencil on paper

The date of this drawing suggests it may have been one of Darley's first to be published; in 1840, the publisher Thomas Dunn English paid him for a few designs to be featured in the *The Saturday Museum*.

OLIVER HERFORD, 1863–1935

"Scene II," undated
Ink on paper

This scene by the prolific author and illustrator, Oliver Herford,
appears to have been intended for a dramatic work.

RICHARD SCARRY, 1919–1994

[Man wearing huge sombrero on a spotted horse], undated
Pen and ink with watercolor on paper

This exaggerated, comical figure, likely drawn early in Richard Scarry's career, bears little resemblance to his trademark style of later years.

DAVID CLAYPOOLE JOHNSTON, 1799–1865

[Sketch of women and horses], undated
Pencil on paper

This sketch by Johnston, often called the "American Cruikshank" displays his working method with an early stage of an image that he would later detail in watercolor to be issued separately as a print.

LUDWIG BEMELMANS, 1898–1962

[Urban scene]
for *Italian Holiday* (Boston: Houghton Mifflin, 1961)
Black ink brush on art board with collage

This illustration — depicting a busy Italian city, complete with a priest, two policemen, two nuns, and a photographer — serves as the endpapers for Bemelmans' whimsical travelogue. On top of the original drawing the artist applied eleven separate pieces of paper for the background and human figures. The book is clearly intended

for an adult audience, much like *The Donkey Inside*, Bemelmans' 1941 book about his travels in Ecuador. The illustrations, however, lend the work a decidedly child-friendly tone.

LUDWIG BEMELMANS, 1898–1962

[Young girl skating with a pillow tied to her back and her "snooty" poodle in line with her], undated
Watercolor on art board

This one-off illustration was acquired by Betsy Shirley along with endpaper designs for Bemelmans' *Italian Holiday*, (shown opposite), and may have been created during the same period.

Wanda Gág, 1893–1946

"Cats at the Window"
for "Checkerboard" (New York: Weyhe Gallery, 1930)
Wood engraving

This unusual piece of Gág ephemera appeared in the newsletter issued by the Weyhe Gallery, where the artist's etchings, lithographs, and woodcuts were often on display. A description of the newsletter indicates that the artworks featured in it were wood engravings or linoleum cuts printed directly from the blocks.

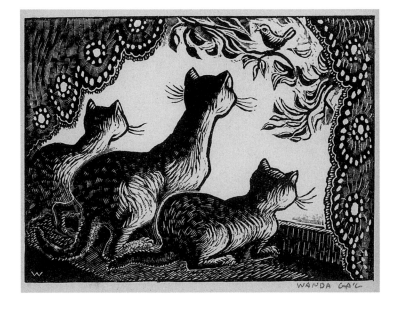

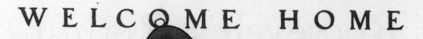

WELCOME HOME

A DINNER TO

THEODORE ROOSEVELT

JVNE

TWENTY

SECOND

NINETEEN

HVNDRED

AND TEN

AT

SHERRY'S

NEW YORK

COPYRIGHT 1910 BY P. F. COLLIER & SON

Drawn by Maxfield Parrish

MAXFIELD PARRISH, 1870–1966

[Title page]
From *Welcome Home; a Dinner to Theodore Roosevelt*
(New York: P. F. Collier & Son, 1910)
Printed page with hand-coloring

Parrish provided the title page illustration for this humorous souvenir collection of poetry, photographs, and related material, on the occasion of Roosevelt's return from his adventures of diplomacy, war, and big-game hunting. The artist chose to depict a New York policeman holding a bouquet because Roosevelt had once been the city's police commissioner. The little gendarme sports Teddy's campaign helmet and signature spats, while the kid gloves and oversize nightstick refer to the statesman's famous motto: "Speak softly and carry a big stick."

[GUSTAVE C. WALLÉ]

[Mark Twain], 1909
Paper

This likeness of Mark Twain is recorded as having been cut by an itinerant silhouettist on a Hudson River Day Line steamer.

PETER NEWELL, 1862–1924

[J. Ernest G. Yalden], undated
Carved and painted wood

Yalden was a neighbor and friend of Newell, who was known for making whimsical portraits and toys from wood.

ETHEL REED, b. 1874

The Arabella and Araminta Stories
by Gertrude Smith
(Boston: Copeland and Day, 1895)
Color printed poster

Copeland and Day, revivalists of fine printing in late nineteenth century America, were among the first publishers in this country to give illustrators equal billing with authors, both in advertising releases and on title pages. This poster featuring the story's four-year-old twin sisters within a ring of red poppies closely resembles the book's first illustration in black-and-white. Smith's mesmerizing prose is a perfect match for Reed's stylized illustrations, reminiscent of Japanese prints.

L. F. Hurd

"The Bow of Orange Ribbon," ca. 1895
for *The Bow of Orange Ribbon*,
by Amelia E. Barr
Lithographed poster

Hurd's curvilinear poster design came at the height of the art nouveau movement and a renaissance in American poster art. Amelia E. Barr (1831–1919), an Englishwoman by birth who settled in Texas, then New York, wrote several popular romance novels during this period. *The Bow of Orange Ribbon*, a picturesque story of colonial New York, went through numerous editions and was followed by a sequel, *The Maid of Maiden Lane*, in 1900. This poster was intended to publicize an unidentified edition of the novel, possibly the 1893 version by Dodd, Mead & Co.

Unidentified artist

"If you want a good position become a first class penman," 19th century
Ink on paper

This anonymous piece of folk art likely dates from the 1830's to the late 1860's, when good penmanship was especially prized for bookkeeping as well as letter writing, and before the invention of the typewriter.

H. L. Stephens, 1824–1882

[Two drawings of anthropomorphic animals], undated
Ink on paper

In Stephens' first book, *The Comic Natural History of the Human Race* (1851), the artist caricatured popular figures by affixing their heads to the bodies of animals. In this pair of drawings attributed to him, he turns the tables by dressing animals up in human finery.

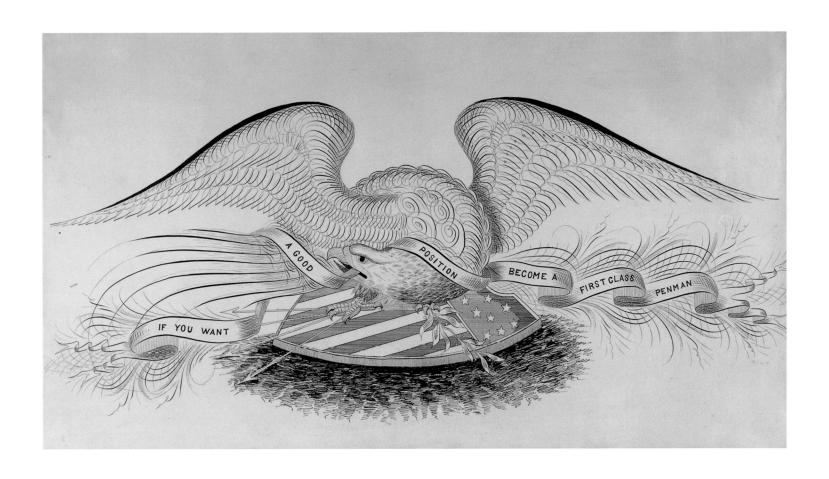

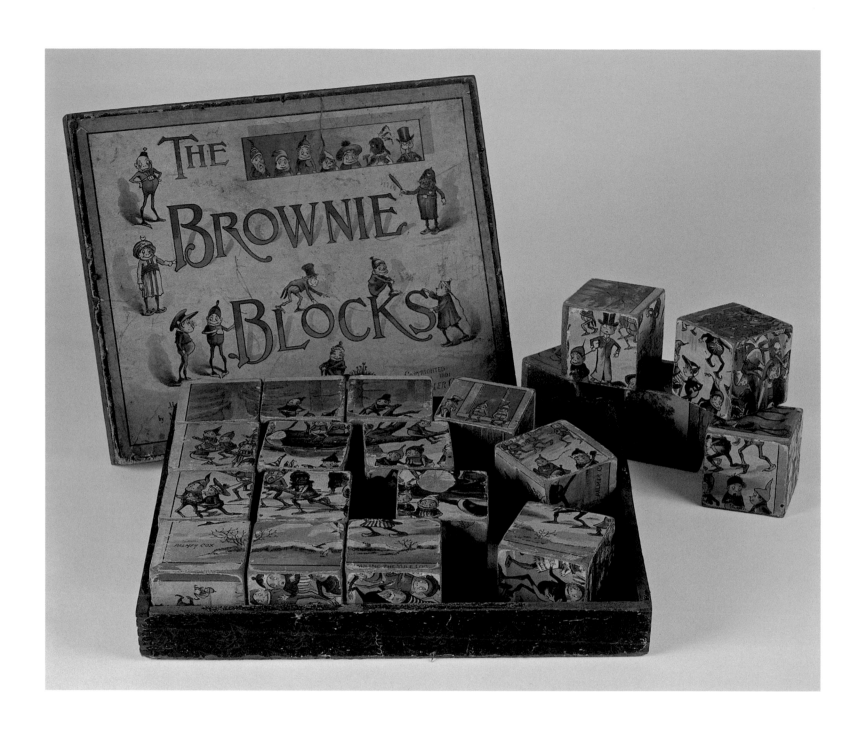

PALMER COX, 1840–1924

"The Brownie Blocks"
New York: McLoughlin Bros., 1891
Lithographed paper over wooden blocks

Cox's acumen for product development led to the creation of a
popular set of twenty cubes covered with lithographed images that
can be arranged into a reproduction of any of six drawings, one of
which can be seen on p. 154.

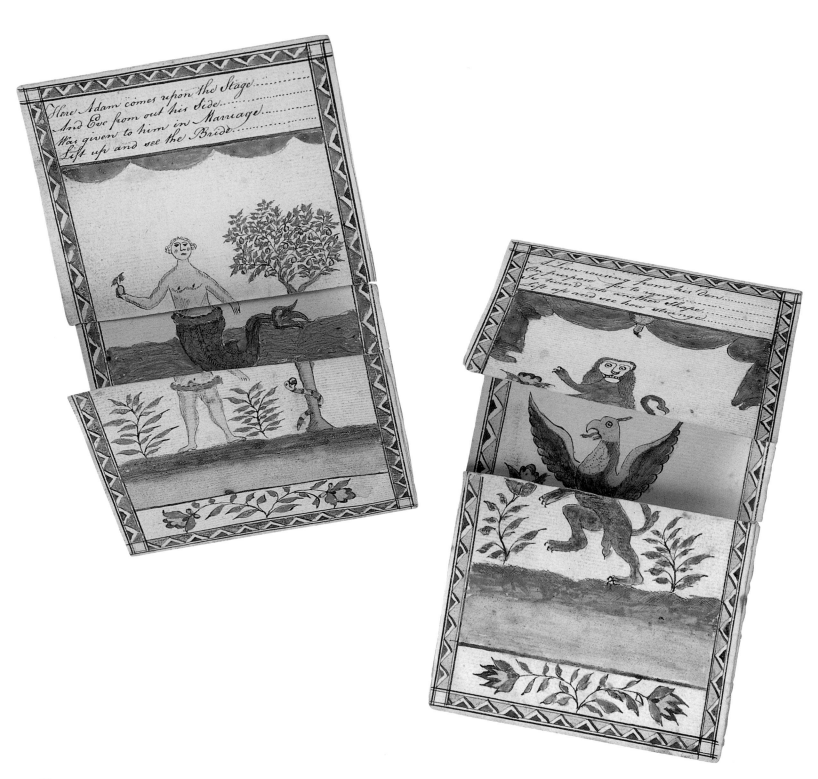

UNIDENTIFIED ARTIST

[Harlequinade page], ca. 1790
Ink and watercolor on paper

The heyday of the harlequinade, a simple two-flap novelty that could reveal four differently combined pictures, was during the late 1700s. Benjamin Sands has always been attributed as the author of the two samples shown which display the metamorphosis of Adam and Eve and a lion, though the text can be traced to the original anonymous harlequinade, known in a copy from 1654, titled *The Beginning, Progress, and End of Man*.

Left: "Here Adam comes upon the stage / And Eve from out his side / Was given to him in marriage / Lift up and see the bride" Eve then turns into a mermaid.

Right: "A Lion rousing from his den / On purpose for to range / Is turned into another shape / Lift up and see how strange" The new creature is a Griffin, who in turn morphs into an eagle, clutching a swaddled babe.

HAMMATT BILLINGS, 1818–1874

[The Priest]
[Jack in front of his house]
for *The House that Jack Built*, ca. 1840
Pen and ink on paper

Hammatt Billings illustrations for the perennially popular children's tale show his finesse in character sketches as well as with architectural rendering. Though many editions of this story were published throughout the nineteenth century, none found so far contain these images.

FREDERICK S. CHURCH, 1842–1924

Illustrated letter to Eva Schley,
June 11, 1901
Ink on paper

"My Dear Mrs. Schley, I beg to announce that I have moved my Studio to the above address." This elaborate change of address is from a series of letters that Church sent to Eva Schley, of the prominent banking family that served for many years as patrons to the artist.

UNIDENTIFIED ARTIST

"An Invaluable Pair of Bracelets," ca. 1830
Ink and watercolor on paper

Though emblem books containing pictures with short allegorical interpretations appeared as early as the sixteenth century, Stacey Grimaldi's *The Toilet*, printed in England in 1821, was the first to associate moral virtues with the items of a lady's dressing table. *The American Toilet*, published in 1827, adopted the British model's flap-book style, in which a hinged paper flap concealed and revealed the virtue behind each instrument of vanity. The illustration shown here is taken from a manuscript imitation of the original *American Toilet* that may have been intended as a personal gift. "Clasp them on carefully each day you live / To good designs efficiency they give."

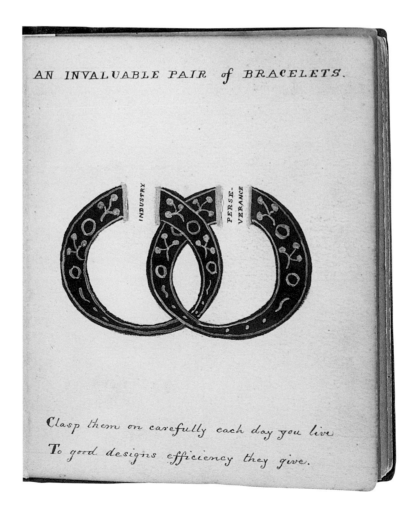

Biographies of artists

(NOTE: Though efforts have been made to include all artists in this volume, a few have been omitted due to lack of documented biographical information.)

ANDERSEN, HANS CHRISTIAN (1805–1875)

Hans Christian Andersen rose from meager circumstances to become one of the world's best-known storytellers. Born in Odense, Denmark, in 1805, Andersen first published a booklet of tales for children in 1830. Though several of his early stories were based on popular folktales, his work grew more innovative and original, eventually introducing the world to the Ugly Duckling, the Little Mermaid and the Steadfast Tin Soldier.

ANDRÉ, R. (1834–1907)

The writer who would eventually become known as Richard André was born William Roger Snow to a prominent London family. In 1855, after spending his large inheritance, Snow joined the army and traveled the world. He published his first work in 1860. Titled *Sketches of Chinese Life & Character*, it was based on his observations and experiences while living in Hong Kong. By the early 1870s, Snow had become a playwright. In 1875 both his marriage and his military career came to an abrupt end as a result of his infidelities, causing him to assume an alias. Working as Clifford Merton, Snow began a prolific career as a writer and illustrator of children's literature until his abandoned wife discovered his alias. After their divorce, Snow changed his name once again. Thereafter known as Richard André, he collaborated with the children's author Juliana Ewing; his success as an illustrator continued on after Ewing's death in 1885.

ANGELO, VALENTI (1897–1982)

Having begun in the profession as a photoengraver for other authors' works, Valenti Angelo provided illustrations for publications of the Grabhorn Press in the 1920s and 1930s before starting to create his own books. His first juvenile production, *Nino*, appeared in 1938; it was followed by more than ten titles written by Angelo alone, and by numerous collaborations with authors such as Ruth Sawyer and Clyde Robert Bulla.

ANGLUND, JOAN WALSH (b. 1926)

An Illinois native, Joan Walsh Anglund attended the School of the Art Institute of Chicago and the American Academy of Art in the mid-1940s, but did not attempt to write or illustrate a book until she followed her husband's suggestion to do so. She was inspired to write *A Friend is Someone Who Likes You* (1958) by watching children playing in her neighborhood in New York, and realizing that her family's move to that city did not have to mean loneliness or isolation. Since that time, Anglund has written or illustrated nearly eighty books of stories and poetry for children and adults. Many of her works, like *Friend*, serve as straightforward lessons to children on heartwarming subjects. Her books have been published in more than a dozen languages around the world, with over forty million copies sold to date.

ATTWOOD, FRANCIS GILBERT (1856–1900)

Francis Gilbert Attwood began his career as a caricaturist while attending Harvard College. Though he did not earn a degree there, he was one of the five founders of the famous humor magazine, *Harvard Lampoon*, in 1876. Attwood worked mainly as a freelance illustrator for books and magazines until 1883, when he became a regular contributor to John Ames Mitchell's newly founded magazine, *Life*. There, Attwood developed his style as a decorator and miniaturist, drawing intricate borders and title-pages as well as deftly executed cartoons with political and social humor. In 1887 he began drawing a monthly review of national events that was featured on the magazine's final page. "The Month" highlighted Attwood's independent political views with liberal doses of satire, and helped to establish *Life* as a controversial publication in its early years. It also brought Attwood his greatest and most lasting acclaim.

BEMELMANS, LUDWIG (1898–1962)

Ludwig Bemelmans was born in the Austrian Tyrol, present day Italy. After becoming involved in the wounding of a hotel manager, he immigrated to the United States to avoid a reform school sentence, arriving at Ellis Island in New York on Christmas Eve, 1914. In addition to writing and illustrating children's books (most famously, the five books of the "Madeline" series), Bemelmans also published novels, short stories, essays, biographies, humor, memoirs, and travel guides—and was, as well, a successful painter and restaurateur. The author and illustrator of over forty books for adults and children, he was introduced to the idea of creating works for children by an editor who visited Bemelmans's apartment in the early 1930s and saw the Austrian landscapes the artist had painted on the window shades to ease his homesickness. Bemelmans was at work on a sixth "Madeline" book when he died, after a long illness, in 1962.

BILLINGS, HAMMATT (1818–1874)

A noted Boston architect and artist, Charles Howland Hammatt Billings created designs for monuments, gardens, furniture, and public festivals in addition to a number of churches and buildings in Massachusetts; the National Monument to the Forefathers (1889) in Plymouth is the work most associated with him today. In the late 1840s, Billings began to draw illustrations for magazines and books. His output for the dozens of titles he illustrated includes those done for the first American editions of *Uncle Tom's Cabin* and *Little Women*.

BIRCH, REGINALD BATHURST (1856–1943)

Though born in London, Reginald Bathurst Birch was raised in San Francisco. When his talent for drawing became clear, he was encouraged to study at the Royal Academy in Munich. Birch began submitting drawings to publications in Europe during his eight years abroad, which prepared him for a successful career in children's illustration upon his return to the United States. Beginning in 1881, Birch lived in New York and received steady commissions to create pen-and-ink drawings for stories and poems in such magazines as *St. Nicholas*, *Harper's*, and *The Youth's Companion*. Birch's reputation reached its peak in 1886 with his illustrations for Frances Hodgson Burnett's *Little Lord Fauntleroy*, a popular book about an American boy who is swept away to his titled grandfather's English manor. Birch never quite matched the fame he achieved with *Fauntleroy*, and even came to refer to the fictitious character as "my Nemesis." Though he became less productive after the turn of the century, Birch continued to illustrate a dozen or more books. In the last decade of his life, his career experienced a revival that added another twenty titles to his total oeuvre.

BOBBETT, WALTER (active 1880s–1900s)

Walter Bobbett was an illustrator of children's books and magazines who was equally comfortable with pen-and-ink and colored engravings. He was one of the first class of students to train at the Woodstock Art Colony. His most enduring book for children is *Zanzibar Tales: Told by the Natives of East Africa*, a collection of folktales translated from Swahili by George Bateman and first published in 1901.

BOUTET DE MONVEL, LOUIS-MAURICE (1851–1913)

Born in France to an opera-singer father, Boutet de Monvel found wide renown with American audiences through his story illustrations published in the pages of the *Century Magazine*. One of his most popular series of paintings, on the life of Joan of Arc, was later adapted into a book for children. His work concentrated on French themes, including bucolic scenes of juvenile life, and songs for young children.

BURCHFIELD, CHARLES (1893–1967)

American painter Charles Ephraim Burchfield was born in Ohio and attended art schools in Cleveland and New York. Burchfield initially hoped to become an illustrator, but halfway through his training he opted "to just paint pictures." The style he developed would be described variously as realist, regionalist, expressionist, and abstract at different points in his career. Throughout, Burchfield drew inspiration from nature for subject matter, even in later periods when his work became increasingly fantastic and abstract. His paintings were exhibited at museums and galleries nationwide during his lifetime, and continue so today.

BURGESS, GELETT (1866–1951)

Born in Boston, Burgess began his career as a draftsman for the Southern Pacific Railroad Company before becoming a publisher, designer, playwright, novelist, and an illustrator of children's books. He graduated from Massachusetts Institute of Technology in 1887, then moved to San Francisco where he joined a group of aesthetically-minded friends known as "Les Jeunes" and founded the literary journal *The Lark* in 1895. Burgess started two other journals, the highbrow *Phyllida* (1897) and the zany *Le Petit Journal des Refusées* (1896). In 1897, after ending *The Lark*, Burgess moved to New York, where he became a revered figure in Greenwich Village. His best-known creations, the rude and poorly mannered characters the Goops, made their book debut in a compilation of edifying rhymes from 1900 entitled *Goops, And How to Be Them*. In total, he wrote more than thirty-five books and introduced several words to the English language, including *goop* (a stupid or fatuous person), as well as *bromide* (a commonplace saying or trite remark) and *blurb*.

BURKERT, NANCY EKHOLM (b. 1933)

Known for the delicacy and detail of her illustrations, Nancy Ekholm Burkert grew up in the Midwest, and served as the arts editor of the University of Wisconsin's literary magazine while a student there. Her first book illustrations, for Roald Dahl's *James and the Giant Peach*, were published in 1961. Following that success, she created illustrations for various authors, with perhaps her best-known effort being for Randall Jarrell's translation of the Brothers Grimm fairy tale *Snow White and the Seven Dwarfs*, a book that won a Caldecott Honor Book Award in 1973. After receiving a National Book Award nomination in 1980 for the paintings and drawings she provided for *Acts of Light*, a selection of Emily Dickinson's poetry, Burkert began research on her own children's book. Her *Valentine and Orson*, based on a fourteenth-century French poem, was published in 1989, and has been translated into five languages.

Byrnes, Gene (1889–1974)

At one time a shoemaker and bug spray salesman, Eugene F. Byrnes endeavored to have a career in sports, but this was cut short in 1911 when he broke his leg in a wrestling match. While convalescing, he copied cartoons and completed a correspondence course in illustration. His first successful comic strip was "It's a Great Life If You Don't Weaken," which ran in the *New York Telegram*, and saw its title become a slogan for the American army during World War I. In 1917 he began the cartoon strip "Reg'lar Fellers." Said to be a favorite of New York's Governor Al Smith, it followed the young character Jimmy Dugan, in checkered cap and short pants, and his friends, as they are perplexed by school and parents, anxious about growing up, and always hungry. A life-long New Yorker, Byrnes wrote two well-regarded textbooks, *A Complete Guide to Drawing* (1948) and *A Complete Guide to Professional Cartooning* (1950).

Cady, Harrison (1877–1970)

Harrison Cady began his career in illustration as a staff artist and cartoonist for *Life* magazine, and went on to draw for publications such as *St. Nicholas*, *Ladies' Home Journal*, and *The Saturday Evening Post* for more than seventy years. Though he worked with many authors, Cady is best remembered for the iconic illustrations he created for more than seventy enormously popular children's books written by Thornton W. Burgess, a fellow Massachusetts native. Simple animal stories known for their accuracy in depicting the natural world, they featured a variety of endearing main characters including Peter Rabbit (not to be confused with Beatrix Potter's creation of the same name). Cady also illustrated his own books for children, including *Caleb Cottontail: His Adventures in Search of the Cotton Plant* (1921).

Champney, James Wells (1843–1903)

Son of the painter Benjamin Champney (1819–1907), James Wells Champney was a noted genre and portrait artist fluent in the use of oil, pastel, and watercolor. He was apprenticed to a wood engraver in his hometown of Boston before enlisting in the 45th Regiment, Massachusetts Infantry and seeing action at the Battle of Gettysburg. In the years following the war, Champney studied painting in Europe. After returning to the United States, he traveled throughout the South, making over five hundred sketches for Edward King's monumental volume *The Great South* (1875). In later years, Champney worked as a traveling art correspondent in Spain and South America. He also illustrated stories and novels written by his wife, Elizabeth W. Champney (1850–1922).

Church, Frederick S. (1842–1924)

A native of Grand Rapids, Michigan, Frederick Stuart Church was educated at art academies in Chicago and New York. In addition to his gentle genre paintings featuring beautiful classically-dressed women at leisure, he gained renown for his high-spirited illustrations for children's fables. Perhaps his most famous work remains his original drawings for the first edition of Joel Chandler Harris's *Uncle Remus, His Songs and His Sayings* from 1881.

Cogger, Edward P. (b. 1833)

Cogger was a New York-born wood engraver who worked regularly for McLoughlin Brothers.

Cox, Palmer (1840–1924)

Raised in the Scottish community of Granby in Quebec, Canada, Cox went to San Francisco in 1863 and found work as a ship joiner before embarking on a successful career with a local railroad. From his arrival in the city, he took night classes at the San Francisco Graphic Arts Club, and began submitting drawings and humorous sketches to local papers. In 1874 he decided on a full-time commitment to writing and illustrating and, using Mark Twain as a model, published an ambitious subscription-based work, *Squibs of California, or Everyday Life Illustrated*. It was an economic failure, but with his illustrations for periodicals gaining favor, Cox moved to New York. He worked there for humor magazines and produced a few small publications, but found his greatest satisfaction in creating illustrations for the children's serials *St. Nicholas*, *Wide Awake*, and *Harper's Young People*, among others. Cox's famous characters, the Brownies, first appeared in the January 1883 issue of *St. Nicholas*, and set the tone for the remainder of his career. Quirky, adventurous, and fun, the little sprites were inspired by the Scottish folklore Cox heard growing up in the Grampian Mountains, and refined by suggestions from children across America who wrote to the magazine with their ideas. Individual Brownies evolved to take on allegorical roles, such as the Policeman and the Wheelman, as well as ethnic characteristics reflecting the period's mass immigration, all of which were employed by Cox to expand children's concepts in their turn-of-the-century world. He estimated that he drew over a million Brownies during his lifetime, as the empire developed into a series of popular books, a theatrical production, and products ranging from toys to jewelry to Brownie carpets. Cox also licensed his characters to appear in endorsements for a wide variety of other companies' products, including candy, soap, coffee, and rubber boots. Cox's gravestone reads: "In creating the Brownies, he bestowed a priceless heritage on childhood."

Crane, Walter (1845–1915)

One of the most influential nineteenth-century British illustrators, Walter Crane was born in Liverpool, England. He received little formal education until, through his father's connections, he was apprenticed for three years to master wood engraver William James Linton (1812–1897). In 1865 Crane went to work for Edmund Evans (1826–1905), a leading color engraver, and over the next five years he

illustrated several "toy books" for Routledge and Son that reflected his growing interest in Japanese prints. Crane's illustrations did much to raise the quality of inexpensive picture books. In the 1870s and 1880s, he created images for a number of children's stories, including a popular series of sixteen titles by Mrs. Molesworth. He also wrote and illustrated more than twenty-five books for his own children, most of which were never published. In 1876 Crane collaborated with his sister, Lucy Crane (1842–1882), on several projects, in particular the immensely popular *The Baby's Opera*, a collection of versified fairytales set to music. By the late 1880s, Crane had moved on to illustrating literature for adults, including works by Shakespeare and Spenser. In addition to his work as illustrator, Crane was acknowledged as a leading member of the British Arts & Crafts movement, and produced decorative designs for textiles, ceramics, and wallpaper, including papers created specifically for children's rooms.

CRUIKSHANK, GEORGE (1792–1878)

One of the first great illustrators and caricaturists of the modern era, British painter George Cruikshank followed the path set by his father, caricaturist Isaac Cruikshank (1756–1810), to begin his career as a deft social and political commentator, using as his weapon the media of wood and steel engravings. In the 1820s Cruikshank's interests shifted to theatre and literature. During this prolific middle period he illustrated Grimm's *German Popular Stories* (1824–1836), and Charles Dickens's *Sketches by Boz* (1836) and *Oliver Twist* (1838), as well as many other books of the Victorian period. As he grew older he became a zealous supporter of temperance; his major works after 1840 reflect his concern with the abuses of alcohol and tobacco, and include *The Bottle* (a series of eight plates produced in 1847), its sequel, *The Drunkard's Children* (1848), and *The Worship of Bacchus, or the Drinking Customs of Society* (1862), after his oil painting of the same title.

DARLEY, FELIX OCTAVIUS CARR (1822–1888)

F.O.C. Darley, caricaturist and illustrator, was born in Philadelphia to parents of British origin. He learned his art as a teenager by copying old master engravings and contemporary illustrations by English artists such as Thomas Rowlandson and George Cruikshank, and began his career by selling sketches of Philadelphia street scenes to a local newspaper around 1840. His illustrations were soon appearing in periodicals such as *Harper's Weekly*. Darley received an important commission from the American Art Union in New York in 1848 to provide images for Washington Irving's *Rip Van Winkle*, followed the next year by a similar set for *The Legend of Sleepy Hollow*. The author was pleased with the results, and the artist went on to illustrate all of his major works. By 1850, Darley had established himself as the country's foremost illustrator, and in 1856, was commissioned to provide drawings for the complete works of James Fenimore Cooper, a thirty-two-volume set published between 1859 and 1861. Darley's work appeared as well in books by Henry Wadsworth Longfellow, Charles Dickens, Nathaniel Hawthorne, and William Shakespeare. American book illustration might be said to have begun with Darley, who illustrated more than three hundred books and countless magazine articles.

DAUGHERTY, JAMES HENRY (1889–1974)

Born in North Carolina, James Henry Daugherty grew up in Washington, and studied at the Corcoran School of Art and the Pennsylvania Academy of Fine Arts before moving to London with his parents in 1905. While there, he studied with the painter Sir Frank Brangwyn (1867–1956), and became interested in American history through reading the work of Walt Whitman. When Daugherty returned to the United States, he settled in Brooklyn and began a career as a commercial artist, providing illustration for advertising and magazines. In 1913 he married Sonia Medwedeff (1893–1971), a children's author who introduced Daugherty to the field of book illustration. Of the nearly one hundred titles he illustrated, those that brought him the greatest distinction concerned popular American heroes including Abraham Lincoln, Lewis and Clark, Marcus and Narcissa Whitman, Henry David Thoreau, and Thomas Jefferson, some of which he wrote himself. In 1940 he was awarded the Newbery Medal for *Daniel Boone*, a figure that he had often heard about in tales told by his grandfather. Many of Daugherty's illustrations, achieved with pen, brush, and crayon, were a striking blend of color and prismatic pattern, a reflection of his alternate career as a synchromist painter. Daugherty is also known for the striking posters he designed for the United States Navy during World War I.

DENSLOW, W. W. (1856–1915)

William Wallace Denslow's most lasting contributions to children's literature are his illustrations in L. Frank Baum's *The Wonderful Wizard of Oz* from 1900. The two men met in 1896, at a time when Denslow was eager to leave his job designing advertisements and work on a children's book. They first collaborated on *Father Goose, His Book* (1899), before the radical success of *Oz*. Denslow's fantastic illustrations were original in their integration with Baum's text, sometimes cutting into words or printed directly over the type. Following this huge artistic and financial windfall, Denslow and Baum separated over a bitter disagreement concerning the production rights of the 1902 musical version of *Oz*, for which Denslow had designed the sets and costumes. Denslow edited and illustrated interpretations of some of the best-known juvenile works of the time, including *Denslow's Mother Goose, Being the Old Familiar Rhymes and Jingles of Mother Goose* (1901) with hand lettering designed by Frederic W. Goudy, and *Denslow's Night Before Christmas* (1904). He also collaborated on books with other authors, including *The Pearl and the Pumpkin* (1904) with Paul Clarendon West, which became a Broadway musical in 1905. Despite his efforts, however, Denslow never regained the notoriety he achieved with Baum.

DOOLITTLE, AMOS (1754–1832)

Amos Doolittle, one of the first American copper plate engravers, was born in Cheshire, Connecticut, and trained there as a silversmith. A self-taught engraver, he moved to New Haven while still a young man and lived there the rest of his life. In the spring of 1775, Doolittle, as a member of the New Haven Company of Guards, marched to Cambridge under Captain Benedict Arnold. He arrived just after the battles at Lexington and Concord, but visited the towns and interviewed participants. Upon his return home he engraved on copper a set of four engravings of the villages and the battles that took place there. Doolittle supported himself as an engraver, regularly turning out bookplates, certificates, portraits, currency, maps, illustrations for books and periodicals, and sheet music. He applied his talents with the burin to patriotic causes, such as a wall map of the new nation's territories according to the Peace of 1783, and his iconic portrait of President George Washington, surrounded by the arms of the Federal Government and the thirteen states, which he issued between 1791 and 1796.

DRAYTON, GRACE GEBBIE (1877–1936)

The daughter of Philadelphia publisher George Gebbie, Grace Drayton was the one of the first and most successful female cartoonists. She first gained prominence in 1900 when she introduced an original comic series, "Bobby Blake and Dolly Drake" to the Sunday edition of the Philadelphia *Press*. The cute, chubby-cheeked characters of the series presaged Drayton's most lasting creation, the Campbell's Soup Kids. The adorable Kids appeared on streetcar advertising in one of the company's first marketing efforts in 1905. Unfortunately for Drayton, her name never appeared on any of the drawings, which allowed Campbell's to hire other artists to continue the characters after her departure. In the years following this dampened success, Drayton created new comic characters such as Dolly Dimples, illustrated books based on her older ones, and became even more well-known to children through her Dolly Dingle paper dolls issued between 1916 and 1922.

DU BOIS, WILLIAM PÈNE (1916–1993)

Born in Nutley, New Jersey, William Pène du Bois studied with his father, Guy (1884–1958), a distinguished American painter who moved his family to France from 1924 to 1930. Du Bois was set to attend the Carnegie Institute of Technology at age 18 when his first children's book, *Elizabeth, the Cow Ghost*, was accepted for publication. Over the next several years he produced five more books, including the first two stories of his *Otto* series detailing the adventures of a gigantic dog and his owner, Duke. With the United States' entrance into World War II, Du Bois took a position as editor and illustrator of the military publication *Yank*. After the war, he went back to children's books, winning the Newbery Medal for best children's book in 1947 for *The Twenty-One Balloons*. In the decade following he won two Caldecott Honor Awards for out-standing illustration in his books *Bear Party* (1951) and *Lion* (1956). Du Bois wrote and illustrated over twenty-five children's books, and illustrated more than a dozen for other authors. He was also a founding editor of the *Paris Review*.

EATON, CAROLINE KETCHAM (1843–1910)

Caroline Ketcham Eaton was born in New York City to Tredwell and Mary Van Winkle (whose family surname had earlier inspired Washington Irving's famously somnolent character "Rip"). Eaton studied at the Yale University School of Art and married a Yale botany professor, Daniel Cady Eaton, in 1866. Her prolific output of watercolors includes many shoreline scenes of her family's beach cottage in South Lyme, Connecticut.

FALLS, C. B. (1874–1960)

Born in Fort Wayne, Indiana, Charles Buckles Falls taught himself drafting while employed as an architect's assistant. He ultimately became a freelance graphic designer, and worked extensively in advertising, book and magazine illustration, printmaking, and various aspects of mural, costume, and poster design. Falls rose to prominence in the world of children's books by designing and illustrating *The ABC Book* in 1923, followed the next year by his own edition of *Mother Goose*. He illustrated many books by other authors, including works by the Brothers Grimm, Louisa May Alcott, and Robert Louis Stevenson. In addition to his artwork, Falls created, edited, and published a sixteen-page periodical containing stories, poems, and drawings by such regular contributors as author Theodore Dreiser and humorist Montague Glass. During World War I, he designed posters for military recruitment, and was active in the campaign to collect books to send to American soldiers overseas.

FIELD, EUGENE (1850–1895)

Though born in St. Louis, Eugene Field was sent back east for school by his father, a transplanted New England lawyer. After studying at Williams College, Knox College, and the University of Missouri at Columbia, Field embarked on his career as a writer and editor for newspapers in Missouri, Kansas, and Colorado. In 1883 he was offered a position in Chicago, and remained there until his death. Though in his lifetime he was famous for his long-running *Chicago Daily News* humor column "Sharps and Flats," the gifted "children's poet" is best remembered for his rhymes celebrating childhood and its joys, among them, "Wynken, Blynken, and Nod," and "Little Boy Blue."

FOX, FONTAINE (1884–1964)

Fontaine Talbot Fox Jr. was born in Louisville, Kentucky. He began his career as a reporter and cartoonist for the *Louisville Herald*,

often satirizing the town's unreliable Brook Street trolley. Fox later drew for the *Louisville Times* and the *Chicago Evening Post*, eventually selling his work to large syndicates beginning in the 1920s. His comic strip, "Toonerville Folks," which was based on his early trolley sketches, appeared in more than two hundred daily newspapers. Its cast of characters inspired books and an animated film. The success of his vision meant Fox was one of few cartoonists in his day to have his own copyright.

FROST, A. B. (1851–1928)

Philadelphia native Arthur Burdett Frost was a mainly self-taught illustrator and humorist. He began his career in 1870 by providing illustrations for an edition of Charles Dickens's *American Notes*. Later in that decade Frost studied in London, where his work was noticed by Lewis Carroll who arranged to have Frost illustrate his book *Rhyme? and Reason?* (1883). During this period Frost was regularly illustrating for magazines, as well as publishing *Stuff and Nonsense* (1884), a compilation of his own comics. After the turn of the century, having been established as one of the country's foremost illustrators, Frost moved his family to Paris to study painting. It was an unsuccessful foray plagued by illness. In 1914 he returned to the United States and recommenced his career as an illustrator, relying on such profitable commissions as Joel Chandler Harris's *Uncle Remus* series.

GÁG, WANDA (1893–1946)

Wanda Hazel Gág was born in New Ulm, Minnesota, to Bohemian immigrant parents, and grew up in a home where she was surrounded by folk art and music. The oldest of seven children, she was fifteen when her father, an artist and photographer, died, leaving her to help educate and support her family. Gág received scholarships to attend the St. Paul School of Art and the Minneapolis School of Art, followed by a year at the Art Students League in New York, 1917–1918. After several years struggling as a commercial artist in New York, Gág, inspired by works such as Thoreau's *Walden*, retreated to "Tumble Timbers," a ramshackle house in rural New Jersey. During this time (1923–1930) she honed an aesthetically principled personal style of an intensity that won her both popular and critical acclaim. A literary agent who saw some of Gág's prints and drawings in a gallery exhibit introduced her to the world of children's literature; her first book, *Millions of Cats* (1928) won a Newbery Honor Award, as did *The ABC Bunny* in 1934. The artist-author won renown for the unique way in which her illustrations were integrated with hand-lettered text. Of Gág's ten books for children, four were translations of tales from the Brothers Grimm's *Kinder und Hausmärchen* (*Snow White* included). In 1930 Gág married and moved to a century-old farm in New Jersey that she christened "All Creation." In her later years she became increasingly interested in lithography and oil painting.

GRAMATKY, HARDIE (1907–1979)

Hardie Gramatky was born in Dallas, Texas, and grew up in Los Angeles. He attended Stanford University and Chouinard Art Institute for two years each, but opted to pursue a career before taking a degree. From 1930 to 1936 Gramatky was a head animator for Walt Disney Productions, where he perfected a gentle, buoyant style of drawing. From 1937 to 1940 he worked as a pictorial reporter for *Fortune* magazine in New York. Tugboats on the city's East River inspired Gramatky to write his first book for children, *Little Toot* (1939), the story of a lollygagging young tugboat who becomes a hero. During World War II the author made training films for the U.S. Air Force, after which he went on to write more than ten children's books, while at the same time working as an illustrator for advertising agencies, magazines, and other authors. During his career, Gramatky produced sequels for *Little Toot*, with his most popular character plying waterways around the world, in addition to other books about anthropomorphized vehicles.

GRANT, CAMPBELL (1909–1992)

Born in Berkeley, Campbell Grant studied at the California School of Arts and Crafts in Oakland, and at the Santa Barbara School of the Arts, staying on for two years as the school's librarian. While there, he illustrated an adventure story about Santa Barbara's Chumash Indians, beginning a lifelong interest in archeology and Native American rock art. During the Depression years Grant painted landscapes in oil and watercolor for the Federal Arts Project. In the fall of 1934 he went to work as an animator at Walt Disney Studios, where he would remain on staff until 1946. At Disney, he worked on the *Snow White*, *Dumbo*, *Bambi*, and *Fantasia* films; he also adapted Disney material for the Little Golden Books imprint. In 1965 Grant shifted from children's illustration to focus on archeology. *The Rock Paintings of the Chumash: A Study of a California Indian Culture* (1965), his first of several books on the subject, remains one of the best sources of illustrations depicting Chumash cave paintings.

GRUELLE, JOHNNY (1880–1938)

Johnny Gruelle was the relatively anonymous creator of the enormously popular children's character Raggedy Ann. He grew up in Illinois, a location which would influence the idyllic pastoral settings that later appeared in many of his stories. He began his career as a newspaper comic artist and a magazine illustrator. His inspiration for Raggedy Ann was an old faceless doll found by his daughter in their attic. After her tragic death in 1917, Gruelle began *Raggedy Ann Stories* (1918) in her memory. He added a brother doll, Raggedy Andy, in 1920, and went on to write over forty titles featuring the beloved pair, several of which were published posthumously. Gruelle also wrote and illustrated more than a dozen other children's books featuring characters such as Beloved Belindy and Wooden Willie.

Illness forced Gruelle to move to Miami, Florida, in 1931, where he continued to produce children's books until his death.

HALM, GEORGE R. (1850–1899)

An illustrator as well as a book decorator and designer, George Halm was born in Ogdensburg, New York. Halm is known for his achievements in all aspects of book production, from designing original type fonts and bindings, to creating posters to market publications. He also contributed illustrations regularly to the magazines *St. Nicholas*, *Scribner's*, *Outing*, *Frank Leslie's Illustrated Newspaper*, and *Century Magazine*, as well as serving as art director for the magazine *Decorator and Furnisher*.

HERFORD, OLIVER (1863–1935)

Best remembered today for his profuse wit and volumes of light verse, Oliver Herford was also an accomplished author and illustrator of children's books and satires. He was born in Sheffield, England, and moved with his family to Chicago at the age of twelve. Herford attended colleges in England and the United States, and received art training at the Slade School of Fine Art in London and the Académie Julien in Paris, following which he moved to New York and began to submit columns to *Century Magazine*. Later, while serving on the staff of *Life* and *Harper's Weekly*, Herford became a children's author and illustrator. Several of his lighthearted books in this genre, such as *The Rubaiyat of a Persian Kitten* (1904), were versified stories about animals.

HOCHSTEIN, ANTHONY (1829–1911)

Anton Hohenstein was born in Bavaria, and immigrated to the United States in the 1850s, changing his name within a decade. Hochstein lived for more than forty years in Hoboken, New Jersey, where he painted miniatures, specializing in works with animals and plants as subject matter. His work was included in exhibitions at the National Academy of Design.

HOPKINS, LIVINGSTON (1846–1927)

Livingston Hopkins, known as 'Hop,' was born in Bellefontaine, Ohio, served in the Civil War, and began a career as an illustrator in New York. In 1882 a visiting publisher invited him to become a cartoonist for the Sydney *Bulletin*, Australia's version of New York's satirical journal, *Puck*. Hopkins kept that position for thirty years, producing over 19,000 drawings for the magazine along with calendars, and postcards that often used allegorical animals in the service of social satire. A collection of his political cartoons, *On the Hop*, was published in 1904. By the end of his professional life, Hopkins had become a director and part owner of the periodical that had made him famous.

HOWARD, JUSTIN H. (active 1856–1876)

Justin H. Howard was active between 1856 and 1876, and was best known for his comic illustrations. He began his career contributing cartoons to early American comic newspapers such as *Yankee Notions* and *Punchinello*, often working in the medium of wood engraving. Howard's drawings appeared regularly in books published by McLoughlin Bros., one of the first firms to embrace color printing technology for use in children's books. Howard illustrated volumes of poetry and fiction, as well as tracts on popular history and religion.

HUMPHREY, MAUD (1868–1940)

Maud Humphrey is remembered equally for her art and for being the mother of actor Humphrey Bogart. Raised in Rochester, New York, she studied at the Art Students League in New York, and in Paris. Returning to America, she began creating illustrations for magazines and children's books. She specialized in sugary depictions of babies and children, which were especially popular and widely used in advertisements for baby food products, and on greeting cards and calendars. Humphrey insisted on rapidly sketching her diminutive subjects while they were at play.

HURD, CLEMENT (1908–1988)

Clement Hurd illustrated over seventy-five children's books— working in such diverse formats as drawing, painting, and wood block prints—but he is best known for his pictures for Margaret Wise Brown's *Goodnight Moon* (1947). He was born in New York and studied architecture at Yale University, but after graduating chose instead to pursue painting. Hurd moved to Paris to study with Fernand Léger (1891–1955), afterward returning to New York to eke out a living as an artist during the Depression. His break came in 1938 when he won an informal competition to illustrate Gertrude Stein's only published children's book, *The World is Round*; he would eventually illustrate three separate editions of the book over the years. In 1939 Hurd married Edith Thacher (1910–1997), a children's author, whom he met while both were studying at Bank Street College. The couple worked on more than fifty book projects together.

JOHNSTON, DAVID CLAYPOOLE (1799–1865)

Philadelphia native David Claypoole Johnston was apprenticed to Francis Kearney (1785–1837) for three years to learn printmaking techniques, starting him off on a career in illustration. During his first years he supported himself by acting in theatrical productions in Philadelphia and Boston while submitting illustrations to periodicals and book publishers. In 1825 he moved to Boston and was employed by Pendleton's Lithography. Johnston produced satirical cartoons, caricatures, illustrations for books and periodicals, sheet music vignettes, masthead designs, and portraits during his career.

Over several years starting in 1830, he published nine volumes titled *Scraps*, a series of comic sketches whose title was borrowed from the *Scraps and Sketches* of George Cruikshank, an artist he greatly admired. Johnston collaborated with the author Joseph C. Neal on *Charcoal Sketches, or Scenes in a Metropolis* (1838), which went through several editions. Aside from illustrating books, Johnston was also an accomplished painter, and exhibited work at the National Academy of Design in New York.

KELLER, ARTHUR IGNATIUS (1866–1924)

The son of an engraver, Arthur Keller attended the National Academy of Design and studied painting in Germany. A successful and award-winning artist, he decided to turn toward illustration as a career. Beginning with newspapers, he quickly moved to books and magazines, and was soon the favored illustrator for several noted writers including Irving Bacheller, James Russell Lowell, Mary Roberts Rinehart, and F. Hopkinson Smith. Keller was commissioned to make designs for books by Washington Irving, Charles Dickens, and Bret Harte, and created hundreds of illustrations for popular magazines, including *Ladies Home Journal* and *Collier's*. In the last decades of his life, Keller was a summer resident of Cragsmoor, an artists' colony northwest of New York City.

KELLY, WALT (1913–1973)

Walter Crawford Kelly, Jr., a major influence in American comic art, was born in Philadelphia, though he spent his formative years in Bridgeport, Connecticut. His first cartoons appeared in the Bridgeport *Post* in 1935. In 1936 Kelly moved to California and began working for Walt Disney Studios, as an animator and developing stories for *Snow White*, *Pinocchio*, and *Dumbo*. After moving back East in 1941, Kelly began drawing for Dell Comics, where his most famous creation, the loquacious possum Pogo, made a debut in the first issue of *Animal Comics* (1941). Though the strip was initially called "Albert the Alligator," Pogo quickly became its star character. The strip flourished in comic book form, national newspaper syndication, and even graphic novels into the 1970s. Influenced by Kelly's years at the Disney Studios but emboldened by his innovative and liberal use of both dialects and typefaces, *Pogo* became a popular forum for the artist to satirize society and politics.

KENT, ROCKWELL (1882–1971)

Rockwell Kent was one of the most politically controversial American artists of the twentieth century. He was brought before the United States Congress's House Committee on Un-American Activities on two separate occasions for his involvement with the Communist Party. While much of Kent's work—including drawings, paintings, etchings, and prints—reflected his socialist beliefs, he also produced many apolitical writings and book illustrations. At the peak of his career, during the 1920s and 1930s, his litho-graphs and woodcuts were used to illustrate literary classics, most famously a 1930 edition of *Moby Dick*. A world traveler, Kent published several memoirs about his favored locales ranging from Alaska and Greenland to South America's Tierra del Fuego region. He spent the later years of his tumultuous life, which included three marriages, on his beloved Asgaard Farm in New York's Adirondack Mountains.

KNIGHT, HILARY (b. 1926)

As both of his parents were commercial and book artists, Hilary Knight fell quite naturally into book illustration. At the age of 16 he enrolled in the Art Students League in New York, but two years later his schooling was interrupted by World War II. After time in the Navy, Knight had intended to become a set designer, but his humorous illustrations of children caught the attention of publishers and, through contacts, he was introduced to the talented Kay Thompson. Knight's depiction of Thompson's character Eloise—a feisty, bright six-year-old girl living in New York's famed Plaza Hotel—was quickly embraced by readers with the publication of *Eloise: A Book for Precocious Grown Ups* (1955). Three more Eloise books followed, their popularity cementing her place as a classic character in children's literature. Though Knight is most famous for that series, he also wrote and illustrated nine of his own books for children, and illustrated almost sixty books by other writers for children and adults.

LATHROP, DOROTHY PULIS (1891–1980)

A native of Albany, New York, Dorothy Lathrop became an illustrator after attending Columbia University's Teachers College. It was not entirely clear that Lathrop had made the right career choice when the publisher of her first book, *Japanese Prints* (1918), went bankrupt and neglected to pay her. Over the next ten years, however, Lathrop established herself by illustrating the works of several notable authors. The first children's book she wrote herself, *The Fairy Circus*, won a Newbery Honor Award in 1932. In 1938 Lathrop became the first recipient of the Caldecott Medal for her illustrations in Helen Dean Fish's *Animals of the Bible*. She wrote and illustrated seventeen stories in addition to her illustrations for nearly fifty books by other authors. In her later years, Lathrop published several nonfiction books documenting her concern for wild animals.

LAWSON, ROBERT (1892–1957)

Robert Lawson is celebrated equally for his artistic talents and for his writing. After attending the New York School for Fine and Applied Arts (now the Parsons School for Design at The New School University), he worked as a commercial artist on advertisements and magazines. His first foray into illustrating children's work, for Arthur Mason's *The Wee Men of Ballywooden* (1930), led to a successful second career. Lawson won the Caldecott Medal in

1941 for *They Were Strong and Good*, a book he wrote and illustrated about his own parents and grandparents; he earned two Caldecott Honor Awards, one in 1938 for *Four and Twenty Blackbirds* and another in 1939 for *Wee Gillis*. Lawson was awarded the Newbery Medal in 1945 for *Rabbit Hill*, and an Honor Book Award in 1958 for *The Great Wheel*. One of his specialties as a children's author was in telling the stories of famous men of history, including Benjamin Franklin, Paul Revere, and Christopher Columbus, from the vantage point of their pets. Lawson and his wife, Marie Abrams Lawson (d. 1956), also a writer and illustrator, shared a studio in their Westport, Connecticut, home.

LENSKI, LOIS (1893–1974)

One of the most productive children's writers of the twentieth century, Lois Lenski enjoyed an idyllic small-town childhood in Anna, Ohio, where her leisure time was focused on reading and drawing. She graduated from Ohio State University with a degree in education, and was to set to begin a teaching career when she chose instead to attend classes at the Art Students League in New York. After working as a commercial artist, Lenski traveled to England and Italy to study and received commissions to illustrate children's books. She continued to work as an illustrator for other authors upon her return home, before writing and illustrating her own book *Skipping Village* (1927). Lenski continued to publish titles for young children, while also winning two Newbery Honor Book designations for her series of historical novels about children. When ill health caused her relocation to a warmer climate, Lenski began to think about modern American children and their variety of lifestyles. *Bayou Suzette* (1943) was the first book to result from her shift to a contemporary regional focus, and for it, she received the first of her two Ohioana awards. Lenski would go on to write sixteen more regional novels over the next twenty-four years. *Strawberry Girl*, the best-known of this genre, received the Newbery Medal in 1946, and *Judy's Journey* received the Children's Book Award a year later. Lenski wrote and illustrated nearly one hundred of her own books, and illustrated half as many for other authors.

LEWIS, E. B. (b. 1956)

Earl B. Lewis is the illustrator of over twenty-five children's books focusing on young African American children learning from new experiences or exploring African American cultural and historical themes. Born in Philadelphia, Lewis earned two degrees from Temple University's Tyler School of Art. He is a faculty member at the University of the Arts, Philadelphia, and regularly exhibits his paintings in galleries. Lewis's illustrations for Jacqueline Woodson's *Coming on Home Soon* won a Caldecott Honor award in 2005.

McVICKAR, H. W. (1860–1905)

Harry Whitney McVickar was the son of Rev. Dr. William A. McVickar, the rector of Christ Church, New York, and spent part of his youth living with his family in Paris. He was known for both his book illustrations and his poster designs for *Harper's Bazaar*. A founder of *Vogue* magazine in 1892, McVickar provided drawings to illustrate works by prominent authors such as *Daisy Miller* (1892 and 1901) for Henry James and *Mr. Bonaparte of Corsica* (1895) for John Kendrick Bangs, in addition to illustrating his own books, which included *XXIV Bits of Vers de Société* (1890), *Matrimonial Advice* (1893), and *The Evolution of Woman* (1896). McVickar funded his second career as a real estate magnate through the substantial earnings from his first as an illustrator.

MERRILL, FRANK T. (1848–1923)

Frank Thayer Merrill was a lifelong Bostonian. He studied painting at the Museum of Fine Arts, Boston, as well as in France and England. Merrill made free use of wash and color, which is evident in his body of work in book and magazine illustration, and was recognized for his depictions in historical literature as well as fiction. Merrill's drawings appeared in more than forty books by authors including Washington Irving, William Makepeace Thackeray, Louisa May Alcott, Henry Wadsworth Longfellow, and Mark Twain.

MITCHELL, JOHN AMES (1845–1918)

Educated at Exeter and Harvard College, John Ames Mitchell studied architecture in Europe, and returned to Boston to begin his career as an architect. He became interested in book decoration, and went back to France to study at the Académie Julien and the Ecole des Beaux-Arts before switching to a full-time career as an illustrator and publisher. Mitchell founded the humor magazine *Life* in 1883, and served for over thirty years as its editor, contributing writer, and illustrator. He set the magazine's humorous, opinionated tone, and his criticism of modern medicine and sometimes acerbic political cartoons drew numerous libel suits, most of which the magazine won. *Life's* success was so assured by the mid-1890s that Mitchell was able to devote time to writing novels, most famously *Amos Judd* (1895), *The Pines of Lory* (1901), and *Pandora's Box* (1911), for which he also provided the illustrations.

MORA, JOSEPH JACINTO (1876–1947)

Joseph Jacinto "Jo" Mora was born in Uruguay and moved to New York as a child. After study at the Art Students League in New York, and the Cowles School of Fine Art in Boston, he edited and illustrated new editions of children's classics for the Boston publisher Dana Estes: *The Animals of Æsop* (1900) and *Reynard the Fox* (1901). The following year Mora supplied Estes with illustrations for Laura Richard's book *The Hurdy-Gurdy*, and perhaps his greatest early commission, an edition of *Hans Andersen's Fairy Tales* for

which he created over eighty text cuts and twenty-four full-page half-tone illustrations. In 1904 Mora moved to Arizona to study the Hopi and Navajo Indians, using his talents as a painter, sculptor, and photographer to make a valuable ethnological record of the tribes. His later pictures for children's books often reflect his experience as a cowboy in the last days of the American Wild West. In addition to painting murals and creating historical dioramas and sculptures, Mora wrote and illustrated three books, including *Trail Dust and Saddle Leather* (1946) and the posthumously published *Californios* (1949). Many children of Mora's day were also familiar with his authentic yet fanciful maps and posters, or "cartes," of places such as the Yellowstone and Yosemite national parks.

MOSER, BARRY (b. 1940)

Barry Moser has illustrated over 250 books for adults and children, ranging in scale from classic novels to alphabet books. He is especially well-known for his wood engravings, which he cuts himself, and his watercolors. He was born in Chattanooga and has studied at Auburn University, the University of Tennessee, and the University of Massachusetts at Amherst. In 1970 he began designing, printing, and illustrating his own books under a private imprint. In 1978 other presses began to notice Moser, and subsequently he was commissioned to redesign editions of classics such as *Alice's Adventures in Wonderland* (1982), *Through the Looking-Glass* (1983), and *The Hunting of the Snark* (1983). The critical and popular success of these works was followed in the late 1980s by Moser's award-winning illustrations for three volumes of Brer Rabbit stories adapted by Van Dyke Parks. In later years he has continued to create images for classic novels and children's literature, while also branching out into nonfiction and inspirational literature.

NAST, THOMAS (1840–1902)

The "Father of American Caricature," Thomas Nast was born in Germany and came to New York in 1846. His earliest exposure to art came through his job as doorkeeper at Thomas Jefferson Bryan's Gallery of Christian Art, where he was allowed to copy the paintings on his own time. Nast began his career in illustration as a draftsman for *Frank Leslie's Illustrated Newspaper* at the age of fifteen, earning five dollars a week and learning from some of the era's best illustrators. In 1859 he left *Leslie's* for the *New York Illustrated News*, for which he covered John Brown's funeral. The next two years found him in England and Europe capturing various events in images that he sent to periodicals in London and New York. After his return to the United States in 1861, Nast married and began his long tenure with *Harper's Weekly*. Within a year his Civil War pictorial reports established him as the paper's artistic authority, and his work during the following two decades established him as one of America's greatest political cartoonists. Nast used the medium of wood engraving to inform his readers (as well as the illiterate) about the evils of the corrupt New York City gov-

ernment, and to raise their voices against other elected officials on the national level. Nast was the creator of some of the country's most iconic emblems: the Democratic and Republican parties' donkey and elephant, and the modern depiction of Santa Claus.

NEILL, JOHN R. (1877–1943)

John Rea Neill became a fixture in American children's literature by illustrating over forty titles in L. Frank Baum's "Oz" series after Baum had parted ways with illustrator W. W. Denslow. Born in Philadelphia, Neill began his professional education at the Pennsylvania Academy of Fine Arts, but dropped out to become a reporter for various newspapers including the *New York Evening Journal*, the *Philadelphia Inquirer*, and the Philadelphia *North American*. Through the *Evening Journal*, Neill befriended, and came under the lasting artistic influence of, adventure illustrator Joseph Clement Coll (1881–1921). Neill met L. Frank Baum at the *North American*, which published the cartoon strip, "Queer Visitors from the Marvelous Land of Oz." Neill became the "Royal Illustrator of Oz" beginning with *The Marvelous Land of Oz* (1904), and collaborated with Baum on other titles. After Baum's death, Neill continued illustrating "Oz" stories by Ruth Plumly Thompson, and eventually penned three of his own titles in the classic fantasy series.

NEWELL, PETER (1862–1924)

Born and raised in Illinois, Peter Newell moved to New York City to attend the Art Students League, and remained in the area for the rest of his life. Always a freelance artist, he worked from his studio in Leonia, New Jersey, a town that was home to many illustrators and artists at the turn of the century. Newell worked closely with the Harper and Brothers firm throughout his career, contributing comic material to *Harper's Weekly* and *Harper's Bazaar* that ranged from single-pane cartoons to a full series of half-page humorous views of the world's fairs. Newell was the artist selected when the company decided to publish updated editions of Lewis Carroll's classic books *Alice's Adventures in Wonderland* (1901), *Through the Looking Glass* (1902), and *The Hunting of the Snark* (1903). He illustrated over forty books and a wide variety of stories for periodicals including *Cosmopolitan*, *Metropolitan*, *McClure's* and *Collier's*, by authors such as John Kendrick Bangs, Stephen Crane, Philip Curtiss, Burges Johnson, Frank Stockton, and Mark Twain. Newell is best known for the six novelty children's books he wrote and illustrated himself, beginning with the two volumes of *Topsys and Turvys* (1893 and 1894). He explored other inventive die-cut designs for *The Hole Book* (1908), *The Slant Book* (1910), and *The Rocket Book* (1912).

OPPER, FREDERICK BURR (1857–1937)

Pioneering comic artist Frederick Burr Opper was born in Madison, Ohio, and had his first newspaper experience in the printing office

of the *Madison Gazette*. His art training consisted of a single term at Cooper Union in New York, and a brief apprenticeship with cartoonist and illustrator Frank Beard (1842–1905). Opper's first big break came in 1881, when he was hired to draw comics for *Puck*, the humor weekly founded by cartoonist Joseph Keppler (1838–1994). He kept the position for eighteen years, until William Randolph Hearst hired him away for the "Comic Section" (a relatively new idea at the time) of the *New York Journal*. Opper's technical versatility, and his ability to produce original comic series in high volume, was well-suited to the emerging newspaper medium. "Happy Hooligan," a series featuring an imperturbable but unfortunate hobo, was his most successful creation during this period. Opper remained on Hearst's staff—simultaneously illustrating a number of books—until poor eyesight ended his long career in 1932.

PARRISH, MAXFIELD (1870–1966)

One of the most popular and commercially successful artists of the first three decades of the twentieth century, Frederick Maxfield Parrish was raised in Philadelphia in a Quaker household; his father was the noted etcher and painter Stephen Parrish (1846–1938). He attended Swarthmore and Haverford colleges, but left to study at the Pennsylvania Academy of Fine Arts. In 1895 he received his first commission for magazine covers, and began to develop the luminous, fairytale-like quality for which he would become famous. Parrish was an innovator in the use of color glazes, which he applied to give his fantastic works a translucent, three-dimensional feel. The first children's book he illustrated was L. Frank Baum's *Mother Goose in Prose* in 1897. He illustrated several more books for children and adults during his career, with his name often featured more prominently than that of the author. Parrish's financial success by the 1890s allowed him to follow his father and other painters, illustrators, and writers, and live at the artists' colony in Cornish, New Hampshire, begun by the sculptor Augustus Saint-Gaudens and the painter Thomas Dewing. By the early years of the twentieth century, Parrish was one of the most sought after and highly paid illustrators working in America. His popularity inspired corporate commissions for product advertisements, many of which, such as his Edison Mazda images, are remembered today even when the corporations themselves are not. In his later years Parrish began painting illustrations on a grander scale, such as murals, and eventually shifted his focus away from commercial art in favor of figureless and fantasy landscape paintings.

PETERSHAM, MAUD FULLER (1890–1971)
PETERSHAM, MISKA (1888–1960)

Maud and Miska Petersham were the authors and illustrators of numerous children's books, including animal tales, Bible stories, books of facts, and tales of places around the world. They are credited with introducing themes of racial tolerance and multiculturalism to children's literature. The couple met when they were both employed in the art department of a New York advertising agency, and were married in 1917. They immediately began illustrating children's books together, including two popular works by Olive Beaupre Miller, *Nursery Friends from France* (1925) and *Tales Told in Holland* (1926). In 1929 the Petershams published their first co-authored work, *Miki*, a story inspired by Miska's youth in Hungary. The success of *Miki* was followed by dozens of other books, including *An American ABC*, for which they won a Caldecott Honor Award in 1942, and *The Rooster Crows*, which earned a Caldecott Medal in 1946.

PITZ, HENRY CLARENCE (1895–1976)

The son of a German bookbinder, Henry Clarence Pitz was born in Philadelphia and began his career as a student at the Pennsylvania Museum and School of Industrial Art (now University of the Arts in Philadelphia), but his studies were interrupted by World War I. After serving in the American Expeditionary Forces in France, Pitz showed examples of his drawings to New York publishers and his work soon appeared in periodicals such as *Boys' Life* and *St. Nicholas*. In 1922 he ventured into book illustration for the first time with John Bennett's *Master Skylark*. Pitz went on to illustrate over 160 books for others, and write several of his own on illustration techniques and history. Successful also as a painter, Pitz taught and lectured for more than thirty years at regional schools, including the Pennsylvania Academy, and the University of Pennsylvania.

POGÁNY, WILLY (1882–1955)

The multi-dimensional artist William Andrew Pogány was born Vilmos Andreas Pogány in Hungary, and studied art in Budapest, Munich, and Paris before immigrating to the United States in 1914. Over the next several decades he became widely known for both his grand and small-scale works, at first for stage sets and costume designs in New York, then for murals, portraits, and illustrations for books and magazines. During Hollywood's early years, Pogány served as art director for numerous films, and painted portraits of stars such as John Barrymore and Carole Lombard. The walls of various theatres, hotels, and private residences in and around New York still exhibit examples of the artist's unique style as a decorative muralist. In the field of illustration, Pogány was represented in both books and magazines. In the 1940s he executed cover designs for many magazines, including every issue of the *American Weekly*. Many consider his masterpiece in book illustration to be Samuel Taylor Coleridge's *The Rime of the Ancient Mariner* (1910), for which he designed the gilt binding, calligraphic text, and tipped-in color plates. In all, Pogány illustrated over 150 books, including many children's classics.

POTTER, BEATRIX (1866–1943)

Born into a wealthy Victorian family, Beatrix Potter spent her childhood summers in the Scottish highlands and England's Lake

District, where she and her younger brother collected and tamed small wild animals they studied and sketched in detail. Encouraged by her parents, and instructed by her governesses and visits to London museums, Potter created a series of Christmas cards which were published around 1890. Her most famous creations, the rabbits Flopsy, Mopsy, Cottontail, and Peter, made their appearance in 1893 in a letter to a friend's child who was sick with scarlet fever. In 1902 *The Tale of Peter Rabbit* was published to wide acclaim, leading Potter to write twenty more children's books, illustrating each with her signature watercolors. Success gave her the means to buy Hill Top Farm and Castle Cottage in Sawrey, England, where she worked with her farmhands to revive an endangered breed of local sheep. At the age of 47, Potter married the solicitor William Heelis, settled in the Lake District permanently, and focused her attention on her farm. Preservation of the local landscape was another of Potter's passions; at her death she left 4,000 acres to The National Trust, encompassing several farms and cottages.

PROVENSEN, ALICE (b. 1918)
PROVENSEN, MARTIN (1916–1987)

Alice Twitchell and Martin Provensen had strikingly similar backgrounds before meeting and marrying in 1944. Both were born in Chicago, won scholarships to the School of the Art Institute of Chicago, and transferred to study at the University of California, though they did not meet until, during World War II, Provensen was assigned to a Navy-sponsored film project at Walt Disney Studios where Alice Twitchell was working as an animator. The couple's experience drawing film storyboards would influence the pace and sequencing of the more than forty picture books on which they collaborated, beginning in 1947. The Provensens illustrated children's books of their own, as well as those by other authors. Their artistic styles were virtually indistinguishable and they were especially well known for their depictions of animals, which were heavily influenced by the fauna at their own Maple Hill Farm in New York's Hudson Valley. In 1984 they were awarded the Caldecott Medal for *The Glorious Flight: Across the Channel with Louis Blériot, July 25, 1909.*

PYLE, HOWARD (1853–1911)

Known as "the father of American illustration," Howard Pyle was born in Wilmington, Delaware, and was raised in a Quaker home. Early on, he was exposed to fairytales, children's stories, and fine art by his mother. Evidence of artistic talent convinced his parents to support his study for three years with Francis Adolf Van der Wielen, an Antwerp-trained painter living in Philadelphia. In 1876, after several illustrations Pyle sent to *Scribner's* and *St. Nicholas* were published, he moved to New York. Once there, he became so firmly established as an illustrator through his work with *Harper's Weekly* that he was able to return to Wilmington in 1879 and open a studio. Pyle's success in teaching courses at the Drexel Institute of

Arts and Sciences in Philadelphia inspired him to open his own art school in Wilmington in 1900, where he became an influential teacher to such early-twentieth-century illustrators as N. C. Wyeth, Jessie Willcox Smith, and Maxfield Parrish. Pyle was particularly successful in delineating the characters and events of early American history and in 1883 began a long series of children's books and adaptations of medieval legends, the first of which was *The Merry Adventures of Robin Hood.* Near the end of his career Pyle became interested in mural painting, and devoted his energies to major commissions in three public buildings designed by Cass Gilbert. This new interest led Pyle to take his first voyage to Europe in order to study the great murals of Italy; he died in Florence in 1911.

REED, ETHEL (1874–1910 or 1925)

Ethel Reed, born in Newburyport, Massachusetts, was one of a select few American female illustrators working in the 1890s to gain recognition during her lifetime. She was a largely self-taught artist, although she briefly apprenticed to a painter of miniatures and attended the Cowles Art School in Boston in 1893. Reed exhibited watercolors at the Boston Art Club in the mid-1890s before focusing more exclusively on the graphic arts of poster design and book illustration. She specialized in designing advertisements for romantic novels that often featured pristine young girls at the edge of decadence (possibly based on self-portraits) and suggestively ensconced in whorls of exquisite flowers. Her illustrations for babies' and children's books evinced a similar art nouveau style. Most of her known work was completed in Boston between 1895 and 1897, though books featuring her work were also published in London. Reed was engaged to marry the Boston artist Philip Hale when she went on a trip to that city in 1897; her subsequent disappearance from the publishing world has been attributed to her loss of sight while there. Richard Le Gallienne, an admirer, dedicated a poem to her in 1910 upon hearing that she had become blind, and wrote later of her in his book *The Romantic '90s* (1926), describing "the noble silent beauty of Ethel Reed, whose early death robbed the world of a great decorative artist."

RHEAD, LOUIS (1857–1926)

Louis Rhead, born into a family of British artists that included his father and many of his siblings, studied in Paris and England as a young man, before immigrating to the United States and taking a position with the publisher D. Appleton & Company. Though perhaps best known for his evocative art nouveau posters, many done for the *Century Magazine*, he provided illustrations for new Harper & Brothers editions of many widely-read juvenile classics including *Robin Hood* (1912), *Andersen's Fairy Tales* (1914) *Treasure Island* (1915), *Arabian Nights* (1916), and *Kidnapped* (1921). Another of his passions was fishing, and Rhead wrote and illustrated a series of manuals on the sport.

Rey, Hans Augusto (1898–1977)

Hans Augusto Reyersbach was born in Hamburg, Germany. Though he attended universities in Germany, he never received any formal art training but became a designer while working as a lithographer for a firm that specialized in circus posters. Reyersbach moved to Rio de Janeiro in 1925, and there met his wife, Margret (1906–1996), a German artist. The couple moved to Paris after their marriage. While in France, they created the impish character Curious George, but their series of stories about the mischievous monkey were not published until the Reys relocated to the United States in 1940. The books were a close collaboration between the couple, though Margret did not receive credit in their earliest works. They went on to feature Curious George in seven titles published between 1941 and 1966 that won awards from both the Child Study Association of America and *School Library Journal*. Rey is also notable for having written and illustrated two books on amateur astronomy, in which he explained to both adults and children his idiosyncratic system of star identification.

Richardson, Frederick (1862–1937)

Born in Chicago, Frederick Richardson studied at the St. Louis School and Museum of Fine Arts, and the Académie Julien in Paris. He worked in Chicago as an instructor of drawing and advertising at the School of the Art Institute of Chicago and as head of the art department at the *Chicago Daily News*; his work for the paper was compiled and published as *Book of Drawings* in 1899. Richardson moved to New York in 1903 and there had a career as a painter and illustrator, providing drawings for L. Frank Baum's *Queen Zixi of Ix, or the Story of the Magic Cloak* (1905). He created illustrations for several books issued by the Chicago publisher P. F. Volland, as well as for editions of Andrew Lang's fairy books in 1930.

Rockwell, Norman (1894–1978)

Norman Rockwell was born in New York City. He left high school in the middle of his sophomore year to study at the National Academy of Design, after which he enrolled at the Art Students League. Rockwell was hired as art director for *Boy's Life*, the magazine of the Boy Scouts of America, before he turned twenty, and kept a relationship with that organization through 1976 as the illustrator of their annual calendar. In 1915 Rockwell moved to New Rochelle, New York, home to a community of artists and illustrators. From his studio there, he produced graphic work for a number of periodicals, but his most important connection was made in 1916 when he sold his first cover illustration to *The Saturday Evening Post*, one of the most widely read magazines of the time. Rockwell went on to paint 322 covers for the *Post* between 1916 and 1963, and through that highly public forum became known as the painter whose work captured the look and feel of small-town America. In the 1960s Rockwell's increasingly liberal politics led him to leave the conservative *Post* and begin work as an on-the-scene illustrator

for *Look* magazine. In his final years, his pictures began to lose the decidedly idealistic mood for which he was known, and take on a gravity that was more in keeping with the times.

Rogers, W. A. (1854–1931)

Ohio native William Allen Rogers evinced a talent for drawing at an early age. At fourteen he was already submitting cartoons to a group of midwestern newspapers, becoming the first American cartoonist to be syndicated, and in the 1870s began working for the New York papers *The Daily Graphic*, and *Harper's Weekly*. By 1880 Rogers had begun a career drawing opinionated political cartoons for *Life* and the *New York Herald*, which were compiled into two books published in 1899 and 1917. Rogers's series of particularly trenchant anti-German drawings published in the *Herald* during World War I won him membership in the French Legion of Honor. Rogers led a simultaneous career as an illustrator of children's books and serials, as well as being an author. His most notable graphic creation was the title character of James Otis's *Toby Tyler* (1881), a Horatio Alger-esque tale of a boy who joins the circus.

Sarg, Tony (1882–1942)

Born in Guatemala to a German sugar and coffee planter father and an English mother, Tony Sarg was educated in Germany and began his artistic career in London. He moved to the United States in 1915, becoming an American citizen soon after. Sarg had success as a book illustrator starting with his first commission, Irvin S. Cobb's *Speaking of Operations* (1915), and went on to illustrate books for others as well as writing and drawing nearly a dozen of his own. Sarg was a popular illustrator for periodicals and turned in work for *The Saturday Evening Post*, *Cosmopolitan*, and *Collier's*. While highly regarded for his illustration work, Sarg is best known for transforming American puppetry in the first half of the twentieth century. In the 1920s he gained notoriety for his marionette shows, such as *Rip Van Winkle*, *Don Quixote*, and *Alice in Wonderland*. One of his most memorable creations, for Macy's department store in New York, was the collection of giant animal balloons that for years was a feature of its Thanksgiving Day parades. Sarg also designed textiles, wallpaper, and furniture, especially for children.

Scarry, Richard (1919–1994)

Richard Scarry was one of the best-selling children's authors of all time. His more than one hundred books have been translated into thirty languages and have sold over three hundred million copies. Scarry was born in Boston and attended the School of the Museum of Fine Arts, Boston, from 1939 to 1942, after which he entered the United States Army. In 1949 he illustrated his first children's book, *The Boss of the Barnyard* by Kathryn Jackson, followed by several more of her titles. Scarry worked on other authors' books

for several years before beginning to write and illustrate original stories of his own. In 1949 he married Patricia Murphy (1923–1995), one of the authors he had worked with, and the couple relocated to a farm in Ridgefield, Connecticut. In 1955 Scarry designed the character Smokey Bear, mascot of the U.S. Forest Service, but as an author and illustrator, his first big commercial success came in 1963 with the publication of *Richard Scarry's Best Word Book Ever*, containing more than 1,400 defined and illustrated objects. Scarry moved his family to Switzerland in 1969, where he continued to produce highly popular children's books until his death.

SENDAK, MAURICE (b. 1928)

Maurice Sendak grew up in Brooklyn, the son of Jewish immigrants from Poland. At an early age, he took pleasure in comic books, and their style became an influence on his later work. His first success as an illustrator, for Ruth Krauss's *A Hole Is to Dig* (1952), allowed him to follow a career in children's literature both as an artist and as an author. In the years following, Sendak became famous for his nineteen picture books, especially for his loosely-related trilogy, *Where the Wild Things Are* (1963, which won the Caldecott Medal in 1964), *In the Night Kitchen* (1970, a Caldecott Honor Book in 1971), and *Outside Over There* (1981) which won both a Caldecott Honor Book Award and a National Book Award in 1982. Sendak has illustrated more than sixty books by other authors, and has also been active in opera and theater, designing costumes and sets and writing libretti.

SEUSS, DR. (1904–1991)

Theodor Seuss Geisel, better known as Dr. Seuss, is recognized the world around. His eighty-one books have been published in twenty languages, have sold more than two hundred million copies, and have earned him three Caldecott awards. Geisel was born in Springfield, Massachusetts, and attended Dartmouth College, where he edited the humor magazine *Jack-o-Lantern*. In 1926 he left graduate school at Oxford University and began selling cartoons to magazines including *Life* and *Vanity Fair*. His transition to children's literature was made in 1937 when his first children's book, *And to Think That I Saw It on Mulberry Street*, was published. During World War II, Geisel made short films for the U.S. Army, two of which won Academy Awards. After the war he returned to children's books, revolutionizing the form with his sprightly illustrations and trademark verse in anapestic tetrameter. The enthusiastic reception to *The Cat in the Hat* (1957), an exercise in phonics education, led Geisel to found an imprint for children, Beginner Books, which was eventually acquired by Random House. Perhaps the most famous nonsense poet of all time, the man known as Dr. Seuss inspired everything from Broadway shows to theme park rides. In tribute, the Association for Library Service to Children established the Theodor Seuss Geisel Award, given annually to the author and illustrator of the most distinguished book for beginning readers.

SEWELL, HELEN (1896–1957)

Helen Moore Sewell was born at the Mare Island Navy Shipyard in California, where her father was stationed. She was raised on Guam, and educated in Brooklyn at Packer Collegiate Institute and at Pratt Institute. Sewell began her career designing greeting cards, which led her into children's book illustration; two of her early projects were Susanne Langer's book *The Cruise of the Little Dipper and Other Fairy Tales* (1923) and Mary Britton Miller's *Menagerie* (1928). Sewell's adaptability, however, became one of her outstanding qualities as an illustrator: though she wrote and illustrated eleven books for children, she was most highly regarded for her work for other authors including Elizabeth Coatsworth and Laura Ingalls Wilder, particularly for her illustrations for the first editions of Wilder's "Little House" series in the 1930s and 1940s. Late in her career Sewell illustrated two books for the author Alice Dalgliesh, the second of which, *The Thanksgiving Story* (1954), won a Caldecott Honor Award in 1955.

SHEPARD, ERNEST H. (1879–1976)

Though he had a long and prolific career, the British illustrator Ernest Shepard is best remembered for his work for two internationally best-selling classics of children's literature, A. A. Milne's *Winnie-the-Pooh* (1926) and Kenneth Grahame's *The Wind in the Willows* (1931). After studying at the Royal Academy School, Shepard got his start as an illustrator and cartoonist at the journal *Punch*, where he worked for more than thirty years with time off to serve in World War I. After the war, he was elected to the magazine's editorial board, and through those contacts gained the commission to illustrate Milne's book of children's poems, *When We Were Very Young* (1924). Shepard's success with that title led to his work on Milne's Pooh stories, and his creation of the elegantly simple line-drawn characters Winnie the Pooh, Piglet, Eeyore, and Christopher Robin. For *Winnie-the-Pooh*, Shepard based the honey-loving title character on a stuffed bear named Growler that belonged to his son, Graham. In his later years, Shepard also wrote two autobiographies and illustrated his own juvenile fiction.

SHEPPARD, WILLIAM L. (1833–1912)

Born in Richmond, Virginia, the illustrator and sculptor William Sheppard served with the Confederate Army during the Civil War. That experience provided him with the inspiration for many drawings and landscape paintings, sculptural monuments to Confederate heroes, and illustrations for Carlton McCarthy's volume *Detailed Minutiæ of Soldier Life in the Army of Northern Virginia, 1861–1865* (1882). After the war Sheppard studied in Europe and provided drawings for *Harper's Weekly* and other publications. Among his more notable illustrations are those he did for Charles Dickens's *Dombey and Son* (1873). As an artist, he is known variously as William Ludlow Sheppard and William Ludwell Shepard.

SHIMIN, SYMEON (1902–1984)

Painter and illustrator Symeon Shimin was born in Russia but spent most of his life in New York. At the age of sixteen, after he had abandoned hope of becoming a musician, Shimin apprenticed himself to a commercial artist while taking art classes at Cooper Union. He became skilled in various media and painting techniques, refining his knowledge through studies of masters such as Goya and El Greco during an eighteen-month study tour in France and Spain in the late 1920s. Over the next two decades Shimin exhibited his paintings and supported himself with freelance commissions, including mural projects. His career in illustration began in 1950 with the publication of a new edition of Herman and Nina Scheider's *How Big is Big?* During his career, Shimin illustrated more than fifty books for other authors and wrote two of his own, often taking periods off in between projects to devote time to painting. His illustrations for children's literature encompass a variety of topics and themes, from animals to poetry to Jewish holidays. Shimin is probably best known for depicting Madeline L'Engle's *Dance in the Desert* (1969).

SHINN, EVERETT (1876–1953)

The American painter Everett Shinn was born into a Quaker family in Woodstown, New Jersey. After studying industrial design at Philadelphia's Spring Garden Institute, he became a draftsman for a lighting fixtures company before enrolling at the Pennsylvania Academy of Fine Arts in 1893. During his years at the school, he worked as staff artist for the *Philadelphia Press* and was one of the "Philadelphia Four," a group of newspaper-trained men who formed the nucleus of a new wave of urban realism in American art. Shinn moved to New York in 1897 and while still working as an illustrator, joined with other like-minded painters to form "The Eight," whose group exhibition in 1908 brought a new vocabulary to American art. The friends, who were also known as "The Ashcan School," rebelled against traditional, conservative art promoted by the National Academy of Design in favor of more realistic images of urban life and scenery. They also championed modern painters whose work they featured in their groundbreaking Armory Show of 1913. In addition to writing, acting, and producing plays, Shinn painted murals and created nearly one hundred images for magazines. Of the twenty-eight books he illustrated, twenty-one were completed after 1938, as his art gradually became less motivated by social progressivism.

SMITH, E. BOYD (1860–1943)

Elmer Boyd Smith was born in New Brunswick, Canada, and raised in Boston, but his early and formative exposure to art occurred mainly in France, where he was inspired by the work of painters Pierre Puvis de Chavannes (1824–1898) and Louis-Maurice Boutet de Monvel (1851–1913). Boyd's *My Village* (1896), the first of over seventy books he illustrated, was based on his summer travels around

Paris. In 1905 Smith wrote and illustrated his first children's book, *The Story of Noah's Ark*, which was followed in 1906 by *The Story of Pocahontas and Captain John Smith*. The popularity of these books established him as one of America's leading children's illustrators, alongside such artists as Jessie Willcox Smith and Howard Pyle.

SMITH, JESSIE WILLCOX (1863–1935)

Born in Philadelphia, Jessie Willcox Smith's serendipitous introduction to children's book illustration is all the more remarkable for the stature she eventually achieved in the field. It was only upon joining a friend at a drawing lesson around 1885 that her talent was discovered, leading her to abandon her job as a kindergarten teacher and pursue a career in art. Smith attended the School of Design for Women (now Moore College of Art) in Philadelphia, and afterward the Pennsylvania Academy of Fine Arts, where she studied with Thomas Eakins (1844–1916). She graduated in 1888, and started working for the *Ladies Home Journal* as an illustrator in their advertising department. In 1894, Smith began taking Saturday classes at Drexel Institute of Arts and Sciences with Howard Pyle, who helped secure her first book illustration commission, *Evangeline: a Tale of Acadie* (1897) by Henry Wadsworth Longfellow. Smith was more at ease, however, depicting mothers and children, and this is where she built her reputation. Prime examples can be found in her illustrations for Robert Louis Stevenson's *A Child's Garden of Verses* (1905) and Louisa May Alcott's *Little Women* (1915). In 1917 Smith began providing drawings for the magazine *Good Housekeeping*. In the following decade her watercolors, many of them of children at play, graced more than two hundred covers. Smith is best known for illustrating a children's classic, Charles Kingsley's *The Water-Babies* (1916); she held on to the dozen watercolors from that project until her death, and made a bequest of the collection to the Library of Congress.

STEPHENS, H. L. (1824–1882)

A native of Philadelphia, Henry Louis Stephens illustrated books and periodicals published in that city and New York. While still living in Philadelphia, he published a noted set of caricatures, *The Comic Natural History of the Human Race* (1851), which featured the heads of famous Americans attached to the bodies of animals, birds, fish, and insects. Stephens moved to New York in 1859 and worked for the publishers Harper Brothers and Frank Leslie, and the comic paper *Vanity Fair* (1859–1862). In the 1860s he illustrated several children's books for the New York firm Hurd & Houghton, including *Death and Burial of Poor Cock Robin*, *The Five Little Pigs*, *Old Mother Hubbard*, *A Frog He Would a Wooing Go* (all 1865), and *Puss in Boots* (1866), He contributed as well to their serial *The Riverside Magazine for Young People: an Illustrated Monthly* (1868–1870). At the same time Stephens enlivened several other comic periodicals, including *Mrs. Grundy* (1865) and *Punchinello* (1870), with his cartoons. His book illustrations include works by Charles Dickens, Mark Twain, and Harriet Beecher Stowe. Stephens is also known

for his satiric and abolitionist drawings published during the Civil War including the series "The Adventures of a Conscript as Told by Himself," and "Journey of a Slave from the Plantation to the Battlefield" (both 1863), in addition to cuts designed for numerous military recruitment posters published in Philadelphia.

TENGGREN, GUSTAF (1896–1970)

Painter and graphic illustrator Gustaf Tenggren was born in Sweden. In 1917 he became the artist for *Bland Tomtar o' Troll* (*Among Elves and Trolls*), a famous Swedish Christmas annual for children. He kept the position for nine years, though he had moved to the United States in 1920. The techniques Tenggren applied to these Scandinavian fairytales carried over to his American career, a highly prolific period between 1923 and 1961. The lush color plates he produced for books such as *Sven the Wise and Svea the Kind* (1932) drew comparisons to the work of Arthur Rackham (1867–1939), the preeminent British illustrator of the preceding generation. Tenggren's romantic style is also evident in his work for Walt Disney Studios, where he became an art director in 1936. The forest scenes in *Snow White and the Seven Dwarfs* (1937) are typical examples. Tenggren's later book illustrations seemed to be influenced by his time at Disney. Though his output increased, his style became flatter and more simplified. The change did not affect his marketability as a household name, however. The 1940s and 1950s saw a steady stream of "Tenggren" fairy and folk tale books including *Little Black Sambo* (1948) and *Thumbelina* (1953).

VAN ALLSBURG, CHRIS (b. 1949)

One of the most lauded contemporary illustrators of children's books, Chris Van Allsburg was born in Grand Rapids, Michigan, and studied sculpture at the University of Michigan and at Rhode Island School of Design. While successful as a sculptor, he was encouraged by his wife Lisa, a third-grade teacher, to think of creating a book for children. The result was *The Garden of Abdul Gasazi*, published in 1979, which earned him a Caldecott Honor Award. He has illustrated fifteen works of his own, including two which won Caldecott Medals, *Jumanji* (1981), and *The Polar Express* (1985), perhaps his best-known work.

VAN LOON, HENDRIK WILLEM (1882–1944)

Born in the Netherlands, Hendrik Van Loon came to the United States in 1902 to attend Cornell University, and then returned to Europe for graduate study at Ludwig-Maximilian University in Munich. He began teaching at Cornell in 1911, but with the outbreak of World War I went back to Europe as a war correspondent. Returning to America, Van Loon began his career as a writer. After his book *Story of Mankind* was awarded the inaugural Newbery Medal in 1922, he wrote and illustrated more than fifty books for children and adults, and became a popular guest on radio shows.

WARD, LYND (1905–1985)

Lynd Kendall Ward illustrated over two hundred books for both children and adults, including several authored by his wife, May Yonge McNeer (1902–1994). A fine arts graduate of Columbia University, he is best known for his seven "woodcut novels," with themes centering on the Depression, told only through illustrations; *God's Man* (1929) was the first. As a child, Ward spent long summers with his family in the Great Lakes wilderness, which served as inspiration for the watercolors in his first self-written children's book, *The Biggest Bear*, a Caldecott Medal winner in 1953. He published two more children's books before his death, and illustrated two others that were winners of the Newbery Medal.

WILLIAMS, GARTH (1912–1996)

Born in New York to a cartoonist and a landscape painter, Garth Williams spent his childhood on a farm in New Jersey. After his family moved to England, Williams accepted a scholarship at London's Royal College of Art to study painting and sculpture. He won the British Prix de Rome in 1935, traveled throughout Europe, then returned to New York and made an unsuccessful attempt to win a position as a cartoonist for the *New Yorker*. A contact presented him with the opportunity to illustrate E. B. White's manuscript of *Stuart Little*, which was published in 1945. The overwhelming success of the book confirmed his choice of a career in children's literature. Williams went on to illustrate White's enormously popular *Charlotte's Web* (1952), the new editions of Laura Ingalls Wilder's Little House series in the 1950s, and Margery Sharp's *The Rescuers* (1959), among many other titles. Of his eight self-illustrated works, *The Rabbits' Wedding* (1958) is the most famous. Its then-controversial story line of a white rabbit marrying a black rabbit caused the book's removal from library shelves in the southern U.S.

WINTER, MILO (1888–1956)

Milo Kendall Winter was an illustrator who specialized in the whimsical and the imaginary. Many of his best-known works, such as *The Aesop for Children* (1919), *The Arabian Nights Entertainments* (1914), *Alice in Wonderland* (1916), and *Gulliver's Travels* (1912), reflect his unique style. Born in Princeton, Illinois, Winter was trained at the School of the Art Institute of Chicago, and illustrated dozens of children's books and textbooks for publishers in that city and in New York. He was for many years both an illustrator and editor for *Childcraft*, a children's encyclopedia published in Chicago, and worked, as well, as an art and film editor in the 1940s.

WYETH, ANDREW (b. 1917)

Born in Chadds Ford, Pennsylvania, and son of illustrator N. C. Wyeth, Andrew Wyeth spent summers with his parents at their home in Maine. At fifteen he became one of his father's pupils, and

within five years successfully exhibited his watercolor landscapes and seascapes in New York's Macbeth Gallery. His realistic style, in the tradition of Winslow Homer, distinguished him from many of the abstract expressionists who dominated American painting at the time. Wyeth met his wife Betsy in Maine, and it was she who introduced him to a friend who would become the subject of what is the artist's most widely recognized painting, *Christina's World* (1948). After the sudden death of his father in 1945, Wyeth focused more heavily on studies of the human figure. He spent the latter half of his career painting the scenes and neighbors of his private worlds in Pennsylvania and Maine.

WYETH, N. C. (1882–1945)

Painter, muralist, and illustrator Newell Convers Wyeth, was born in Needham, Massachusetts. With the encouragement of his mother, Wyeth studied drafting at the Mechanic Arts School in Boston and illustration at the Massachusetts Normal Arts School. The most crucial period of Wyeth's artistic development occurred after 1902, when he moved to Delaware to study with Howard Pyle; within a few months, Wyeth saw one of his illustrations published on the cover of *The Saturday Evening Post*. Seeking a wider visual experience, he traveled through the American West three times between 1904 and 1906, then married and settled in Chadds Ford, Pennsylvania. For the next four decades he was a regular contributor to *The Saturday Evening Post* as well as *Harper's*, *Outing*, *McClure's*, *Century*, and *Scribner's*, but was more successful in the field of book illustration. Beginning in 1911 with Robert Louis Stevenson's *Treasure Island*, Wyeth illustrated eighteen volumes in Scribner's Illustrated Classics series. He averaged one book per year for the series, which included adult histories and romances; he ultimately produced over three thousand paintings to accompany works by authors such as James Fenimore Cooper and Jules Verne. During his career, Wyeth maintained a personal interest in easel painting and created a dozen murals in buildings along the east coast, but this never overshone his reputation as one of the most prominent artists in the history of American illustration.

YOUNG, ART (1866–1943)

Arthur Henry Young, was born in Illinois, and studied at art schools in Chicago, New York, and Paris. Young made his reputation by publishing his drawings and cartoons in periodicals such as the *Chicago Daily News*, *Life*, *Judge*, *Puck*, and *The Nation*. His illustrations on political topics led him to create more pointedly Socialist work. He found an important forum in *The Masses*, a serial begun in 1910 by the Dutch radical Piet Vlag and edited by Max Eastman. Though indicted for espionage because of his cartoons (an episode that led to the closing the *The Masses* in 1917), Young remained politically committed to his causes, particularly through his own Socialist humor magazine *Good Morning* (1919–1921), all the while poking fun at the foibles of all classes.

ZEMACH, MARGOT (1931–1989)

Margot Zemach was a children's author and illustrator whose métier was adapting folktales for children. During her career she translated stories native to Sweden, Denmark, Russia, Germany, and Italy, many of which she discovered while living and traveling extensively in Europe. Zemach studied at the Los Angeles County Art Institute, and, in 1955, won a Fulbright scholarship to study drawing in Vienna where she met her husband, Harve Zemach (1933–1974), also a Fulbright scholar. Zemach illustrated several books written by her husband, beginning with *A Small Boy is Listening* (1959), a story about the musical life of Vienna. In 1974 they won both the Caldecott Medal and the Lewis Carroll Bookshelf Award for *Duffy and the Devil: a Cornish Tale*.

Index of artists

A note about this book

This volume began as a collaboration between Betsy Beinecke Shirley and Greer Allen. Betsy knew Greer from his wonderful design work on the exhibition catalog for the 1991 show of Betsy's collection at the Beinecke Library: *Read Me a Story – Show Me a Book*. They collaborated again in 1994 to produce *History for Pleasure*, a 3-volume set of facsimiles from her collection. Their third project began when they decided to create a keepsake of Betsy's collection for friends and family. When Greer saw all of the fascinating artworks in Betsy's collection, he immediately knew that such a book should be shared with the world.

Betsy and Greer worked together, along with Greer's wife, Sue, to have the collection photographed over the Winter of 2004. When Betsy became ill and passed away in September 2004, Greer made it his goal to finish the book in her memory. He worked dauntlessly on plans for the book and was ready to prepare the layout in April 2005. Following a sudden illness, Greer passed away that month, before completing the book design.

The project was brought to fruition by Howard Gralla, working with the beautiful photographs made by Stan Godlewski. Background research and an ample share of the writing of captions and biographical entries were done by Patrick Kiley. Rigorous editing, proofreading, and further research were accomplished by Sandra Markham. Christa Sammons added valuable input at every stage of this publication.

I remain in debt to the valuable contributions of Sue Allen and members of Betsy's family, especially her daughters, Betsy Michel and Jody Gill, as well as many other enthusiastic supporters, including John Hill and Nancy Kuhl.

Gratitude is owed to the Jockey Hollow Foundation for support in publishing this volume.

TIMOTHY G. YOUNG

Grateful acknowledgement is made to the following publishers and copyright holders:

Page 20 and back jacket: Maud and Miska Petersham, [Boy and girl with animals and hornbook]. Reprinted with the permission of Simon & Schuster Books for Young Readers, an imprint of Simon & Schuster Children's Publishing Division from *An American ABC* by Maud Fuller Petersham and Miska Petersham. Copyright © 1941 Macmillan Publishing Company; copyright renewed © 1969.

Page 20: Maud and Miska Petersham, [Boy with a gun running from a skunk, rabbit, and raccoon] for *An American ABC*. Copyright © 1941 Maud and Miska Petersham. Reprinted by permission of the Petersham Estate.

Page 22: Joan Walsh Anglund, [The letters 'T' ("Thank") and 'U' ("Unicorn")]. Illustration from *In a Pumpkin Shell* copyright © 1960 and renewed 1988 by Joan Walsh Anglund, reproduced by permission of Harcourt, Inc.

Page 24: Alice and Martin Provensen, [Study for the cover]. "Illustrations" by Alice and Martin Provensen, copyright © 1978 by Alice & Martin Provensen, illustrations, from *A Peaceable Kingdom: The Shaker Abecedarius* by Richard Meran Barsam, illustrated by Alice and Martin Provensen. Used by permission of Viking Penguin, A Division of Penguin Young Readers Group, A Member of Penguin Group (USA) Inc., 345 Hudson Street, New York, NY 10014. All rights reserved.

Page 26: Clement Hurd, [Press proof (variant) for cover of *Goodnight Moon*]. Goodnight Moon © 1947 by Harper & Row. Text © renewed 1975 by Roberta Brown Rauch. Illustrations © renewed 1975 by Edith Hurd, Clement Hurd, John Thacher Hurd and George Hellyer, as Trustees of the Edith & Clement Hurd 1982 Trust. Used by permission of HarperCollins Publishers.

Page 28 and back jacket: Rockwell Kent, "The Cow Jumped Over the Moon." Copyright © 1958 Rockwell Kent. Reprinted by permission of Plattsburgh State Art Museum.

Page 46: Barry Moser, "Brer Rabbit Prepares His Plan." Illustration from *Jump! The Adventures of Brer Rabbit* by Joel Chandler Harris, copyright © 1986 by Pennyroyal Press, Inc., reproduced by permission of Harcourt, Inc.

Page 47: Ernest H. Shepard, [Badger, Toad, Mole, Rat and Otter] for *The Wind in the Willows*. Copyright © 1959 Ernest H. Shepard. Reprinted by permission Curtis Brown Group, Ltd.

Page 47: Ernest Shepard, [Badger, Toad, Mole, Rat, and Otter]. Reprinted with the permission of Atheneum Books for Young Readers, an imprint of Simon & Schuster Children's Publishing Division from *The Wind in the Willows* by Kenneth Grahame, illustrated by Ernest H. Shepard. Jacket Illustration Copyright © 1960 Ernest H. Shepard.

Page 64: Wanda Gág, "Fairy Story." Copyright © 1937 Wanda Gág. Reprinted by permission of Gary Harm, Administrator of the Wanda Gág Estate.

Page 70: Wanda Gág, [Cover design for *Snow White and the Seven Dwarfs*]. Copyright © 1938 Coward-McCann. New edition published in 2004 by the University of Minnesota Press. Reprinted by permission of the University of Minnesota Press.

Page 70: Wanda Gág, "The Seven Dwarfs discover Snow White in their bed" for *Snow White and the Seven Dwarfs*. Copyright © 1938 Coward-McCann. New edition published in 2004 by the University of Minnesota Press. Reprinted by permission of the University of Minnesota Press.

Page 71: [Unidentified artist for Walt Disney Productions], "The Faithful Little Men Watched over their Princess Constantly" for *Snow White and the Seven Dwarfs*. Copyright © 1937 Disney Enterprises, Inc. Reprinted by permission of Disney Enterprises, Inc.

Page 71: [Unidentified artist for Walt Disney Productions], [Happy] for *Snow White and the Seven Dwarfs*. Copyright © 1937 Disney Enterprises, Inc. Reprinted by permission of Disney Enterprises, Inc.

Page 73: Maurice Sendak, [Study for "The Hobbit"]. Copyright © 1967 Maurice Sendak. Reprinted by permission of Maurice Sendak.

Page 81: Margot Zemach, [Jake and Honeybunch]. Illustration from *Jake and Honeybunch Go to Heaven* by Margot Zemach. Copyright © 1982 by Margot Zemach. Reprinted by permission of Farrar, Straus and Giroux, LLC.

Page 84: Norman Rockwell, "Lemme see him, Huck. My he's pretty stiff" for *The Adventures of Tom Sawyer*. Copyright © 1936 Norman Rockwell. Reprinted by permission of Sidney Shiff.

Page 85: Dorothy P. Lathrop, [Proof with lettering for the paste-label used on the front cover]. Reprinted with the permission of Simon & Schuster Books for Young Readers, an imprint of Simon & Schuster Children's Publishing Division from *Hitty: Her First Hundred Years* by Rachel Field, illustrated by Dorothy P. Lathrop. Copyright © 1929 Macmillan Publishing Company; copyright renewed © 1957 Arthur S. Pederson.

Page 85: Dorothy P. Lathrop, "The surrounding roots made a kind of deep chair for me." Reprinted with the permission of Simon & Schuster Books for Young Readers, an imprint of Simon & Schuster Children's Publishing Division from *Hitty: Her First Hundred Years* by Rachel Field, illustrated by Dorothy P. Lathrop. Copyright © 1929 Macmillan Publishing Company; copyright renewed © 1957 Arthur S. Pederson.

Page 89: Lynd Ward, [Johnny and his father] for *The Biggest Bear*. Copyright © 1952 the Houghton Mifflin Company. Reprinted by permission of the Houghton Mifflin Company.

Page 103: Nancy Ekholm Burkert, "The Scroobious Pip from the top of a tree…" for *The Scroobious Pip*. Copyright © 1968 Nancy Ekholm Burkert. Reprinted by permission of Nancy Ekholm Burkert.

Page 107: Walt Kelly, "Cinderella and the Three Bears" for *Pogo Possum*, no. 8. Copyright © 1951 Walt Kelly. Reprinted by permission of Scott Daley.

Page 114: Ludwig Bemelmans, "The fire chief could not see the castle from his window…" for *The Castle Number Nine*. Copyright © 1937 Ludwig Bemelmans. Reprinted by permission of Barbara Bemelmans.

Page 114: Ludwig Bemelmans, "What nonsense is this to wake me up with in the middle of the night!" for *The Castle Number Nine*. Copyright © 1937 Ludwig Bemelmans. Reprinted by permission of Barbara Bemelmans.

Page 114: Ludwig Bemelmans, "And Baptiste counted on his fingers…" for *The Castle Number Nine*. Copyright © 1937 by Ludwig Bemelmans. Reprinted permission of Barbara Bemelmans.

Page 115: Ludwig Bemelmans, "When he understood them all…" for *The Castle Number Nine*. Copyright © 1937 Ludwig Bemelmans. Reprinted permission of Barbara Bemelmans.

Page 118: Symeon Shimin, [Artist's dummy for title page]. Illustration from *Dance in the Desert* by Madeleine L'Engle, pictures by Symeon Shimin. Text copyright © 1969 by Madeleine L'Engle. Pictures copyright © 1969 by Symeon Shimin. Reprinted by permission of Farrar, Straus and Giroux, LLC.

Page 118: Symeon Shimin, "At the crest of a dune stood a magnificent lion…". Illustration from *Dance in the Desert* by Madeleine L'Engle, pictures by Symeon Shimin. Text copyright © 1969 by Madeleine L'Engle. Pictures copyright © 1969 by Symeon Shimin. Reprinted by permission of Farrar, Straus and Giroux, LLC.

Page 119: Symeon Shimin, "At the crest of a dune stood a magnificent lion…" [printed image]. Illustration from *Dance in the Desert* by Madeleine L'Engle, pictures by Symeon Shimin. Text copyright © 1969 by Madeleine L'Engle. Pictures copyright © 1969 by Symeon Shimin. Reprinted by permission of Farrar, Straus and Giroux, LLC.

Page 119: Symeon Shimin, [Title page]. Illustration from *Dance in the Desert* by Madeleine L'Engle, pictures by Symeon Shimin. Text copyright © 1969